"A terrific sequel to the first *Master Shots*. If there's a cool way to move the camera, Christopher Kenworthy has explained it to us. I can't wait to get it in my students' hands."

— John Badham, director, *Saturday Night Fever, WarGames*; author, *I'll Be in My Trailer*

"The most comprehensive and practical breakdown of shooting technique, Kenworthy's *Master Shots, Volume 2*, is required 'bedside reading' for anyone who's serious about making movies."

— Neill D. Hicks, author, *Screenwriting 101: The Essential Craft of Feature Film Writing*; *Writing the Action-Adventure Film: The Moment of Truth*; and *Writing the Thriller Film: The Terror Within*

"Christopher Kenworthy's second volume of *Master Shots* will inspire every filmmaker to think carefully about placement and movement of actors as seen through the camera lens. This book increases the reader's appreciation for the critical work of the cinematographer and the director as they speak the language of film through images."

— Mary J. Schirmer, screenwriter, screenwriting instructor, *www.screenplayers.net*

"*Master Shots, Volume 2*, is an inspiration for every director, cinematographer, and writer. When breaking down a script, I always have *Master Shots* laying open within arm's reach."

— Stanley D. Williams, PhD., executive producer, director, *Nineveh's Crossing*, LLC & SWC Films

"Kenworthy has delivered one of the greatest no-filler books on camera technique I've ever seen, pairing motivation and mechanics to achieve maximum visual impact. This isn't a book of glossary terms, it's a game-changer."

— Troy DeVolld, author, *Reality TV: An Insider's Guide to TV's Hottest Market*

"*Master Shots, Volume 2*, tells you how to achieve powerful dialogue scenes. Each explanation is clearly and simply illustrated by stills from popular movies. Computer-generated illustrations accompany each scene to show exactly where to place the camera. *Master Shots, Volume 2* is brilliant. A must-have companion to the first *Master Shots*."

— Tony Levelle, author, *Digital Video Secrets*

"Any director should read this book to get a feel of the scope of potential in shooting dialogue. And if you can convince your actors to read it as well, finally everyone will be on the same page on set."

— Erin Corrado, *onemoviefivereviews.com*

"This encyclopedia of 100 industry-standard master shots tells you how to best communicate any storytelling idea — through framing, positioning, and dynamic movement. And it doesn't just tell you how, but why. After reading this book you'll never neglect the importance of that living and breathing, yet invisible actor in every scene: the camera."

— Carl King, author, *So, You're a Creative Genius… Now What?*

CHRISTOPHER KENWORTHY

MASTER SHOTS VOL 2

Published by Michael Wiese Productions
12400 Ventura Blvd. #1111
Studio City, CA 91604
(818) 379-8799, (818) 986-3408 (FAX)
mw@mwp.com
www.mwp.com

Cover design by Johnny Ink. www.johnnyink.com
Interior design by William Morosi
Edited by David Wright
Printed by McNaughton & Gunn

Manufactured in the United States of America
Copyright 2011 by Christopher Kenworthy

Library of Congress Cataloging-in-Publication Data

Kenworthy, Christopher.
 Master shots, volume 2 : 100 ways to shoot great dialogue / Christopher Kenworthy.
-- 2nd ed.
 p. cm.
 Original ed. published in 2009.
 ISBN 978-1-61593-055-5 (pbk.)
 1. Cinematography. 2. Motion pictures--Production and direction. 3. Dialogue in motion pictures. I. Title. II. Title: Master shots, volume two.
 TR850.K46 2011
 777--dc23
 2011016837

CONTENTS

INTRODUCTION

Many people think that feature films look cinematic because their budget was large. What I hope to show through the *Master Shots* books is that the cinematic look costs nothing. A strong scene is about where you put the camera and how you position and direct your actors. This is especially true when shooting dialogue.

With the skills you will learn in *Master Shots, Volume 2*, you can make your dialogue as strong as it deserves to be, so that every plot point, every emotion, and every subtle meaning is communicated clearly, while you draw the best performances out of your actors.

When the original *Master Shots* was first published, it immediately received strong reviews and rapidly became a bestseller. I received countless emails from filmmakers who said the book had opened their eyes to setting up shots. Many said they never knew so much thought went into setting up a shot. Others said they didn't know one camera setup could work on so many levels. It was gratifying to know that filmmakers were willing to delve deeper than ever into their craft.

Within a few months the book became a big hit at film schools, and I was soon watching many student films that had been improved by the advice in my book. Filmmakers who won awards wrote to tell me how *Master Shots* had helped. To my great surprise, a handful of Hollywood directors (who I'd admired for decades) wrote to tell me how much the book had helped them. One director even told me he'd never go to set without my book in his hand.

Master Shots didn't just present 100 shots that people could copy. It opened filmmakers' eyes to the techniques that achieve the best effects. It encouraged them to combine these shots in new ways, to make up their own moves. Despite this, there was one theme that kept coming up over and over again when people wrote to me. They nearly all asked, "What's the best way to shoot dialogue?" Your film cannot work without good dialogue scenes, so *Master Shots, Volume 2*, offers you the critical techniques needed to bring dialogue to life.

Although the original *Master Shots* covers dialogue in many chapters, it is not specifically about dialogue. Since writing the first *Master Shots* book, I have directed a feature film and worked on many other projects, and I became obsessed with shooting dialogue in interesting ways. More importantly, I wanted to find methods to shoot dialogue in a way that captures the essence of the script. I watched hundreds and hundreds of films to research this book. Every one of the films included here contains good dialogue scenes, and all are worth watching in their entirety.

Unfortunately, many scenes in blockbuster feature films don't make the most of the dialogue found in the screenplay. As the scene opens, the camera soars through a graceful master shot, and then everything stops. The camera stops, the actors stand still and face each other, and the dialogue begins. Many movie conversations are as dull as this, but they needn't be. The best directors know how to position the camera and the actors to fully explore and express the scene.

These images illustrate standard setup, with one actor facing the other, both shot from the same distance and the same angle. In this book I'll refer to this setup as angle/reverse angle.

The angle/reverse angle setup is what results when time is short, people are tired, or the director has run out of ideas. It's okay, it works reasonably well, but it's dull. There are many directors out there striving to stand out from the crowd, but when they come to shoot their dialogue scenes, this standard setup is what they shoot.

This routine setup is used for many reasons. It's quick, easy to set up, and if you're not too concerned about perfecting the lighting, you can even shoot in both directions at once. Also, most audiences won't complain so long as the dialogue is interesting. There are many popular movies that use nothing but this, so why should you try harder?

The directors who shoot dialogue creatively really mine the substance of the script. You shouldn't move your camera or shift your actors just to create eye candy (although a pretty picture is usually more interesting), but you can use clever staging to bring out the scene's deeper meaning and create stronger impact. Watch the films that are cited in this book and you will see how well the scenes play when the camera is used to capture dialogue creatively.

If you block your scenes well, you do more than capture the basic scene; you echo the meaning, emotion, and drama of every moment. That is never more important than with dialogue. It is a tragedy that so many directors are happy to open a scene with a moving master shot, and then just settle into angle/reverse angle for the dialogue. You can do better than that.

There are challenges to shooting in this way. When actors and cameras move, the sound recordist will probably complain and ask you to shoot some close-up coverage. You can do this, of course, but have the courage to capture what you really want. If you start getting technical, some actors will complain about having to hit such precise marks. Find ways to encourage them to work with your techniques, and let them know this is the best way to showcase the skills they bring to their performances.

The good news is that all the camera moves in this book can be achieved with just about any equipment. At a stretch, you can perform them handheld, or with the most basic dollies, cranes, and stabilizers.

You can take any of the techniques in this book and apply them directly to your own film. I urge you take this further and combine these ideas to suit the needs of your film. Once you've studied *Master Shots, Volume 2*, you will understand how tiny shifts in framing and movement can change the scene, which gives you the power to bring your personal vision to the scenes that ultimately end up on the screen.

Christopher Kenworthy
Perth, November 2010

HOW TO USE THIS BOOK

You can dip into any chapter of *Master Shots, Volume 2,* and look for a shot that best suits your scene at any time. I would recommend, however, that you read the whole book, so that you become familiar with the variety of techniques demonstrated.

To really understand a chapter you need to read the text, study the images, and imagine how you could use the shot yourself. So you should already have read *Master Shots, Volume 2,* when your film is in pre-production.

Once you've planned your shots, have the book nearby on set, so that you can find alternative ideas, or add something extra to a scene. One of the best things you can do is combine several techniques in one scene to create something completely new.

Don't be afraid to buy copies of this book for your department heads and your actors. If they can see how you're working, and the high standards you're aiming for, they will be more willing to work with these techniques.

ABOUT THE IMAGES

Each chapter contains several types of images. The opening images are frame grabs from popular movies, to show how successfully the technique has been used before.

The overhead shots show how the camera and actors move to achieve this effect. The white arrows show camera movement. The black arrows show actor movement.

The overhead shots were created using Poser 8, which enables you to animate characters while moving a virtual camera around them. The arrows were added in Photoshop.

To create the simulated shots, Poser renderings were exported and then backgrounds were added. Some of the backgrounds are original photographs, and some are computer renderings.

The final frame in each chapter is a recreation of the scene rendered with computer graphics. These rendered frames are all subtly different from the movie frame grabs, showing that slight adjustments to your setup enhance and expand on the core techniques.

CHAPTER 1
CONFLICT

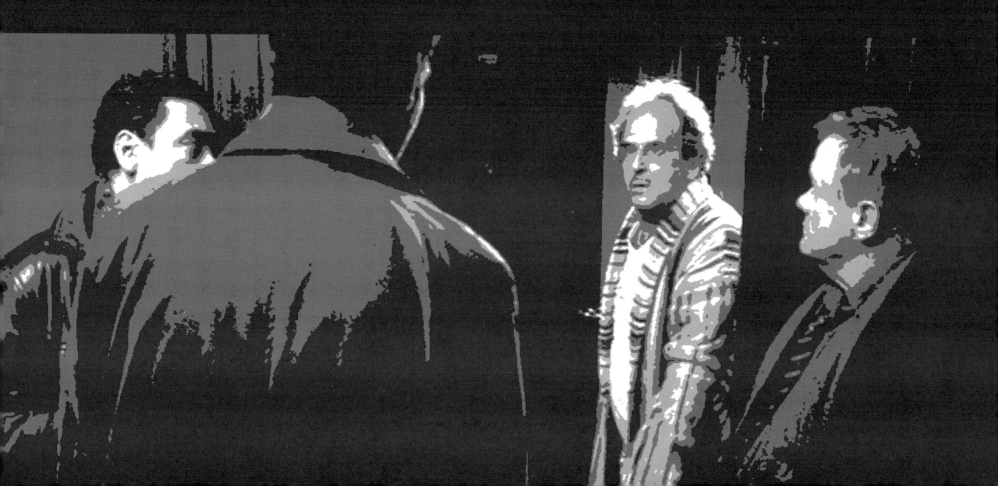

POWER MOVE

There are times when you want one character to frighten or threaten another. You can do this by having each of them move in on the other character's space as they talk.

These shots from *Defiance* show how a subtle difference in camera position and lens choice creates this effect. The opening shot is filmed with a relatively low camera, tilted up slightly. This contrasts with the next shot, which is shot at head height. This creates the feeling that the first character is stronger, or more domineering, because he is looking down.

The first shot is also shot with a shorter lens, so that when the actor moves forward a couple of steps, his movement is exaggerated and he appears to loom forward. The camera also tilts up, making him seem even more domineering. The short lens exaggerates this tilt upward.

If the other actor was shot with a short lens, the contrast between them would not be there. The contrast works as described above, but also helps to establish who is "good" and who is "bad." A short lens tends to make somebody more frightening, while a long lens makes them more appealing. By using contrasting lenses at a pivotal moment in the film, you tell your audience as clearly as possible who is good and who is bad.

If you watch this scene in full, you will notice that they did shoot a low angle of the second character, with a shorter lens, but it is barely used, being there only to connect the shots. This suggests that the effect described here may have been discovered in the editing room, rather than planned from the outset.

If you plan to shoot in this way, remember that combining three forms of contrast creates the effect. One camera stays still, while the other tilts. One shot is wide, the other long. One camera is low, and the other is at head height. It is only by combining these three forms that the full effect is created.

Defiance. Directed by Edward Zwick. Paramount Vantage, 2008. All rights reserved.

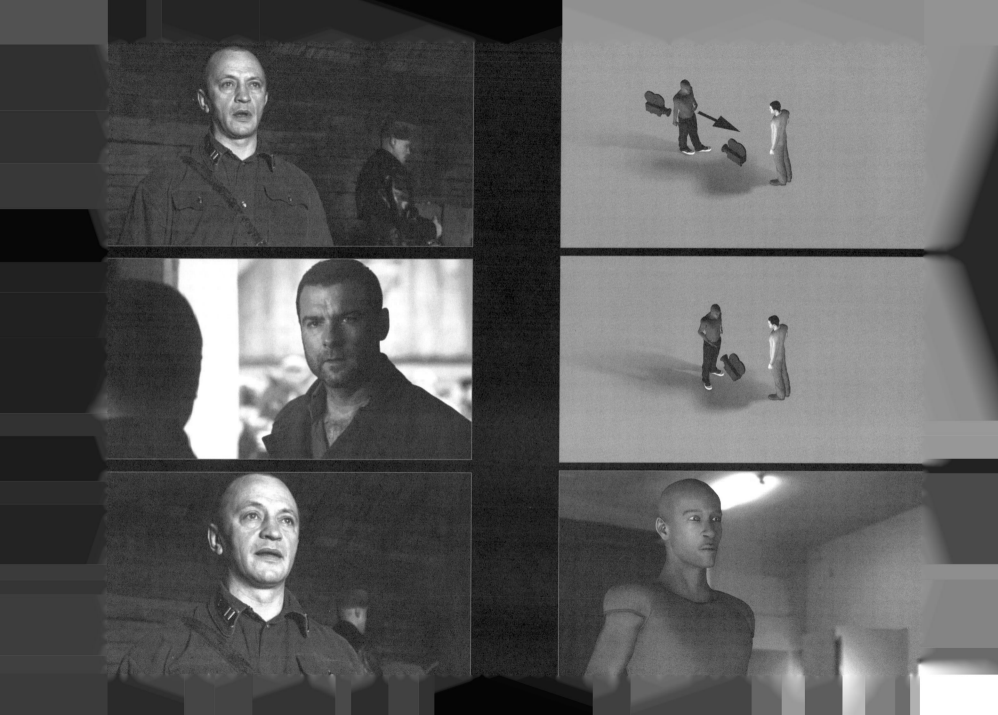

DOORWAY

Conflict always brings interest to a scene, but there are times when character conflict may be almost incidental. You need to shoot these scenes in a way that keeps the focus on the story and the roles of the main characters.

In this scene from *The International,* the character in the apartment is incidental, and although there is some brief conflict with him, it's important that we remain focused on how the other characters respond to this conflict.

The scene opens with a brief master shot to make it clear where everybody is positioned in relationship to the door. We then cut to an over-the-shoulder shot of Clive Owen. The camera is quite low here, to emphasize that he's the hero.

With the geography of the scene well established, it's possible to cut to the cops on either side of the door without any confusion. The ideal setup, as shown here, has the farthest character in focus, with the other two out of focus. A long lens will help generate this shallow depth of field and capture the reaction of the farthest character.

The other cops even turn their attention away from the incidental character, which further emphasizes that this scene is really about Clive Owen's character establishing his authority, rather than on the plot revelations.

Doorways are interesting to directors because they act as barriers, or thresholds that may need to be crossed. Conversations held on these thresholds are tantalizing, because nobody is sure which way the balance of power will fall. This is far more interesting than having two characters come to the door, go inside, and have a chat.

When shooting this sort of scene, the setups can be quite basic with little movement from actors or camera. The way you direct the actors to focus their attention is the key to how this scene will play out when cut.

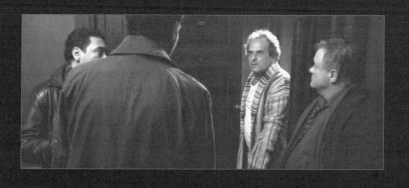

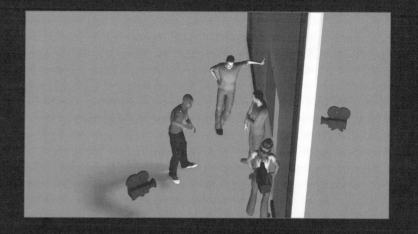

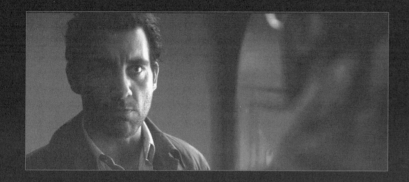

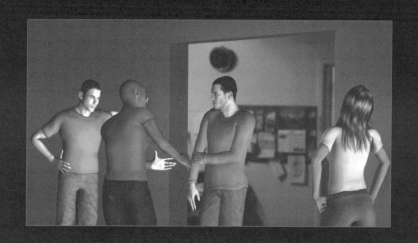

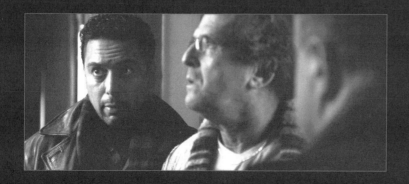

OFFSET GROUP

The more subtle the conflict, the more subtle your camera work needs to be. If you want your character to feel left out of a conversation, a simple arrangement of actors and camera can create the desired effect.

In this scene from *Lost in Translation*, the characters are arranged in a triangle. They are all equal distances from each other, but rather than creating a feeling of equality, this creates some power imbalance, because two of them are a couple and should probably be closer together.

To emphasize this, the opening shot is taken from behind the couple, so that the interloper is almost central in the frame. This makes her seem significant to the audience, and it is clear that she is invading their territory.

The next shot places Scarlett Johansson in the center of frame. Given what has just been said about putting somebody in the center of frame, you would think this would make her the dominant character. But this time a longer lens is used, closer to the actors; this means their faces frame her as they talk. She is left out of the conversation, looking across from one character to the other.

She remains the focus of the audience, but is not the focus of the other two characters, because they are talking to each other intently. This is an extremely clever way of keeping our focus on the central character, while making her feel left out of the conversation.

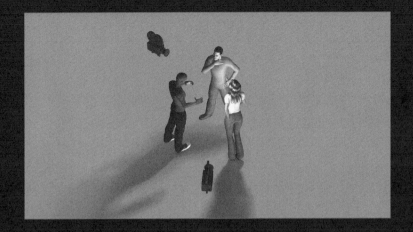

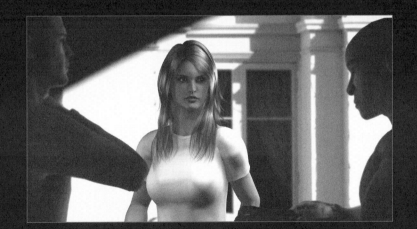

CROSSING LINES

Directors usually take great care to make sure the audience knows exactly where they are situated in a scene. When you establish the geography of a scene clearly, the audience knows exactly where everybody is, and who's talking to whom. Out of this need for clarity, a set of rules has evolved around exactly where the camera should be in any scene. By breaking these rules, carefully and at the right time, you can add to the scene's sense of conflict.

If this scene from *21 Grams* was shot conventionally, the cameras would always stay on one side of the characters. Instead, the camera switches to the opposite side with the cut. This is called crossing the line, and most of the time directors are told not to cross the line.

Imagine a line between the two characters (if they were facing each other). In normal situations, you keep the camera on one side of that line. Here, though, with the first cut, the camera switches from being on her right-shoulder side to being on her left-shoulder side. The next cut remains on her left shoulder.

If you watch the whole scene, you see actors walk in without facing each other, and the camera sometimes pans from one to the other. At other times these cuts across the line are made. The overall feeling is one of disorientation. We don't actually become disorientated, because we know they are talking to each other, but the constant moves and shifts make for an uneasy, restless feeling that captures the emotion of the argument well.

By having him wait for an elevator, the director is able to have him turn his back on her plausibly. Equally, there isn't room for her to move around in front of him, which justifies her standing behind him. You should always look for good reasons to justify the way your characters stand and move, because it helps to add realism and makes the actors more comfortable with their performances.

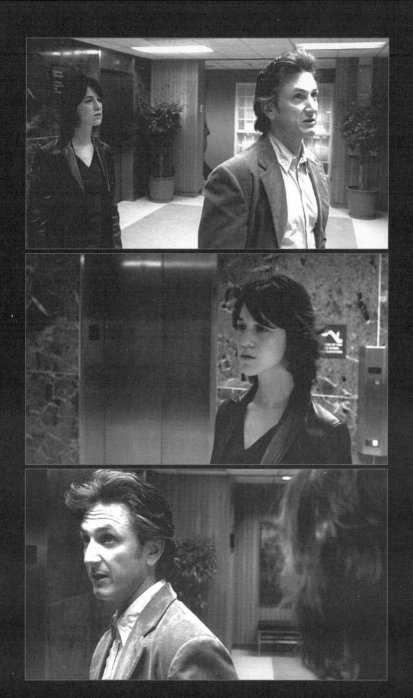

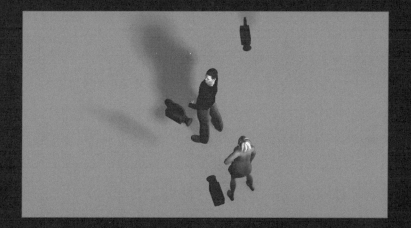

BARRIER

When people are in conflict, something stands between them. You can make this idea literal, by putting a physical barrier between them in the scene. It may be a table or chair, or even, as in this example, a wall and window.

A physical barrier gives characters more of a justification to shout, especially if it's a wall, and this can add realism to your scene if the conflict is strong. Arguments often begin with some distance between the characters, and a physical prop can help. Be aware though, that as the intensity creeps up, that barrier will probably be crossed. In this scene, he eventually moves into her room.

You can experiment with barriers that completely separate the characters, giving them no view of each other, but you may find that having a window helps. They cannot see each other clearly, as the glass is mottled, but they can see each other's position. This means they know where to direct their energies.

Having a line of sight like this, even though it is distorted by the glass, makes it more powerful when one of them turns away from the other. For much of this scene she turns away from him in anger, increasing the conflict between them.

The camera setup can be quite simple. In one room, try to capture the whole scene, so that we see him clearly, and see her indistinctly. The second camera should show only her, and should not look back into the room at him. To do so would draw too much of a connection between the characters when you are actually trying to separate them.

The Reader. Directed by Stephen Daldry. The Weinstein Company, 2008. All rights reserved.

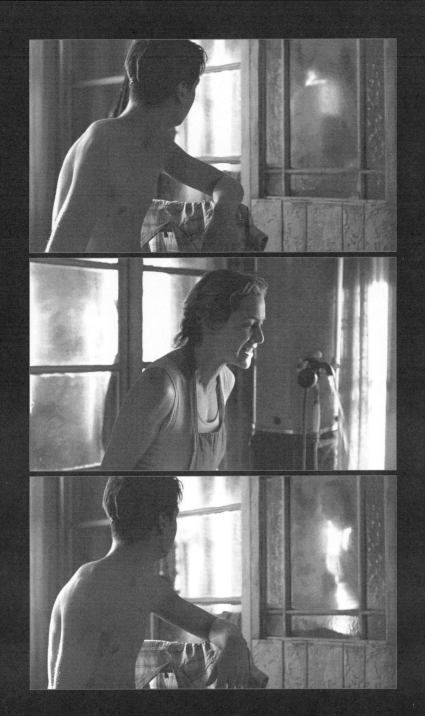

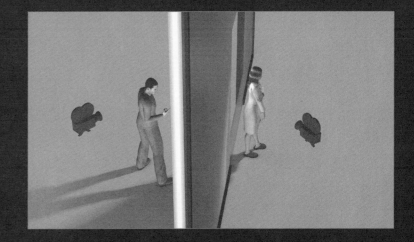

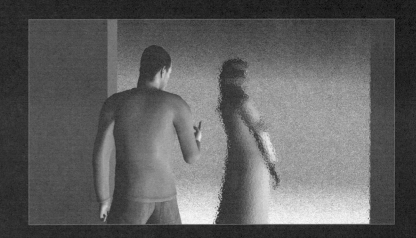

SIDE SWITCH

Capturing both actors in one frame enables you to see their body language and the way they interact physically in the scene. This can be exactly what you need for an argument or conflict. The disadvantage is that you frequently find yourself shooting the actors' profiles, which limits how much we see of their faces.

Body language is important, but to really know what characters are thinking and feeling we want to look in their eyes. If you want to show a medium shot like this, without cutting to close-ups, you have to find clever ways to move the camera and actors to show us more of their faces.

This scene shows the two actors facing each other directly, so that most of their acting comes from their voices and body language. To get their faces in the shot, the director has them walk towards camera, and then dollies along the sidewalk with them. The key to this, however, is that the actors switch sides when they begin to walk away.

This switch serves two purposes. First, it adds some visual interest and realism, because it looks more energetic than simply having the actors move off in a straight line. Second, it gives the director a chance to let each actor have a moment where he or she dominates the frame.

When they first begin to walk, she is almost directly facing the camera, so we listen to her more intently. Then, as they catch up with the camera, he turns his face toward her, and he is the focus of the conversation.

You may find that to get this to work you need the actor that's closer to camera to walk slightly behind the other actor. It might not feel natural to the actors, but it looks real when filmed.

Melinda and Melinda. Directed by Woody Allen. Fox Searchlight Pictures, 2004. All rights reserved.

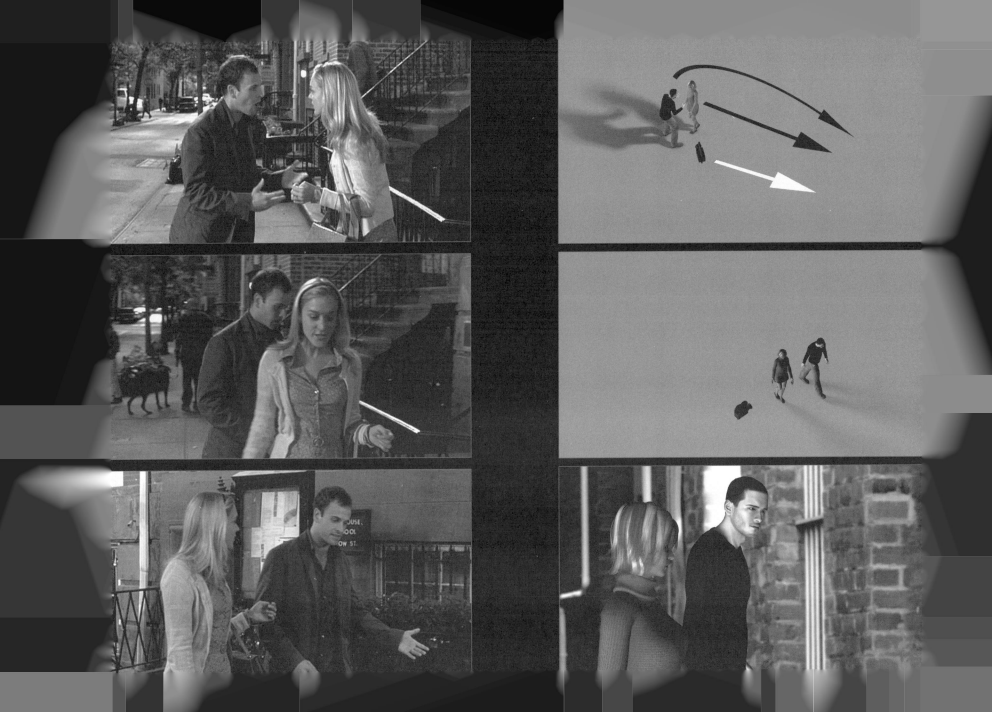

SNAP TURN

This shot gives a surprise impact, when a calm conversation suddenly turns into a conflict. The group of three characters walks along, and then as the argument ramps up, one character comes face to face with another, and they stop in their tracks. These two frame the third character. Although she is central in the frame, she remains an observer (rather than the focus of the scene) because the camera is at their head height, not hers.

The moment where one actor runs forward and turns to face the other is actually quite unrealistic, and will feel so to the actor, but it looks convincing to the audience.

The camera should move slightly slower than the actors. This enables the camera to come to a rest without it looking too sudden. The actors should, therefore, start a short distance away from the camera, and gradually catch up to it, finding their final marks as the camera stops. Although this looks simple, timing it exactly can take a lot of rehearsal, especially as the movement has to be dictated by the lines they are speaking, rather than where they happen to be standing.

The snap turn is almost a reverse of the side switch, but it ends with the characters facing each other. As such, it creates a different effect, because the argument appears out of nowhere and surprises the audience (whereas with the side switch, the argument progresses into a conversation).

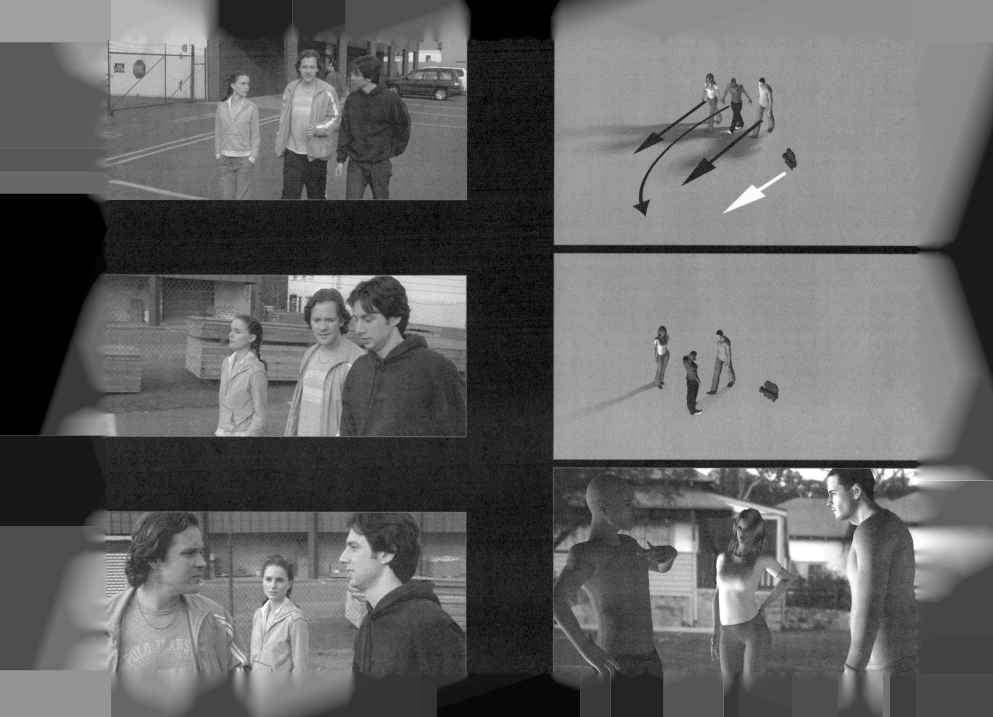

SWING TO CUT

An unexpected cut, during a scene filled with lots of motion, can have a startling effect. Used well, it can add impact to a quiet or calm line.

In *21 Grams*, the two characters move around the room as they argue. In the first frame you can see how the character closest to camera is moving in on the other. The camera arcs around to the left, as they move in to face each other.

As soon as we have established that they are in a face-off, the camera cuts to close-up. Given all the handheld camera moves that have gone before, this is a surprise, and adds real weight to the moment where he whispers an important line.

Often, it's wise to avoid too many cuts during a conversation, as they prevent you seeing those important moments of change on an actor's face. That is why *Master Shots, Volume 2,* shows you lots of ways to keep two or more faces on screen at the same time. In some cases, though, a quick, hard cut to a close-up is exactly what's needed.

The lenses used throughout this scene are short, to match the wide, handheld feel, but at this moment of rest, a long lens is used. This makes his face dominate the frame, so that most of the background vanishes.

When you shoot this type of scene, make sure that your camera comes to rest in the opening, handheld shot. If it doesn't, then cutting to a motionless camera will be too jarring for the audience. The camera doesn't have to completely freeze, but it should settle as the two characters come together.

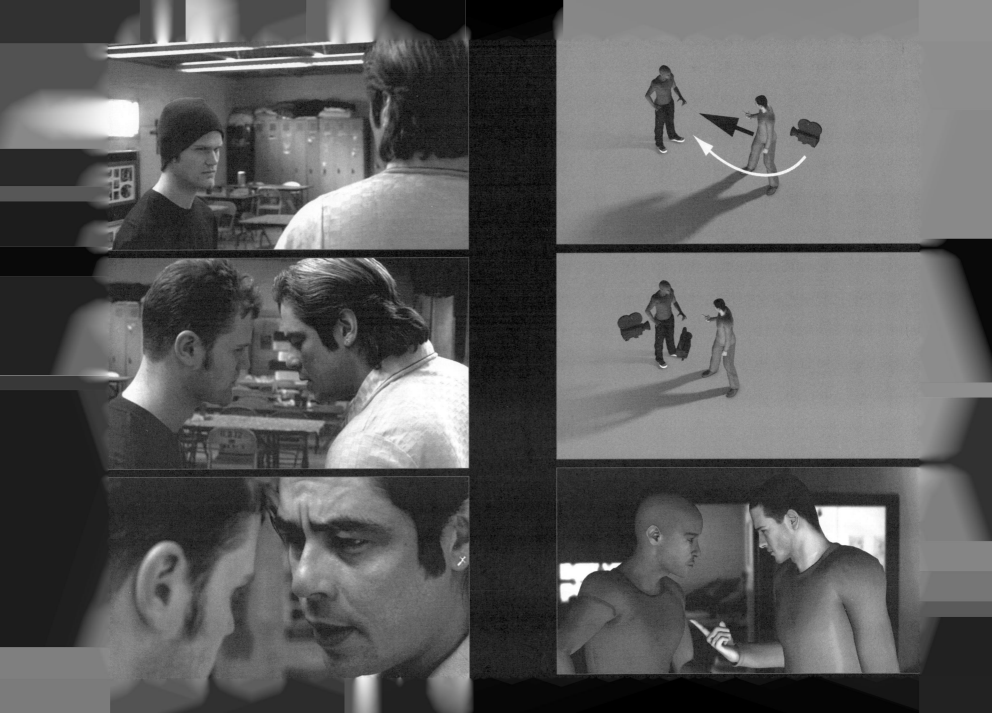

DEEP STAGING

Even when your characters end up fighting, as they do in this scene from *Twin Peaks: Fire Walk with Me,* a lot can be gained by building the main conflict when the characters are at a distance from each other.

This scene is a good example of deep staging, in that there is always something in the foreground, the midground, and the background. Although the viewer is watching the two men face up to each other, the setup gives this small room a much larger feel, making it seem more threatening.

You may think that every shot automatically has a foreground, midground, and background, but many shots focus so intently on the subject — usually the main character — that they lack any depth or sense of space. Directors are especially guilty of neglecting this concept when shooting indoors, but as shown here, it is possible to give an indoor space this level of depth.

By placing both cameras close to the wall, the director has his audience look out into the space of the room. Had the director shot from the middle of the room, this space would have looked quite conventional, and the depth of the space would have been lost.

The cameras remain stationary, and the only movement is made by the deputy as he turns away from the wall and approaches the FBI agent, where the actual fight takes place.

To shoot this sort of scene you only need to be aware of the importance of including foreground, midground, and background, and position your actors and cameras accordingly.

Twin Peaks: Fire Walk with Me. Directed by David Lynch. New Line Cinema, 1992. All rights reserved.

POWER STRUGGLE

Conflict often leads to a direct power struggle, and that can be shown by one character ignoring another. In this scene from *Defiance*, Daniel Craig is trying to get the attention of the distant character, who largely ignores him.

The positioning of the actor in relation to the camera is as important as the camera placement itself. In the first shot Craig's body is turned off to the side, as if he is afraid to face up to the problem. Although he is facing the enemy, his body is turned more towards his friend and confidant who stands beside him. This body language contradicts his words, creating an interesting tension.

The next shot gives the distant character some power, because he is filmed from behind, and acts as though none of this is of interest. His unwillingness to engage in the argument is shown by his body language; but rather than being afraid, he is showing that he is unperturbed. Importantly, the director uses a long lens for this shot, from behind Craig. This foreshortens the distance between them, which makes the distant character seem closer than he should be, as though he's imposing his power on their space.

Then, the director cuts to a wider shot that shows the whole scene, and this builds on everything that has gone before. The enemy is clearly surrounded by his friends, and remains disinterested in the conversation, only glancing around. Craig and his friend, meanwhile, are tiny in the frame, looking isolated in the snow.

By making the main character appear afraid as he tries to regain power throughout this scene, the director creates far more tension than if the hero immediately acted like a hero.

Shooting this sort of scene requires strong direction of the actors and careful placement of the camera. But it is relatively simple to shoot, because there are only a few shots and almost no camera movement.

Defiance. Directed by Edward Zwick. Paramount Vantage, 2008. All rights reserved.

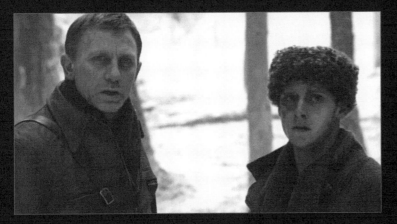

INCREASING TENSION

CIRCLING DIALOGUE

Tension is often hidden underneath the surface, rather than being out in the open. You need to shoot in a way that makes it clear to the audience that a tension is present, while making it plausible that the characters are pretending all is well. This scene from *Inglourious Basterds* shows how the camera can circle two motionless characters, with both appearing calm, yet both knowing disaster looms.

The move around them could be said to be a way of filling time, or just adding some visual interest to a dialogue-heavy scene, but it is much more than that. By leaving them in place, the director emphasizes that they are almost motionless, talking politely, almost in whispers.

The move also means there is a brief moment where the viewer looks almost directly into one of the character's eyes. His fear is evident, even though he is trying to hide it. This shows the audience that the other character can probably also sense his fear, and it is thus a subtle plot revelation.

A move such as this also emphasizes that the two characters are located in opposition and focused on each other. No matter how casually they are playing it, they are extremely intent on each other's words.

To shoot this type of move, it helps if you have a dolly on curved rails, although it can (as with all the shots in this book) be done handheld. If you simply move around the table, the characters will get closer to the camera halfway through and this can weaken the overall effect. The trick is to keep the camera at the same distance from the characters throughout, by moving around them in a smooth arc.

Inglourious Basterds. Directed by Quentin Tarantino. Universal Pictures, 2009. All rights reserved.

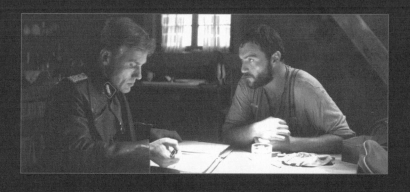

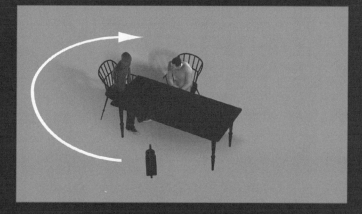

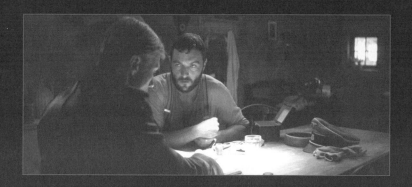

CLOSING SPACE

This scene from *Munich* shows how it's possible to raise the tension, while also showing people opening up to the possibility of trust. There are times when using these contrasting ideas and emotions can give a scene huge impact. It plays much more deeply than if they were simply mistrusting, or if they were merely listening. It's the contrast that makes for tension, and makes us hang on their every word.

First, this is set in an interesting space, with one character physically much higher than the other. During the course of the scene, he comes down to the level of the second character. At the same time, the second character moves closer. They are literally and figuratively crossing a huge divide.

To exaggerate and emphasize this feeling, the director films the opening shots with wide lenses. As the actors get closer, longer lenses are used. When they are at their closest, the longest lenses of all are used. At each cut, this lens choice enhances their movement toward each other.

If you watch the film you'll see that the scene opens with an even wider lens, showing both of them from above, to firmly establish their separation.

To look at these frame grabs, you could say that this is a traditional angle/reverse angle scene, but the small changes made in terms of height, distance, and the choice of lens turn it into drama.

Munich. Directed by Steven Spielberg. DreamWorks SKG, 2005. All rights reserved.

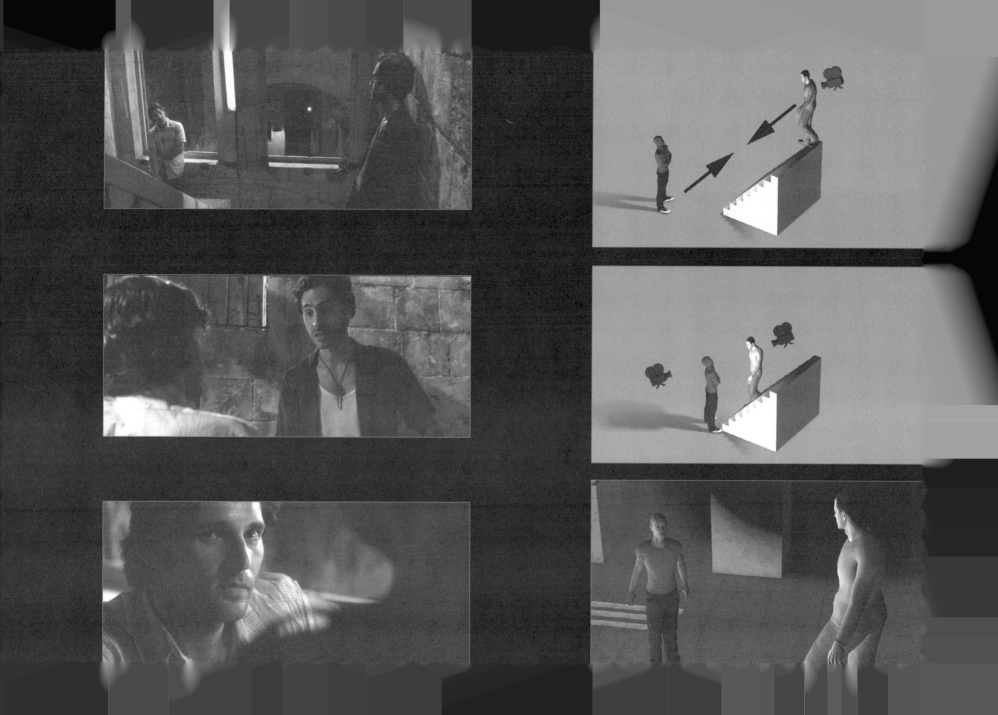

EXAGGERATED HEIGHT

When you want to show one character frightening another, the most obvious techniques can be effective. Placing the more powerful character up high and having him look down at the victim works well.

A brief establishing shot shows that he is trying to get her to raise her hands so he can inspect them. The director then cuts to two shots of their faces.

The shot of him is taken from halfway down her body, so that the viewer looks up at an extremely exaggerated angle. The director also shows her reaction to him, even though it is side-on and out of focus. If the camera was further back, or at her head height, the sense of his domination would be diminished.

The shot from his point of view is made from shoulder height. It focuses on her face and her reaction, rather than his. The viewer identifies with her because the shots reveal her perception of the situation more than his.

In this scene, they both repeatedly look at her hands and then at each other. This adds some interest, movement, and variety to the setup, which otherwise might seem stationary.

Shots like this should not be over-used, because they can quickly become ridiculous. They must be justified by the plot or the needs of the scene.

Twin Peaks: Fire Walk with Me. Directed by David Lynch. New Line Cinema, 1992. All rights reserved.

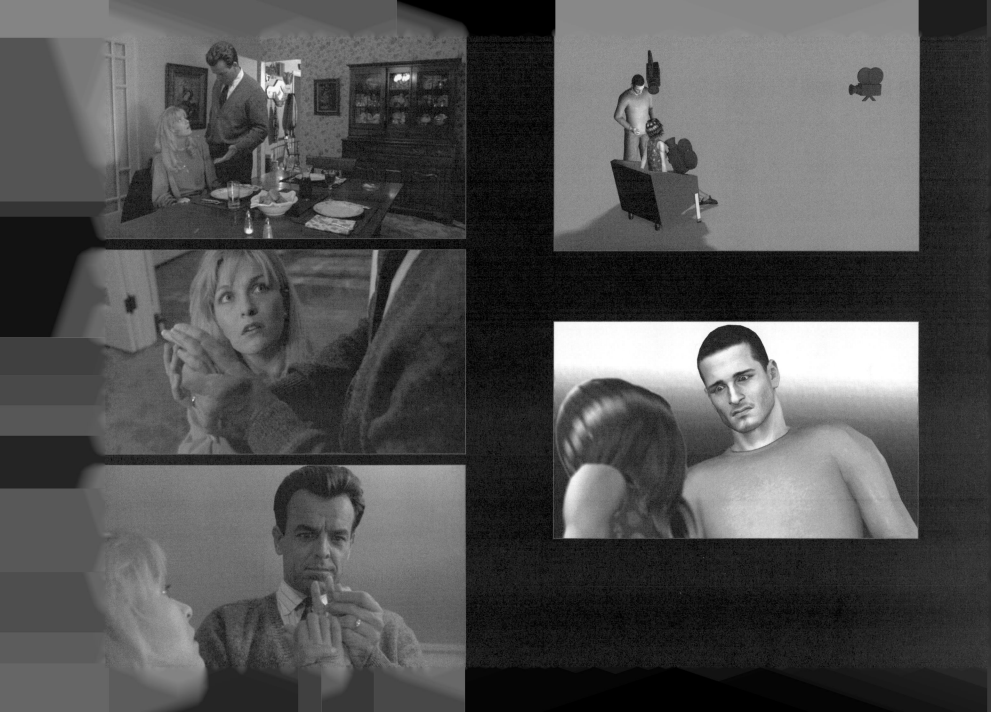

DRAMATIC SWING

When tension is increasing it can be made all the more unbearable when one character remains calm. This is seen quite often, especially when worried civilians are being interviewed by near-bored cops, as in *The Lovely Bones*. In scenes like this, cutting between the two characters in the standard way could break the tension.

To preserve the tension, keep the focus on one character before turning around to show the other. This shot opens with the cop framed on the left, and only the back of her head in shot. The audience is aware that she's in the scene, but they don't get to see her face, and the camera moves away from her. Both voices are audible as the camera pushes forward, and as it passes his shoulder, it finally turns around to look at her. The viewer then sees her stress, because the discomforting sensation has been established.

This move works well when you're trying to show miscommunication, or one character not listening to another. The trick is to focus on a secondary or incidental character at the start of the shot, with the main character's face out of shot. This makes the audience uncomfortable, because they want to see the main character, they want to know how she is coping with the situation. They expect a quick cut to her reaction, but when the camera pushes forward, closer to him, it captures some of the tension she is feeling.

It's worth noting that there's another cop in the background, while behind her there is only an image of the home. This small attention to detail adds to the feeling that there is a strange world on one side, intruding on the home.

The Lovely Bones. Directed by Peter Jackson. DreamWorks SKG, 2009. All rights reserved.

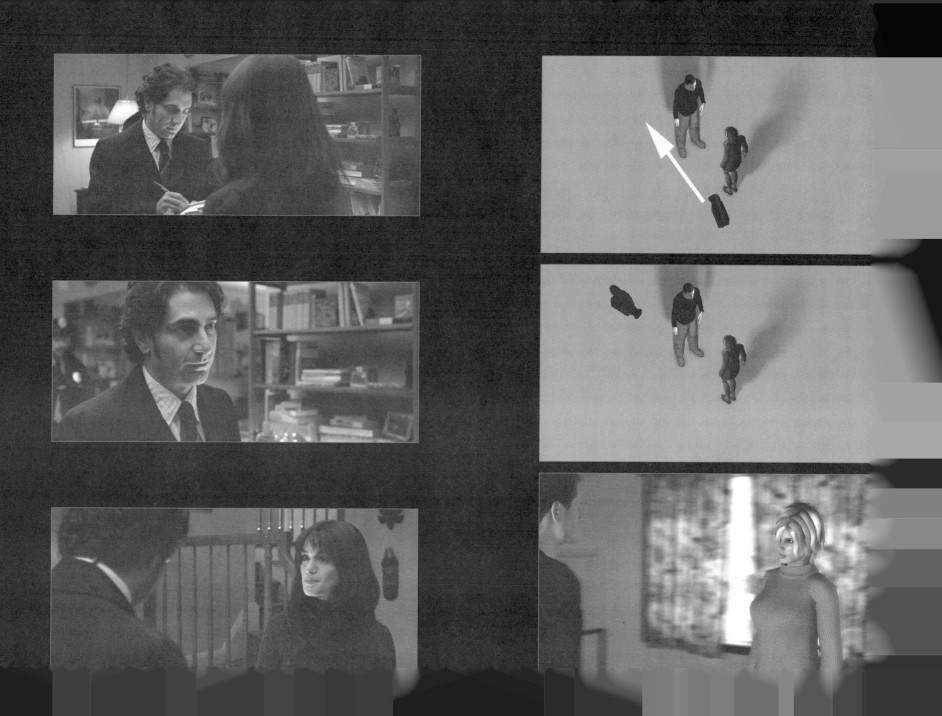

CLANDESTINE

When your characters need to have a secret conversation, without it looking like they're talking at all, you can achieve the best effect with motionless cameras and limited views of the actors.

The scene shown here has one camera set up to establish the geography of the scene. It shows the wide, open space of the gallery, and the actors move into the space without looking at each other.

They talk to each other without making eye contact. The most they do is angle their heads slightly toward each other. This is primarily so that the cameras set up behind them can see their faces. If they looked directly ahead throughout the whole scene, the viewer wouldn't get to see their faces at all.

To get this setup to work, you do need to show the actors' faces, but be wary of an actor who tries to angle his face toward the camera more than you want. Most actors will respect the needs of the scene, but one may find it difficult to act with his back to the camera, and will continually turn his head so that it's in shot. Remind your actor that the purpose of the scene is for him to remain covert as the talk continues.

The establishing shot can be done with quite a wide lens, but the other shots should use a long lens. This throws the foreground (the other actor's shoulder) and the background out of focus, which isolates each character within the scene. You may need to set up your camera well away from the actors, or you will get an unintentional close-up, with an actor's head filling the frame.

Although there isn't much movement in a scene like this, you want to leave some space around the actors' heads to keep some awareness of the space they are sitting in. If your viewer forgets about their location the need for secrecy is lost, so get far enough back to show their surroundings, even when using a long lens.

The International. Directed by Tom Tykwer. Columbia Pictures, 2009. All rights reserved.

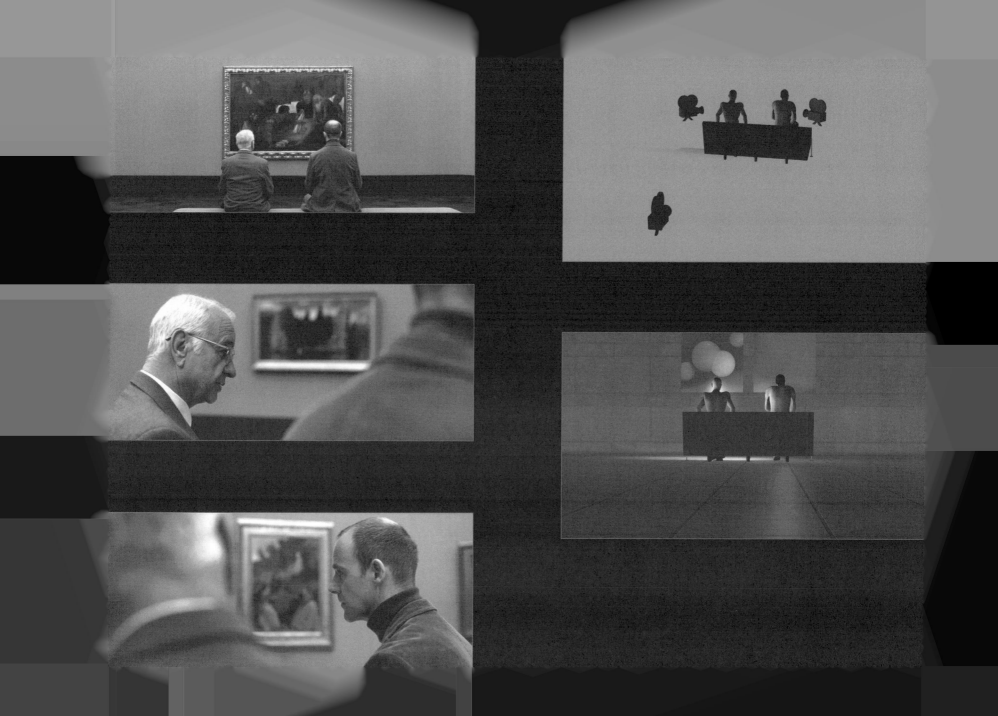

FRAME SHARE

In the standard dialogue setup, you cut from one character on the left of the frame to a character on the right of the frame. You can add tension to a scene by setting it up so that both characters are on the same side of the frame.

These shots from *The Majestic* show how both characters are looking at each other, but both are on the left-hand side of the frame. This is unusual, and makes the audience feel uneasy.

In this scene, one character is seated and the camera remains at his head height throughout because he is the main character. This could work just as well if both were seated, or if both were standing.

The danger here is that, because your audience expects to see one character frame-left and the other frame-right, breaking the rule can disorient them. This is, of course, what you want to some degree, but you don't want them to be confused about where people are, or who's looking at whom.

The trick is to start with a reasonably wide shot, as shown here, which makes it clear where the main character is sitting in the room, and what direction he's looking in. Ideally, you should make the first cut when he's looking directly at the other character.

The second character can then be shown in a medium shot, and it will be clear where everybody is, even though they are sharing the same part of the frame. You can move in closer on the main character, as the director does here by filming Jim Carrey in a medium-close shot, while the other character remains more distant. The uncomfortable feeling is created without confusion.

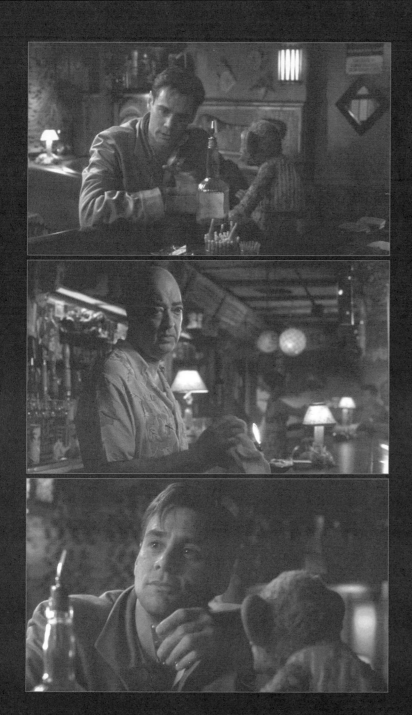

FOCUS ON ONE

When a conversation turns from gentle argument to something more intense, moving in on one character can be a way of indicating the rising pressure.

In this single-shot from *Magnolia*, the camera slowly pushes in on the two characters as they talk, and as it gets closer it slowly moves over to the main character until it is looking up at him.

This works because they are both sitting at the bar and are thus facing the camera. It could work just as well if they were sitting on a park bench, but you need to find a plausible reason to have people sit next to each other as the conversation progresses.

At times, you can direct the actors to look at each other, but these only need to be glances. They can spend most of their time, as real people do, looking forward. This keeps them facing toward the camera, so your audience can take in their expressions.

You need to start a shot such as this from quite a distance away, but the characters will be too small in the frame unless you use a reasonably long lens. The challenge with a longer lens is that it's more difficult to stay in focus as you push in, so you'll need the dolly move to be slow and smooth.

When you come to rest on the main character, the conversation can continue, and the words of the off-screen character remain audible for a while. Don't keep this going for too long, though. You need to end the scene, or cut to a different angle.

Magnolia. Directed by Paul Thomas Anderson. New Line Cinema, 1999. All rights reserved.

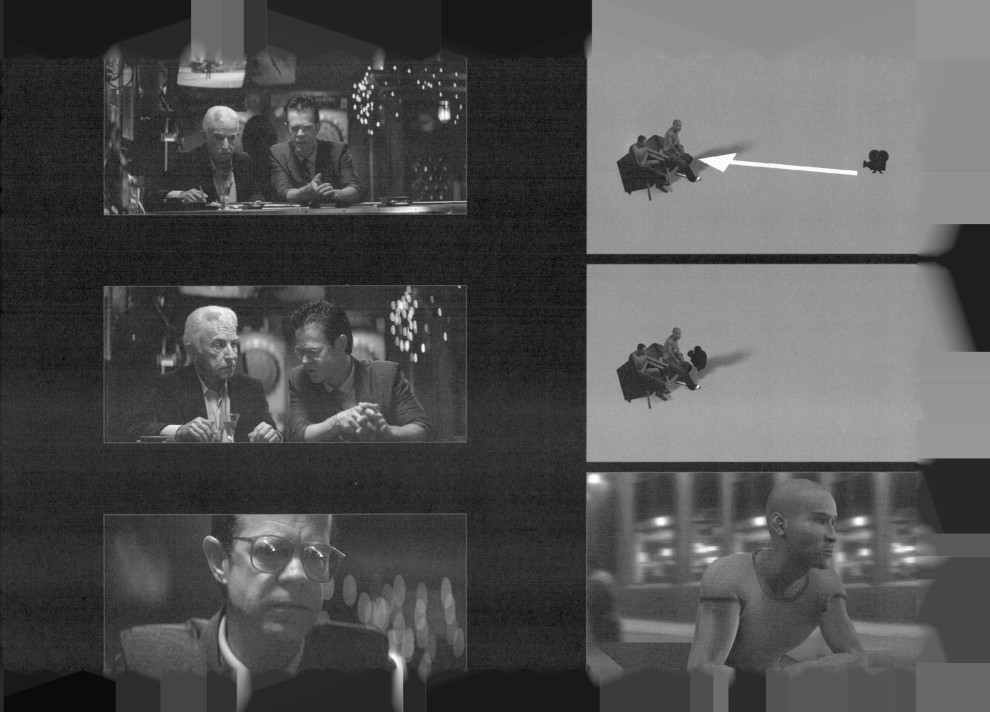

LEVEL CHANGE

Camera height is one of the most neglected tools in a filmmaker's arsenal. Positioning actors at different heights, and putting your camera at different levels, can have profound effects on the scene. One of the most interesting ways to increase tension in a scene is to put the more frightening character low down, while putting a nervous hero high up.

You can see the tension and fear created by this technique in *Inglourious Basterds*, where the director puts the female character above the man she's frightened of. They continue a relatively mundane conversation, but it is their positioning in relation to each other, and the fact that they shake hands while on these different levels, that makes it transfixing.

Although he is seated, the camera is at his level at all times when filming him or when turned on her. This is his first scene in the film, and she is well established as a main character, so by tying the camera to his level the director gives him a strong sense of power. He's taking us away from our viewpoint character. The audience would prefer to be at her eye level, looking down on him, but by being dragged to his level, the viewer feels her fear.

Finally, she is made to sit near him, and is brought down to his level. This gives the audience the sensation of her being pulled into his world against her will.

The final shot, where she takes her seat, is also unnerving, because she is further to the left of frame than normal (for a character who is looking to screen left). This leaves a space on the right of the screen, which unbalances the audience even further.

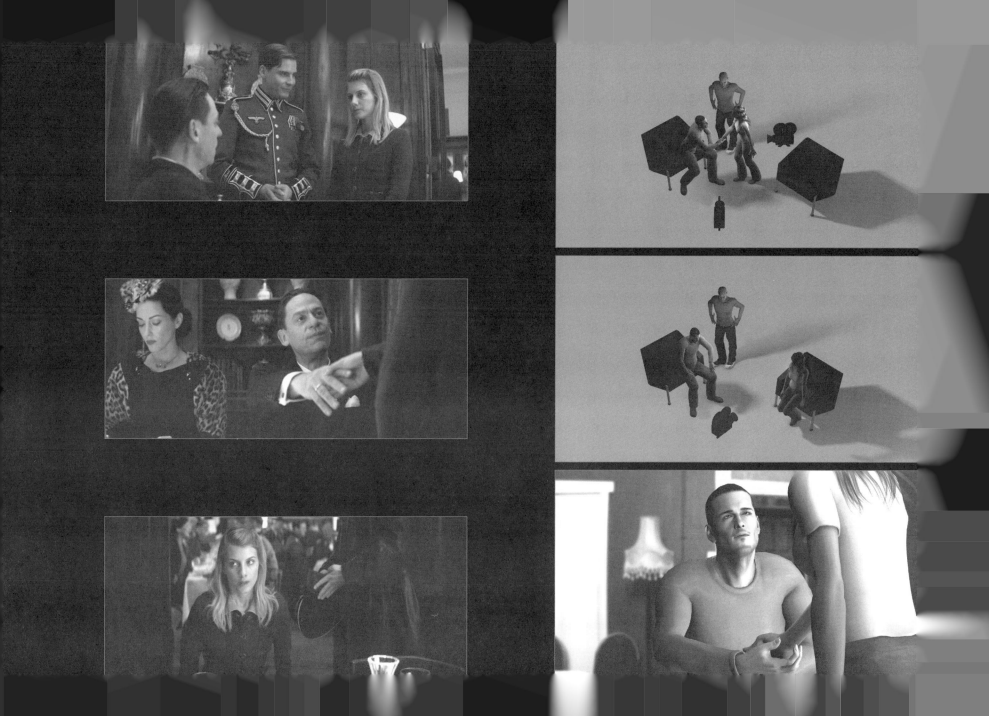

CLAUSTROPHOBIC SPACE

When dramatic or tragic news is revealed to a character, it helps to get close to him to show every nuance of the actor's performance. This can be enhanced by using a long lens, and the actor's position in the frame, to box him in. This creates a sense of claustrophobia that is often experienced by those hearing unbearable news.

To take this even further, the director may slightly disorient the audience by cutting to an unusual angle. In the frames shown here, Naomi Watts is filmed with a long lens. It's an over-the-shoulder shot, but the lens is so long that the foreground character is extremely blurred and the background almost non-existent, so the audience is watching her expression alone. The camera is positioned so that the audience looks almost straight into her eyes and identifies with her.

When the second doctor starts talking, she looks to frame right (her left), but at first the audience doesn't see him. After a while, the director cuts to a shot showing the doctor. Unusually, this is shot from her left-hand side, breaking the standard rules of where the camera should go. The first shot was taken from her right-hand side, so cutting to a shot from her left crosses the line of action (an imaginary line between the two characters who are talking). If used carelessly this cut will confuse the audience, but because she has turned her head and moved her eyes to the left, the director makes it very clear where everybody is.

To maintain the sense of claustrophobia, the director sets this doctor quite close to camera (although not as close as her), and tightly frames him with Watts on one side and another character on the left. They push into the frame much more than usual, which makes this shot feel extremely crowded.

You will create the best effect if you use people to build this sense of claustrophobia, as shown here. If you use other foreground objects, rather than people, the crowding of the frame doesn't have as strong an effect.

21 Grams. Directed by Alejandro González Iñárritu. Focus Features, 2003. All rights reserved.

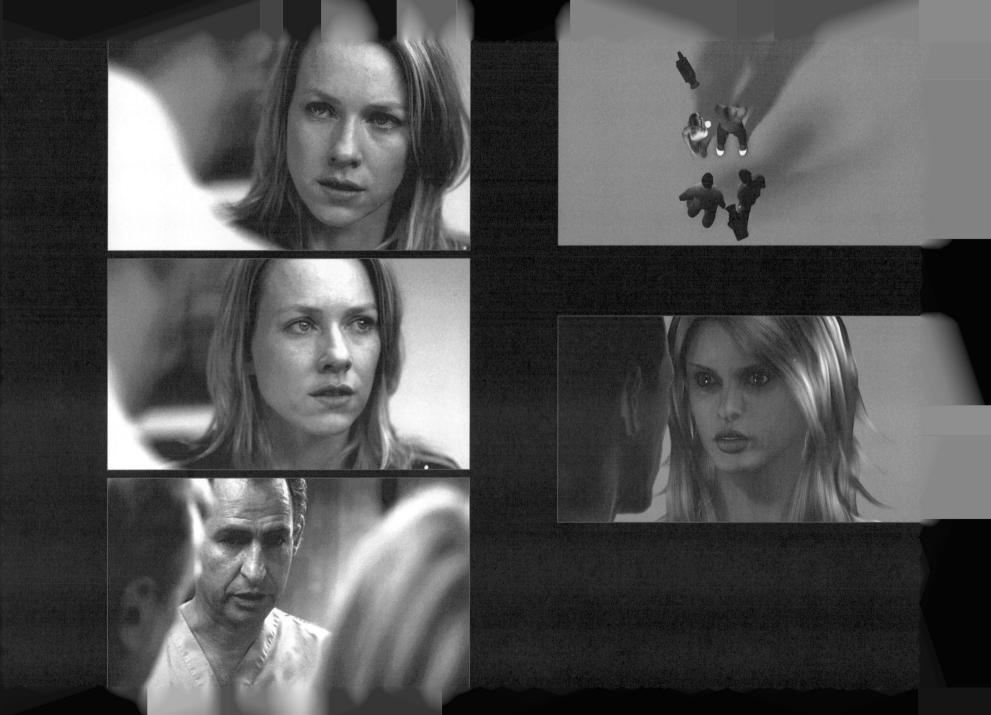

TRACK CHARACTER

As tensions reach boiling point, characters often blurt out their fears. When filmed well, these scenes are compelling, but you need to capture the energy and confusion of the main character.

You can see that as Natalie Portman moves toward the camera, the camera moves continually to the left, panning to the right to keep her in shot as she walks straight forward.

When she turns to her right (moving to screen left), the camera continues to move, keeping her in shot. The camera's actual move to the left is quite small, but because she moves straight forward and then turns, this creates a lot of confusing movement. This is made even more dramatic because the scene is shot from behind an obstruction. It's not clear whether these are pillars, bedposts, or something else, but they serve the purpose of making her seem imprisoned in a confusing world.

The shot of the two listeners is filmed with a stationary camera to reflect the fact that they are dealing with the situation more calmly. The problem here is that cutting from the moving shot to the still shot is quite jarring. One solution is to shoot a close-up of the main character's face, so you can jump cut to it as a transition between shots. Alternatively, you could stay on her (without showing the other characters), until she is facing them.

This technique can be applied in many ways, and you don't necessarily need the foreground obstructions to get it to work. The most important thing is to have the main character move roughly toward camera, as it moves away from her, while panning to keep her in shot, and then have her track across to catch up with the camera. A long lens makes her movement forward seem nightmarishly slow, but then makes her move to the left seem swift, adding to the confused, dreamlike feeling of the scene.

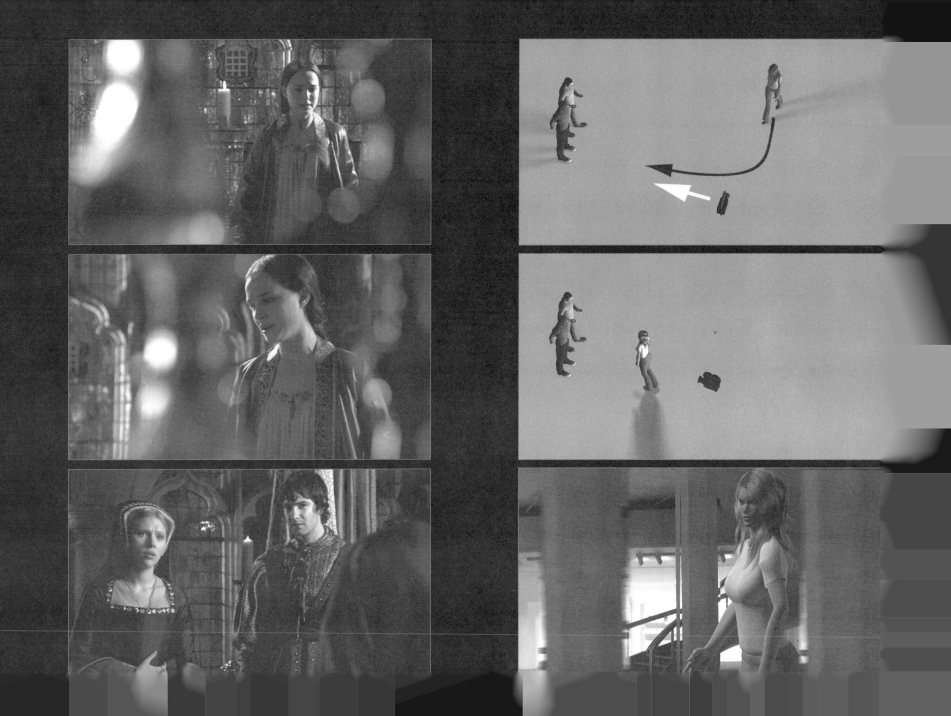

CHAPTER THREE

POWER
STRUGGLES

DISORIENTED

During any power struggle, there is often a moment of change, where one character gains the upper hand. Far from being a moment of relief, this is often a new challenge for the character and one that leaves him feeling disoriented. A camera move can be used to bring up this feeling of being overwhelmed.

At the moment that Chris Pine takes the captain's chair in *Star Trek*, the director wants to show the magnitude of this moment for him, no matter what he actually says, or what is said to him. To achieve this, the director positions the camera so that the chair is central in the frame. Then, as the camera moves forward it moves to the side and rolls over. This gives the scene a slightly drunken feeling, and leaves a space in the frame for Zoe Saldana to enter the left of the frame. Even though the viewer hasn't seen her approach, he feels as if she's been drawn in by the camera move. Her dialogue at this moment may further disturb Pine's sense of self, or ground him back in reality, depending on the type of scene being shot.

Shots like this, where the camera is given a "Dutch angle," work best when they are used rarely. If you use lots of Dutch angles, they won't have much effect. They also work well when they come during a camera move, rather than with a straight cut.

Although you can run dialogue through the entire scene, you will probably find it best to wait until the end, when the second character moves into the frame. By doing this, you give the moment of change all the weight it requires, before you move back to dialogue.

Star Trek. Directed by J. J. Abrams. Paramount Pictures, 2009. All rights reserved.

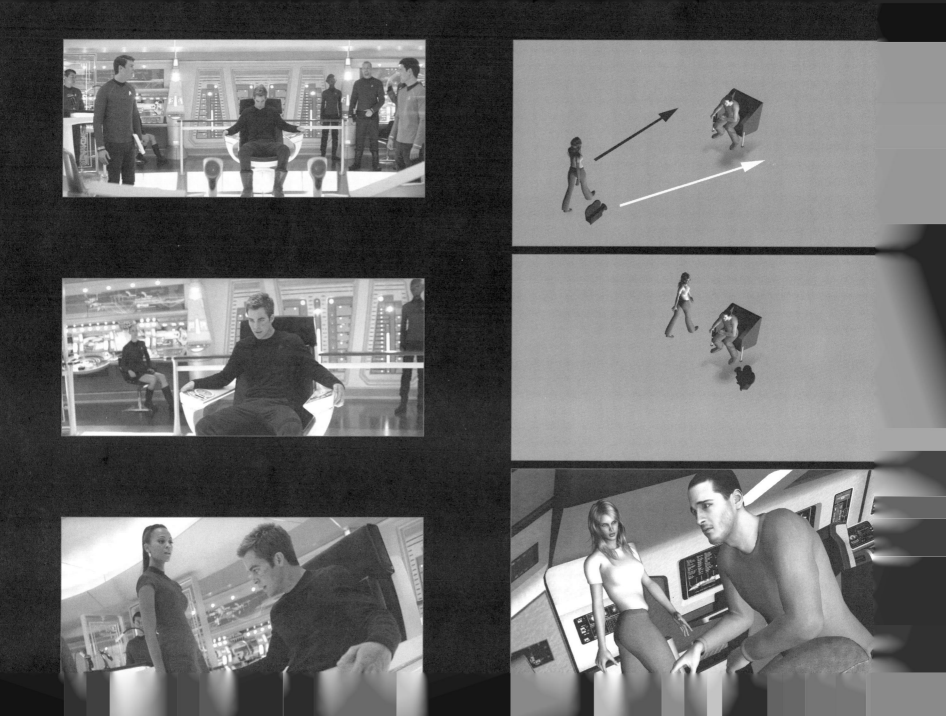

DOORWAY ANGLES

Doorways are interesting places to hold conversations, and they are often the scene of power struggles, because one person wants something and the other resists. In this scene from *Ghost World*, Steve Buscemi is doing his best to get information out of Scarlett Johansson, but she isn't interested. Attention to lens choice and camera placement are essential in portraying this power struggle effectively.

Although he is not a hostile character, Buscemi's arrival is meant to feel like an intrusion. This is shown partly by the way she holds the door, as though ready to slam it in his face.

The shot of her is quite close, with a long lens. This has the effect of making him seem closer to her, and closer to the threshold of her home, than he actually is. It also cuts out the doorway itself, which makes it seem as though he's already in the home. This is a subtle psychological trick.

In the reverse angle, the director has shot with a wider lens, from further back. This means that we can see the door and both characters. The door itself appears ready to move, something the audience notices.

When shooting a power struggle in a doorway, you may shoot a lot of coverage, using different lenses and distances on each actor. But when you cut, restricting yourself to two angles and lenses (as shown here) can be all you need to show the power imbalance between them.

Ghost World. Directed by Terry Zwigoff. United Artists, 2001. All rights reserved.

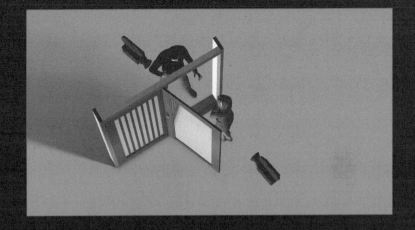

ANGLE EXCHANGE

At first glance, this may look like the standard angle/reverse angle setup, but there's more to it than that. At a key moment, when the power finally shifts between these two characters, he walks away. By the time he's come to rest, the camera places him on the right of frame, where she was. This shows that a power shift has just taken place.

Without the move, this crucial scene would be just a series of angle/reverse angle shots, and its impact would be lost. By putting in the move, the change is made both overtly and on a subconscious level. This makes it a powerful move, even though it's fairly easy to set up.

The first setup is a classic angle/reverse angle, so that she's on the right of the frame, and he's on the left. At the moment that he walks away from her, the camera cuts to a wider shot. He walks to his left (the right of frame). At the same time, she crosses the screen behind him to the left of frame. Without this movement — where they both cross the screen — the geography of the scene would confuse the viewer. This wider shot is also essential because it actually shows them swapping sides of the frame, illustrating the power shift.

The final shot is again set up in classic angle/reverse angle, but now the characters have switched sides, and he is on the right of the screen.

You might be wondering if it really matters whether somebody is on the right or the left of screen. There's a lot of theory about which side you should put the hero on, but few people agree on which side is which. What's important is that you echo moments of change by changing the character's position in the frame.

Almost Famous. Directed by Cameron Crowe. Columbia Pictures, 2000. All rights reserved.

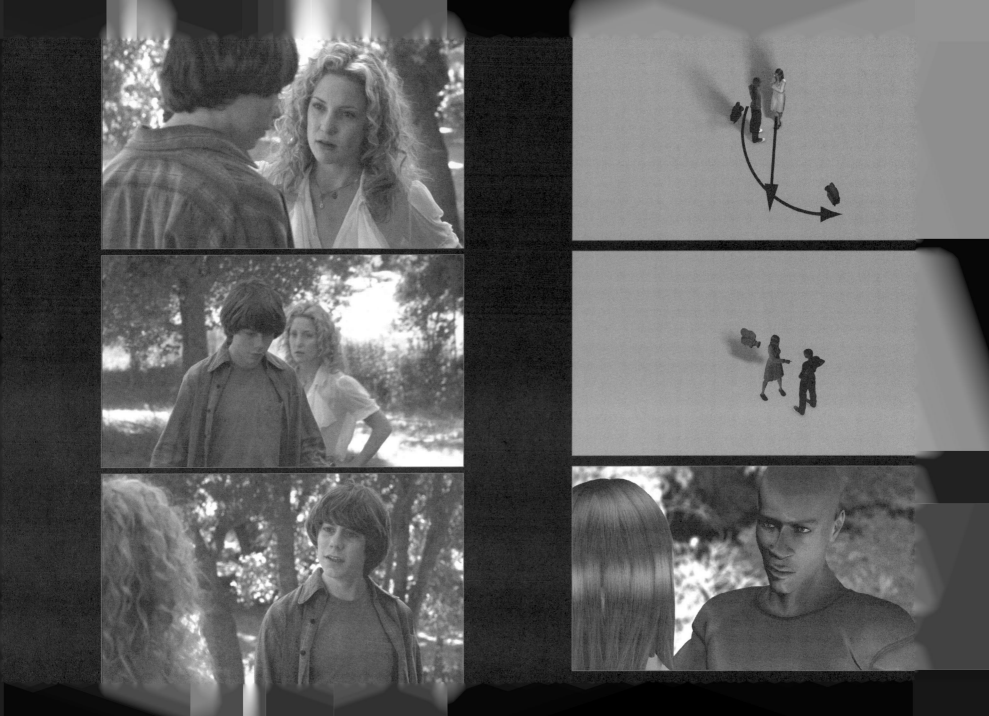

THRESHOLD

A power struggle that takes place in secret is extremely dramatic. Equally, the best secrets are hidden in plain sight. These shots from *The Other Boleyn Girl* illustrate a silhouetted shooting style to reflect the clandestine nature of the struggle. Most importantly, the actors are placed on a boundary between the inside and the outside to create a sense of unease.

The characters are at odds with each other, but rather than having an all-out argument, they are forced to struggle for power over each other. Their argument must remain secret (for plot reasons) and they are always visible to others (for plot reasons), so they speak in whispers, without dramatic movement. The director could have filmed them standing in any space, but he placed them on a threshold between inside and outside to create some uncertainty and unease. The characters aren't really anywhere, because they are neither inside nor outside.

The strong light from outside throws them into silhouette, which adds interest to shots that might otherwise be dampened by their stillness. The audience must listen to and care about every word, so by playing out the scene on this border between spaces, the director makes his audience eager to discover what is going on between them.

Secret conversations are more exciting when they are held within earshot of those who must never hear them, and if your script contains such a scene, putting your characters on a border between spaces will create the tension you want your audience to feel.

The Other Boleyn Girl. Directed by Justin Chadwick. Columbia Pictures/Focus Features, 2008. All rights reserved.

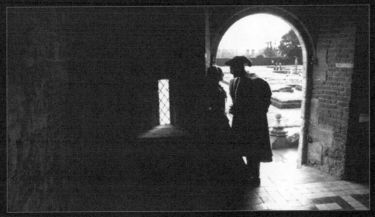

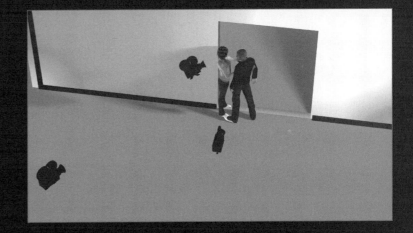

SPACE REVERSE

People locked in a power struggle aren't usually together by choice, but by necessity. Often a dangerous environment or situation throws them together against their will, and the audience sees them forced to confront one another.

It is rare for real power struggles to occur while characters are on the move. Even in the midst of battle, they will usually settle their score when standing at rest. Often, they will stop at a threshold or barrier, facing an obstacle that must be overcome. This tips them over the edge, and makes them challenge each other. When you come to one of these scenes, you can make good use of the space surrounding the actors to emphasize that outside forces have pushed them together.

To make the most of these moments, put the camera on one side of this barrier, and then the other, while the characters remain stuck in the same place, working their way through their argument.

These shots from *Terminator Salvation* show the characters stopped at the edge of a dangerous area. There's no doubt that this is a barrier to the characters, because there are warning signs and barbed wire. The director places the camera quite low, and the characters are looking down, apprehensively, into the space ahead of them. Once they are talking, the scene cuts to a shot from behind the characters, and we can see the unpleasant land beyond that they are unwilling to face.

At the moment the camera turns, she also turns to face him, so that we can see her face as they talk. He angles his body around slightly, so that he isn't completely turned away from camera.

If you shoot this type of scene, you don't need a physical barrier, but it helps. The warning sign used in these shots stays in the center of the screen in both angles, marking the barrier that they can't cross, and also putting something physical between the two characters to emphasize their separation from each other.

Terminator Salvation. Directed by Joseph McGinty Nichol. Warner Bros., 2009. All rights reserved.

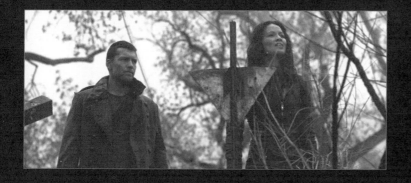

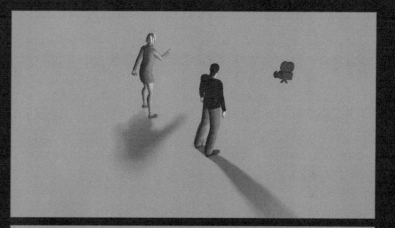

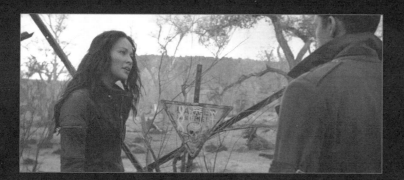

CHARACTER CHASE

You can create a lot of energy in a scene where one character is keen to talk and the other is less interested. This creates the feeling that one character is trying to chase the other. The script will usually dictate this sort of scene, but it's a technique that can be applied cinematically to many scenes with startling results. It can be a useful way to get the actors to move beyond an obvious interpretation.

The camera setup can be extremely simple, with the main idea being that you follow the character that's being pursued. By doing this, you give the audience the sensation of chasing that character, which echoes what the second character is doing. The chase here is subtle and suggested, of course, and is more about one character trying to get the other's attention, rather than an actual chase. As such, the physical movements don't need to be larger than a walk across the room.

In this example, the character played by Malcolm McDowell moves around the room, and the other character follows with a slight time lag. This slight delay is important, because it makes it look like the second character is catching up.

You can shoot this with a single camera, which moves forward and pans to follow the action, or you can cut to a second camera. Whichever you choose, position the second character out-of-frame briefly. This means that he has to re-enter the frame at some point, which again emphasizes the idea that he is catching up.

The Company. Directed by Robert Altman. Sony Pictures Classics, 2003. All rights reserved.

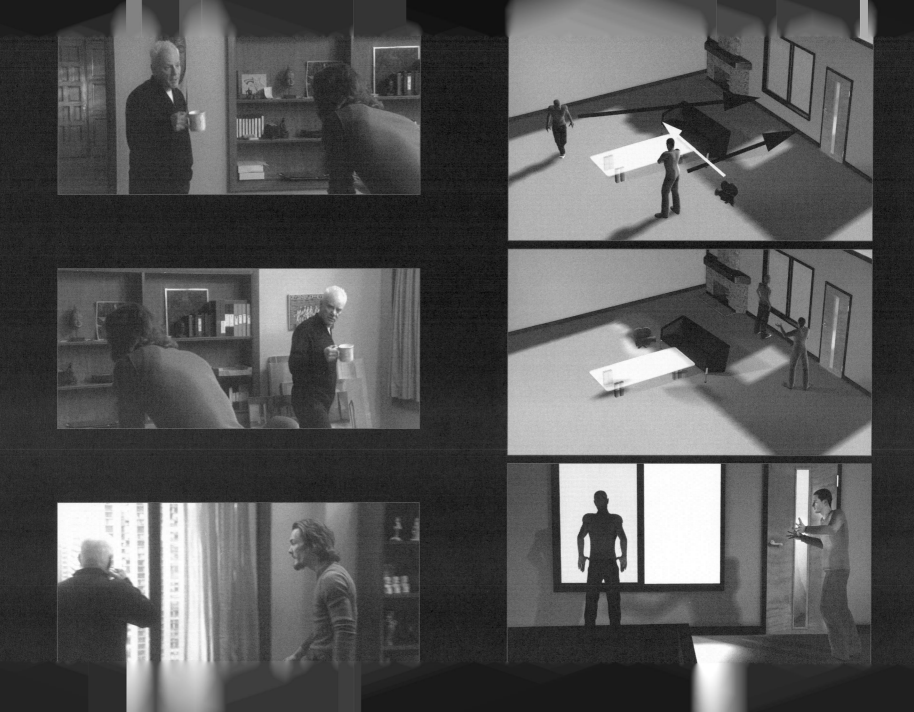

SIDE ON

When a character loses power, you can reveal the intensity of his loss by shooting from the side as he makes a final speech. Although you will spend much of your directing time finding ways to show the characters' faces from the front, this is a time when shooting in profile works. It makes the character, who was formerly powerful, seem cowed and submissive.

There are many ways to shoot a character from the side, but this example from *Star Trek* achieves several different effects at once. By shooting with a long lens, the director focuses tightly on the central character, isolating him from the scene behind him. When he moves away, the long lens causes him to exit the frame almost instantly. The director then racks focus to the background characters to show their reaction.

Actors enjoy scenes such as these, when they get to make a dramatic speech, and most of their best work occurs during moments of change. Unfortunately, the traditional cutting pattern can lead to every moment of change being missed, as the director cuts from one speaker to the next. A shot like this ensures the director doesn't miss any of the actor's work, and there is no need to cut away from this close shot.

When the moment is complete, you will need to cut to a wider shot when the other characters move away from their marks. The only person your audience should see walking out of this close shot is the main character. If you show other people walking out of this frame, you take away some of the emotional impact of the hero's exit.

Star Trek. Directed by J. J. Abrams. Paramount Pictures, 2009. All rights reserved.

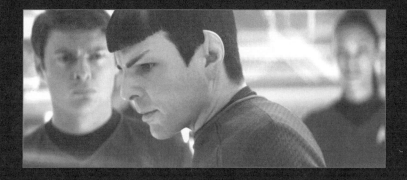

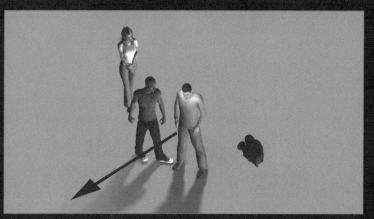

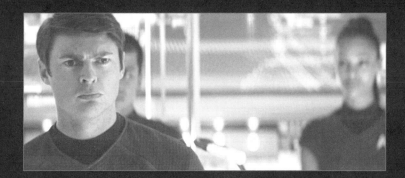

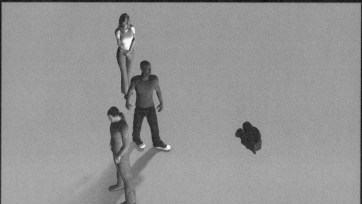

GROUP CONVERSATION

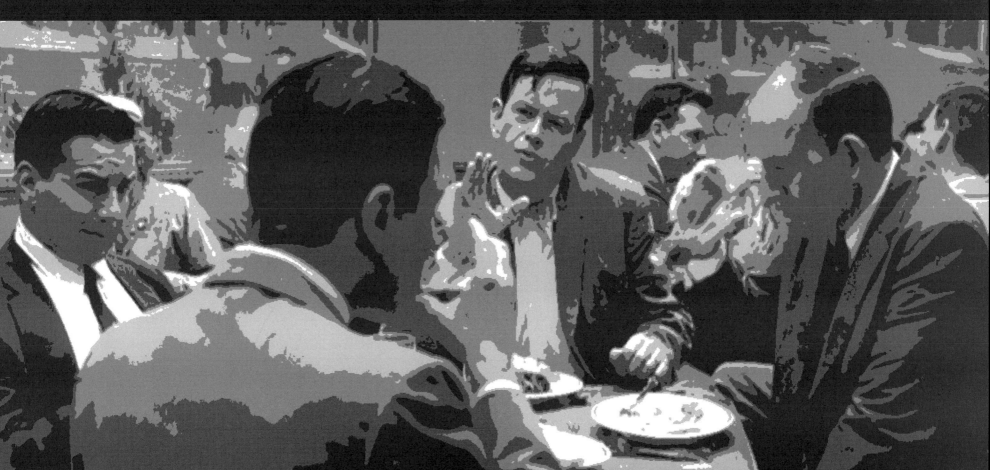

ANGLE ANCHOR

When you're shooting a scene with a lot of people, one approach you can choose is to set up lots of cameras and get endless coverage. This will work, because it will give you plenty to edit with. You should make sure, however, that you don't just get one establishing shot and a medium close-up of each person. If you do, you run the risk of a boring scene or, worse, confusing geography, so the audience doesn't know who's looking at whom.

This can be especially problematic if the scene has been running for a while and you then cut to a character who hasn't spoken. If you haven't established where that character is, you need to do so.

In this scene, Matt Damon has not spoken, and although he's been visible in the background, the audience won't be completely clear about where he is standing. When he does speak, he could be talking to anybody in the room.

The director cuts to a reverse angle, just to the left of Damon's point of view. The characters are arranged in a way that forces them to move in order to see him speak. George Clooney makes direct eye contact, but the other characters (who are closer to camera) have to make a fuss of twisting around to see him. This fixes Damon's position in the scene.

If the director had cut straight to a medium shot of Clooney, the audience would know that the two were talking, but would have no sense of where everybody stood in the room. By setting it up in this way, the director reveals the reactions of many people, without confusing the geography, while maintaining direct eye contact between the two who are talking.

When shooting large groups, arrange your actors so that they have to move or shuffle around to see each other speak. This staging gives far more depth to a scene, and makes the audience sense they are watching a room where something is happening, rather than a room where a lot of actors are talking.

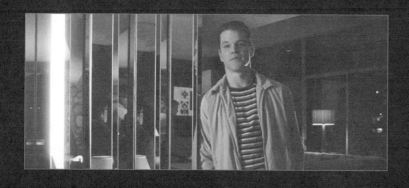

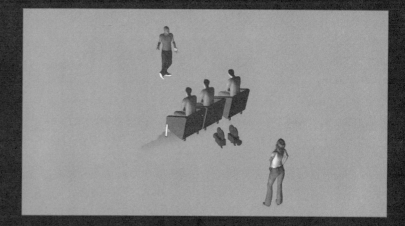

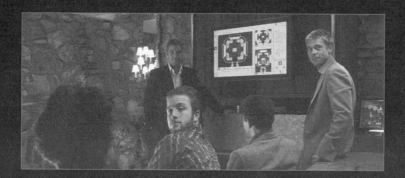

EYELINE ANCHOR

This scene from *Ocean's Eleven* is used again here because the director is faced with the challenge of showing a group conversation with more than ten people. Everybody who's in the scene counts, and they all have something to say. The audience needs to know where everybody is, who's sitting where, and what they're all thinking about. To do this, the audience needs to see that they are all listening to the main character, played by George Clooney.

The shot of Clooney shows him standing against a wall, looking out at the room. He could be looking at any one of the other characters that traipses into the room. In scenes such as this, there are times when you'll need to indicate exactly who's talking to whom (as with angle anchor in the previous section). But at other times, you would simply want to keep Clooney as the focus and make it clear how the scene is set up, so that the audience can follow the conversation.

Clooney looks out in one direction, and everybody else is looking at him. Their eyelines give away exactly where they are in the room. In some cases, their faces are toward the camera, but their eyes are strongly angled to the side, to emphasize the direction of the eyeline.

In another shot, the director emphasizes the eyeline by shooting low and having two people look up in the same direction, their heads angled almost identically. The positioning of these actors' bodies and eyes is not casual. The director has positioned them this way for the precise purpose of showing that they are listening to Clooney.

You can move your camera in a scene such as this, but it can quickly become confusing when you start to cut. You solve this by gathering lots of coverage, from many angles, but also by positioning the actors — and directing their eyes — so that every shot leaves no doubt about who's sitting where, and who they are listening to. Only when the scene is as clear as this will the audience be able to concentrate on the (relatively complicated) dialogue.

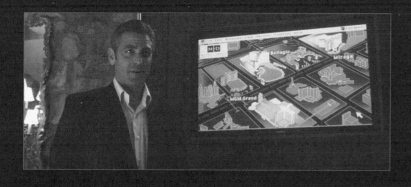

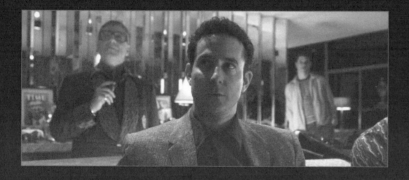

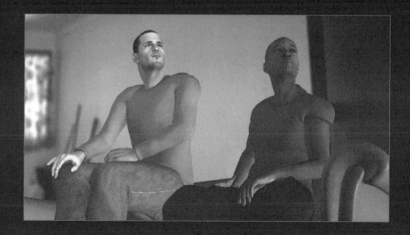

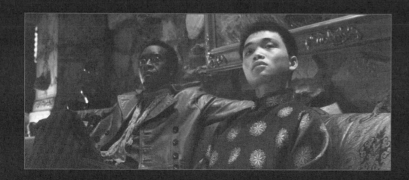

GROUP PIVOT

You can shoot a group of three people in one move, without cuts, and still keep everybody in shot. Although there is nothing wrong with cutting during a scene, you may notice that this book stresses the value of scenes with no cuts. Cutting can, of course, give you more control over which performance you use. On the other hand, when you shoot the scene in one move, the actors will rise to the occasion, and your audience is drawn into the world more effectively than when there are lots of cuts. This is most important when you want them to listen to the dialogue.

This scene from *Munich* shows the characters arranged around a table, with a big space on the camera side. By pushing in at an angle, the director shows the relation of Eric Bana to the other two. As the camera gets closer, he leans forward so that the three of them remain in shot. Then, as the camera comes to the end of its move, it pans left to face the other two actors.

Although all three actors talk throughout the scene, this move shifts the focus from what he is saying to how they are reacting to his words. From this point, you might cut to traditional coverage or end the scene.

For scenes such as this to work, you will have to ask your actors to lean into frame at the appropriate moment. You can see in these stills that they are positioning their bodies, most of the time, to suit the framing. Some actors will find this more challenging than others, but try to let them know that their body positioning is a detail they can use to improve their performance. If you tell an actor to lean in, it is because you want him to appear aggressive, or curious. Describe to your actors how the camera moves and blocking make sense on a performance level, and they will be far more willing to handle the technical side for you.

Munich. Directed by Steven Spielberg. DreamWorks SKG, 2005. All rights reserved.

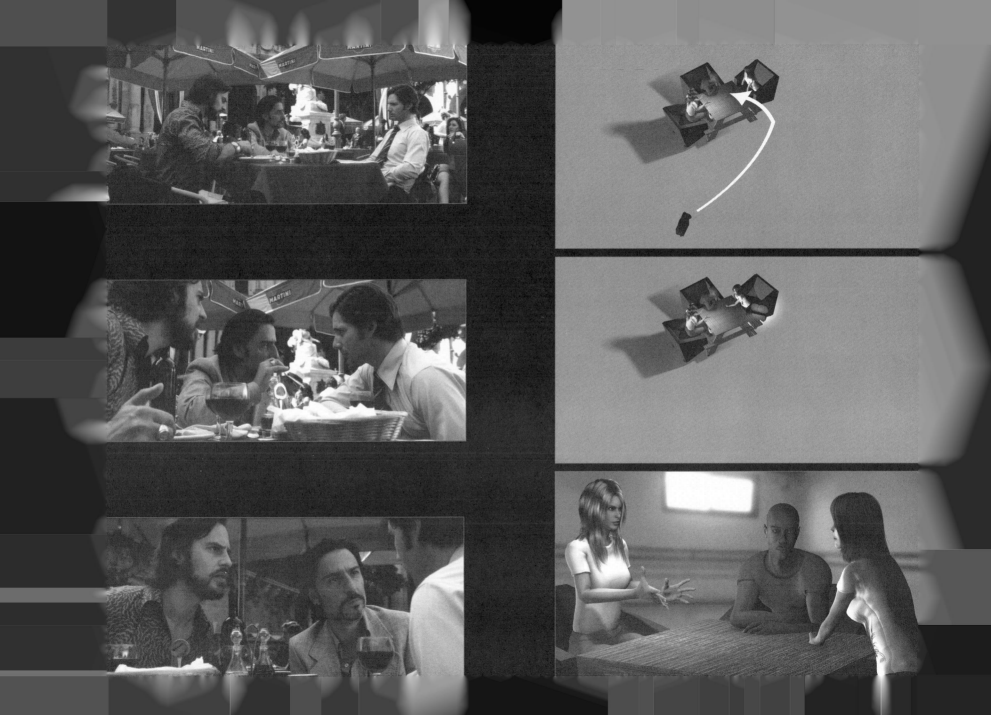

CENTRAL CHARACTER

Even when your group of characters is quite small, somebody can be left out of the conversation. If this is your main character, rather than pushing him to the side, place him right in the middle of the frame.

The exact effect you create will depend on the characters and story, but in general this positioning creates a sense of unease in the central character. Here, Zach Braff is sharing the same piece of furniture with the other two and is clearly uncomfortable. A lot of this discomfort is communicated by directorial choices, such as having the other male actor's shirt off, having him smoke, having Braff lower his head slightly. These all contribute, but the positioning of the camera is also vital.

The wide shot, which shows all three characters, is shot from their head height, looking straight at them. The main character is framed centrally, so the viewer notices him, even though he is the least talkative and offers the least visual interest.

The other two shots frame the characters to the far right and far left of frame, respectively. This pushes them up against Braff, even when he isn't visible. They are pushed against the edge of the frame where the viewer knows he is sitting. This sustains the crushed, uncomfortable feeling throughout the scene.

Although you may spend a lot of your time trying to stop the actors looking straight at each other, this is one setup where the actors on either side of Braff should talk directly to each other. If they don't, then their body language becomes too casual and makes the arrangement feel as though everybody is included. By having these two look at each other, but not at the main character, the director causes his audience to sense Braff's feeling of exclusion.

Garden State. Directed by Zach Braff. Fox Searchlight, 2004.

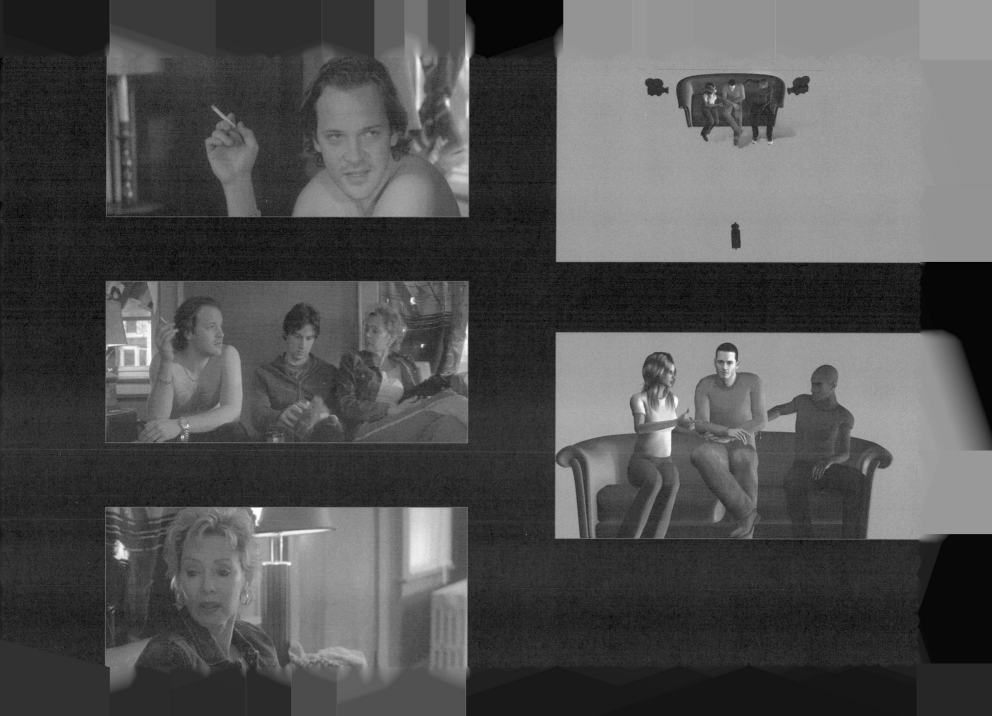

ALONG THE LINE

When you have three or four people in a scene, how do you keep them all visible without endless cuts? One way is to put them all in a line and orient them so that their faces are visible for most of the scene.

If all three characters in this scene were facing the bar, the effect would not work, so the character closest to camera has her back to the bar. This is justified by having her carry a tray of drinks. It's important to have this kind of justification, partly so that your actor feels comfortable, and to prevent this shot from looking like a forced setup.

If she stared at the two men throughout this scene, you would have to keep cutting to a reverse angle of her. This is why, early in the scene, the director has her turn her head toward camera and motion to the dance floor. Again, there is a strong reason for her to do this, in terms of the plot, as there should be.

Although the director did shoot a reverse angle, and uses it a couple of times, he keeps its use to a minimum with this wider master shot. By reducing the cuts, the director gives the scene a good rhythm and the audience listens to what is being said.

By shooting the two men together, who are turning around to listen to her, the director can jump cut straight from the wide shot to the medium close-up of the two of them. This is less jarring than if everybody has a close-up and the director is forced to cut, cut, cut from one person to the next.

North Country. Directed by Niki Caro. Warner Bros., 2005. All rights reserved.

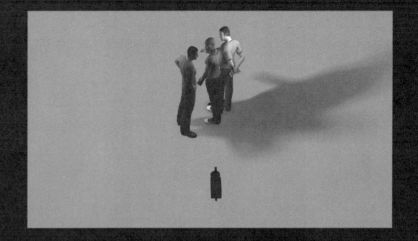

LINE OF THREE

When you want all your actors to focus on something external, position them so that they are all in the frame as the scene plays out. Stand them in a line, at a slight angle to the camera, and have each one look into the distance. This works well if they are standing on the edge of something, such as a balcony, or, as shown here, standing at the railing of a ship.

One danger with this is that if each actor moves into position one after the other, it looks comical. To avoid this, have the central character move in first, as Keira Knightley does here. Then move in the character that's closest to camera. The most distant character can come in last, after some dialogue has been exchanged.

This is meant to be an exciting moment in the film, but the camera doesn't move, so the director makes great use of the characters' eyes and head-angles to bring more energy to the scene.

At first, all of them are looking off into the distance. Then, the director racks focus to the closest character and Knightley looks directly at him as he speaks. (In reality, she probably wouldn't do this, as she can't see his eyes, but it looks good on screen.) Finally, as Orlando Bloom speaks, the focus is on him, and the closest character turns to look at him. Importantly, Knightley continues to keep her face toward the camera. This is because Bloom is quite distant from the camera and his face is small in the frame; if the others both turned around to face him, the shot would appear empty and would lose a lot of its impact.

Pirates of the Caribbean: Dead Man's Chest. Directed by Gore Verbinski. Walt Disney Pictures, 2006. All rights reserved.

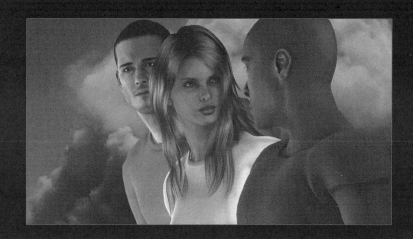

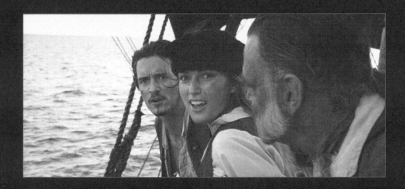

CENTRAL LINE

In many group conversations, most of the action takes place between two main characters. There may be others sitting around with them, but it's the dialogue between these two that matters most. In such scenes you can use the standard angle/reverse angle approach to great effect.

Rather than going in close, you can shoot from outside the group. This keeps everybody in view, so that when the characters on either side do interject, we can see and hear them.

The illustrations show how to position your camera on one side of an imaginary line drawn between the two main characters. This is an exceptionally simple setup, and requires no movement, close-ups, or other coverage. It works because you have four people and they are in a busy environment. Cutting can be problematic, because your actors will need to make sure they time their physical movements from take to take to avoid continuity errors. You could shoot some close-ups to provide coverage to get past such errors, but this setup works best when it uses just the two angles.

In *Revolutionary Road*, this setup is successful because the director used it in an early scene and then returned to it much later in the film, when many things have changed. By using identical angles and only slightly changing the characters' costuming, the director gives his audience the feeling that the more things change, the more they stay the same. If he had shot the scene with lots of motion and multiple angles, this effect would have been impossible to achieve.

Revolutionary Road. Directed by Sam Mendes. Paramount Vantage, 2008. All rights reserved.

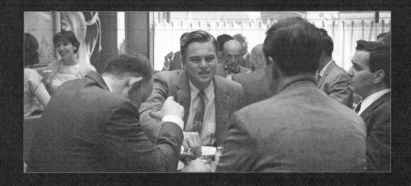

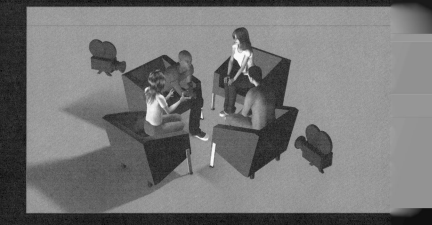

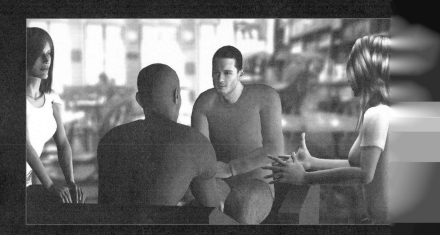

SOLID CAMERA

Sometimes, the last thing you need is a camera move. In this scene from *Grease*, Jeff Conaway barely moves and the camera doesn't move at all. The other characters move all around him, further emphasizing his solidity in this scene.

A setup like this will only work if you have a character who is very cool, strong, or certain in some way, surrounded by others who are either excited (as here), in a panic, or under pressure.

With the camera so still, and the main character doing nothing more than turning his head, it's important that you add visual interest to the scene. In this scene, the director placed the camera a long way back and used a long lens. This makes the distant background appear closer and blurred, again focusing the audience on this small crowd, rather than anything else. The other characters move, partly for the sake of visual interest, but also to turn their faces to camera. By looking at each other, as well as at him, they display more facial expressions to the audience.

Finally, one of the characters turns his back on the camera, ready to rush past Conaway and out of this setup. When you've set up such a solid scene, you need to break out of it strongly, or the next cut will feel jarring. By having a character come toward the screen or turn his back on the camera (as shown here), you get that strong effect.

Grease. Directed by Randal Kleiser. Paramount Pictures, 1978. All rights reserved.

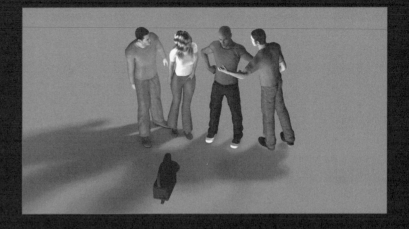

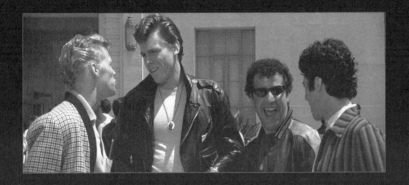

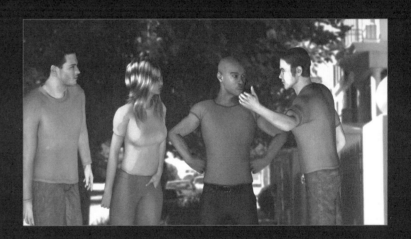

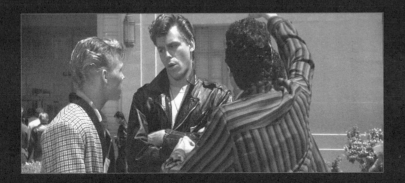

ROUND TABLE

Shooting a large group of people talking around a table can be a huge challenge. It's especially demanding in scenes where the audience needs to know who's talking to whom. Sometimes, the conversation is general, and it's not so important, but in a scene such as this, the audience must know that Brad Pitt is the one who's meant to be the focus of the scene. The fact that he is Brad Pitt does a lot of the work for us, but the director is not so lazy as to rely on this.

When the scene opens there is a brief establishing shot, which shows where everybody is sitting in relation to everybody else. The main character, played by Pitt, is the most strongly lit, and moves the most, leaning into frame, so that the viewer spots him and remembers where he is in the room.

The next shot has him on frame right, looking to frame left. The other characters are in shot, to his left, but the one delivering dialogue is facing away from the camera. This keeps the audience focus strongly on Pitt.

The director then cuts to a similar shot, from a similar camera position, but this time Pitt is placed on frame left and is looking to frame right. It is not just his positioning in the frame, but the way he angles his body and eyes that helps to cement in the viewer's mind where he is sitting, and how this group is arranged around him.

After showing this much of a similar scene, you could easily switch to shots such as close-ups, so long as you keep coming back to these two shots to keep the geography of the scene clear.

Ocean's Eleven. Directed by Steven Soderbergh. Warner Bros., 2001. All rights reserved.

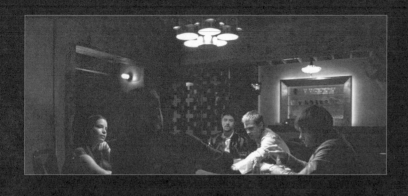

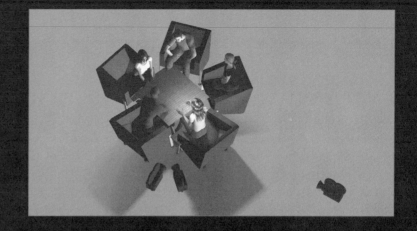

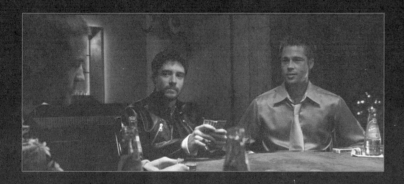

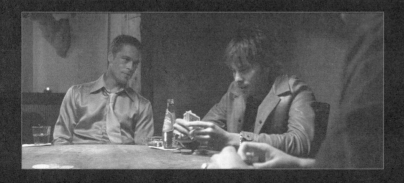

EXPANDING GROUP

Directors tend to see group dialogue as a problem, or at least a challenge. The best directors see it as a great opportunity to expand the story and reveal character. With real skill, it's possible to do all this without ever making a single cut.

This scene from *Munich* starts with a close-up on Eric Bana, with the conversation taking place behind him. What the audience sees on his face is as important as what's being said back there, so it doesn't matter that the background is out of focus.

The camera moves back slowly on a dolly, and as it does, people from the background move forward into the frame. Rather than cutting to them, or having him turn to them, the director has the characters walk right up to him and lean into frame. They move back to the background and continue this dance until they are on both sides of him as the camera reaches its final position.

As the director, you could end the scene at this point or cut to a different angle. If you cut to a motionless camera, make sure this camera has stopped before doing so. If you cut to another moving camera, do so while this camera is still moving.

It could be argued that this setup is far from naturalistic, when looking at the still-frame grabs, but in the context of the film, this scene works. The audience is intent on Bana's reaction, seeing the effect the surrounding drama has on him. If you plan to use a single moving shot to capture an entire scene, make sure your main character is the true focus of the scene and the absolute focus of the other characters in the scene. If they are genuinely intent on getting something out of the main character — a reaction, a comment — then their positioning in the frame is believable.

Munich. Directed by Steven Spielberg. Universal Studios, 2005. All rights reserved.

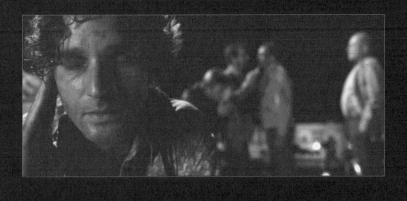

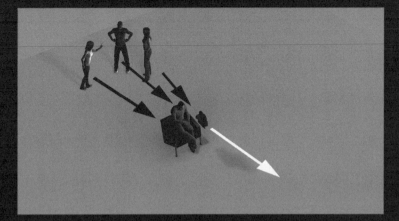

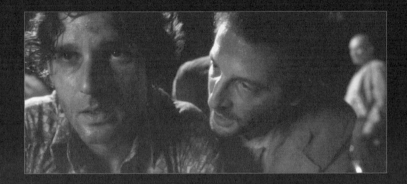

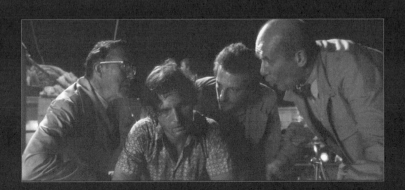

LONG LENS SPACE

When two characters meet for the first time, you need to make the most of the moment. A good screenwriter will often keep the dialogue minimal at this point, so you need to use all the visual skills in your arsenal to connect these characters.

Long lenses have a way of showing distance and proximity at the same time, which is perfect for a dialogue scene where two characters first meet. In these shots from *Paris, je t'aime*, Natalie Portman is a long way from the camera, but the long lens brings her closer.

When she walks toward the camera, the long lens makes her movement forward almost imperceptible, so that crossing the long space of this hallway takes her a long time. This is a perfect way for the director to show that, although there is a growing connection between these two characters, finalizing that connection takes some effort on their part.

The reverse shot of him uses a slightly shorter lens and he appears low-down in the window frame, giving him an air of vulnerability.

The choice of location is as important as the lens choice and camera position. If the director had simply walked her across a room, the effect would not have been as strong. Instead, she crosses a room (from the very farthest wall), then moves all the way down a long hallway. This tunneling effect suggests that she is traveling toward him, rather than just coming over to talk to somebody.

You can see how the director took advantage of her moving into the light at the end of the shot. When she is close to the camera, she becomes illuminated by the window light. Although the character she's talking to is blind in this story (and cannot see this illumination), the effect on the audience is to show her radiance as the connection between them is made.

Paris, je t'aime (segment titled *Faubourg Saint-Denis*). Directed by Tom Tykwer. Victoires International, 2006. All rights reserved.

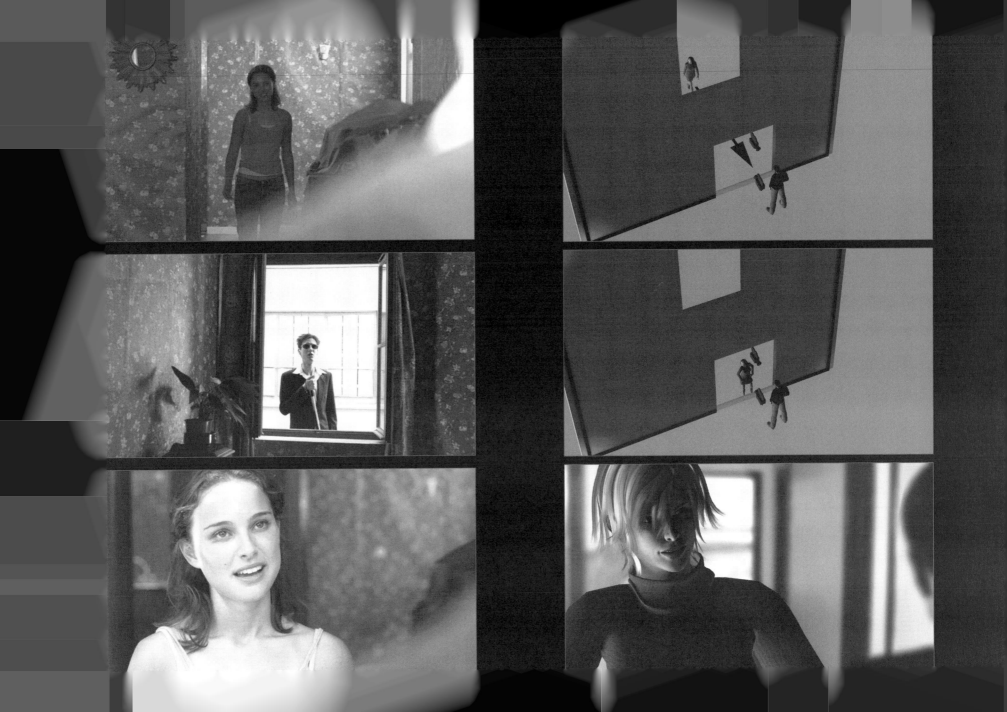

OBSTRUCTION

In many of these chapters you'll notice that when we're trying to connect characters, they are often held apart. Writers tease the audience by keeping lovers apart for as long as possible, and directors echo this by finding visual ways to keep the characters away from each other.

In *Onegin*, the director puts a physical barrier — a bookcase — between the characters. The size of the barrier is made completely clear by shooting from a good distance back, so that the viewer sees the bookcase towering above the two characters.

Despite this barrier, the characters continue to converse. Then, when least expected, the director cuts to a shot of Liv Tyler, filmed through the bookcase. This is a pleasant surprise, because it shows that the two can in fact see each other and a connection is forming between them. This second shot uses a long lens to make the bookcase seem blurred and to foreshorten the distance, so that she seems closer than she actually is.

Don't underestimate the power of these symbolic barriers. It's easy to dismiss them as film theory, but these techniques can enrich your film greatly. Although the audience won't consciously notice what you're doing, putting barriers between characters and then opening them up will have an effect on how your viewers experience the scene.

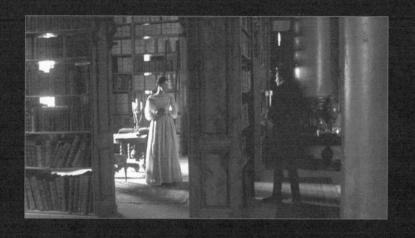
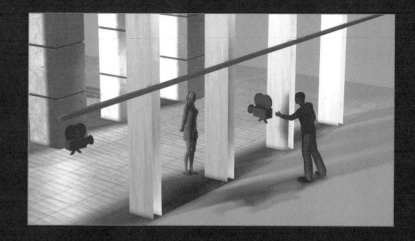
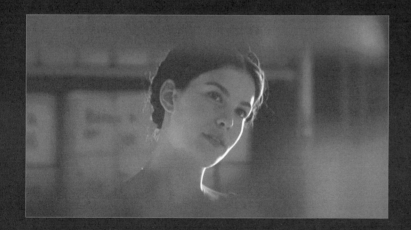

FACING AWAY

This iconic shot from *Nineteen Eighty-Four* shows that turning actors away from the camera can work beautifully during an important dialogue scene. The actors do glance at each other and turn to look at one another in profile, but for most of the scene they are looking out at the scenery.

The setup for a shot like this is extremely simple in terms of positioning the camera at head height, a short distance from the actors. To get the most out of it, though, the director has made sure that the viewer sees a foreground, a midground, and a background. This is a principle that can be used to increase the beauty of any shot, but is especially important when there is little movement, or when faces are concealed.

In this shot, the actors are in the midground. The background is the distinctive landscape, and the foreground is made up of branches and leaves. There are strong plot reasons for the foreground and background to be visible. The background is part of a dream, and the foreground branches show that they are on the edge of the woodland we saw them in earlier. It could be argued that the director is simply showing the audience what they need to see to make sense of the film. Although this could be true, really strong and memorable images often make use of a strong foreground, midground, and background, and you can experiment with them, even when they aren't particularly relevant to the plot.

When, though, do you turn your characters away from the camera? This isn't something you should do often. It should only happen when what they look at is important to them, and when their dialogue is something that the audience can understand without seeing their expressions. For scenes where these criteria are met, this setup has much potential and forms a strong on-screen bond between two characters.

Nineteen Eighty-Four. Directed by Michael Radford. Umbrella-Rosenblum Films Production, 1984. All rights reserved.

ANGLED PUSH

Even the best directors resort to using the angle/reverse angle approach from time to time, but when they do, they often give it a small twist. In this scene from *The Lovely Bones*, the smallest of camera moves makes an ordinary setup into something dramatic.

The camera starts in medium close-up on each character, but as they talk, it pushes in closer. It does this at the same speed for each character, so that as the director cuts between them, each face is the same size as the other in the frame. This draws a connection between the two of them. If the camera moved in on one character but not on the other, it would draw attention to the first character. By moving in on both, the camera draws them together.

It helps if the actors are almost motionless in a scene like this, and facing each other directly. People rarely face each other directly, which is why you have to be cautious about positioning them in this way. In this example, they are both focusing on the ship-in-a-bottle that he's working on, which gives a justification for their seating position. If you can't use a prop, you should only use this approach when there is good reason for one person to directly face another, such as a teacher addressing a student.

The move itself should be slow and weighted so that the audience isn't aware that it's happening. Set up your camera so that you can keep the actors' eyes at the same level in the frame, without having to tilt or raise the camera as you push in.

The Lovely Bones. Directed by Peter Jackson. Paramount Pictures, 2009. All rights reserved.

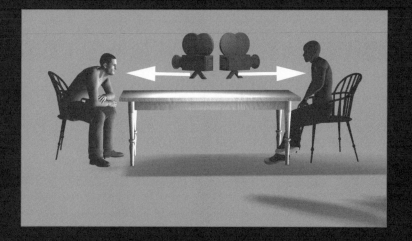

BACK TO CHARACTER

The strongest connections between characters can occur when one person is trying to avoid the other. This is an important technique in romantic situations, because the audience senses the rapport that is being resisted by one character and pursued by the other.

These shots from *Magnolia* show how a stationary camera can capture this dynamic between the actors, by having one move around a lot while the other remains almost stationary. She busies herself, making coffee, moving all around the room, even leaving it at one point. Most of the time, she has her back to him. This serves the purpose of keeping her face toward the camera (so the viewer can see what she's feeling), and also shows her resistance toward him.

He is more animated. Although he remains in roughly the same position, he angles his body toward hers wherever she goes, making his interest in her clear. At one point he moves closer to her, but quickly backs away when she tries to get past.

When she leaves the room, the director holds the camera in the room, without cutting to show where she's gone, so that the viewer feels an awkward moment of suspension.

This scene takes the idea about as far as it can go, and you may not want to emulate this directly. You can, however, use the same principles, even if only briefly. A motionless camera, with one character turning away from the other as she moves around him, creates a strong connection between the two.

Don't think that you always need to have characters facing each other when you're trying to connect them. Sometimes, a refusal to look at somebody is far more enticing to the audience and emotionally demanding for the character.

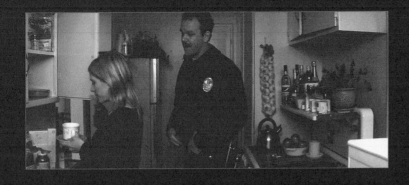

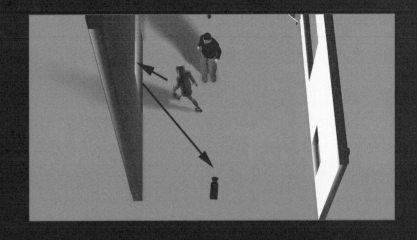

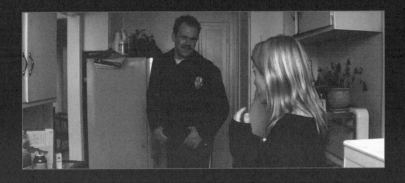

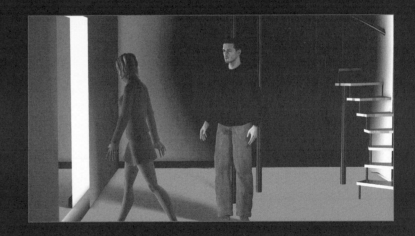

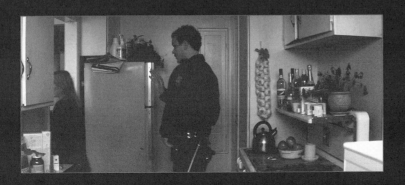

DANCE MOVES

Dance scenes are used relentlessly in films, whether the films are about dance or not. This is largely because it gives you, as the director, the opportunity to push two characters together physically, even though they may not yet be close emotionally. This is enjoyable for the audience, and lets them glimpse where the characters might be heading.

In terms of camera work, dance scenes offer endless opportunities. In recent years there has been a tendency to throw the camera on the dance floor, and have it circle the actors as they swirl around. Although that can work, this scene shows that when the actors are moving, you have the option to leave the camera exactly where it is.

A brief wide shot shows the two characters move together, and then the director cuts to a camera that is at waist height, tilted upward. The camera does not move, apart from the smallest corrections to reframe. Instead, the actors turn, revealing one face and then the other.

The actors will be aware of the camera and should time their movements so that one face is visible to the audience at all times. They should not hesitate or linger when somebody's back is turned to the camera. Be careful, however, not to make it obvious that they are moving their faces into shot.

Although the camera setup is simple, this will need extensive rehearsal to get the timing right, to make sure the actors' movements match the dialogue, and that each face is on screen when you want it be.

V for Vendetta. Directed by James McTeigue. Warner Bros., 2006. All rights reserved.

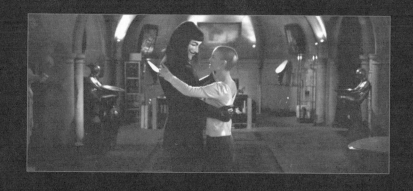

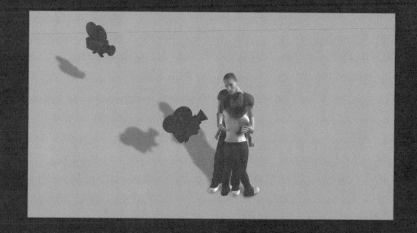

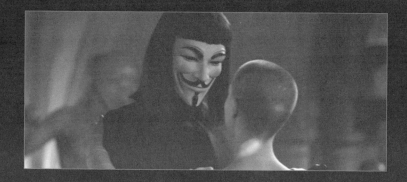

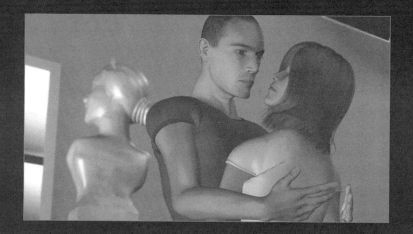

OUTSIDER

A character who's seeking connection with others generates sympathy with the audience. You need to film this sort of scene carefully, or the outsider will seem like a whiny intruder. Spielberg shows how this can be done by placing Henry Thomas outside the main group.

In the first shot, Thomas is trying to get the attention of the others. Although the audience can see him, he's on the outside of the group, farthest from the camera, and in a much darker part of the frame. The risk here is that he's so hidden within the frame that he could almost disappear; so the director has placed his face in the exact center of the frame, both vertically and horizontally. This way, the viewer can't miss him.

The next shot uses a longer lens. Thomas is in roughly the same place, but he is seen from another angle. Most of the frame is taken up with somebody else's back in silhouette. This pushes the audience to the outside of the circle. This setup achieves three things: It shows that the character is on the outside of the group, it makes the audience feel that they are on the outside with him, and it connects the viewer with him as his is the only face in focus.

The third shot looks similar to the opening shot, but is actually from another angle. Now Thomas walks around the table, turning his back to the camera. This again emphasizes his outsider status in the scene, but also shows that he's asserting himself, pushing himself in the way (quite literally) so that he cannot be ignored.

The dialogue that takes place in this scene is frantic, but what's said is perhaps less important than the relationships that are set up visually. Spielberg also shows that repetition can be a powerful thing. When you work with this idea (physically placing a character in a way that reflects their status), making the point three times — in just a few seconds — will drive it home.

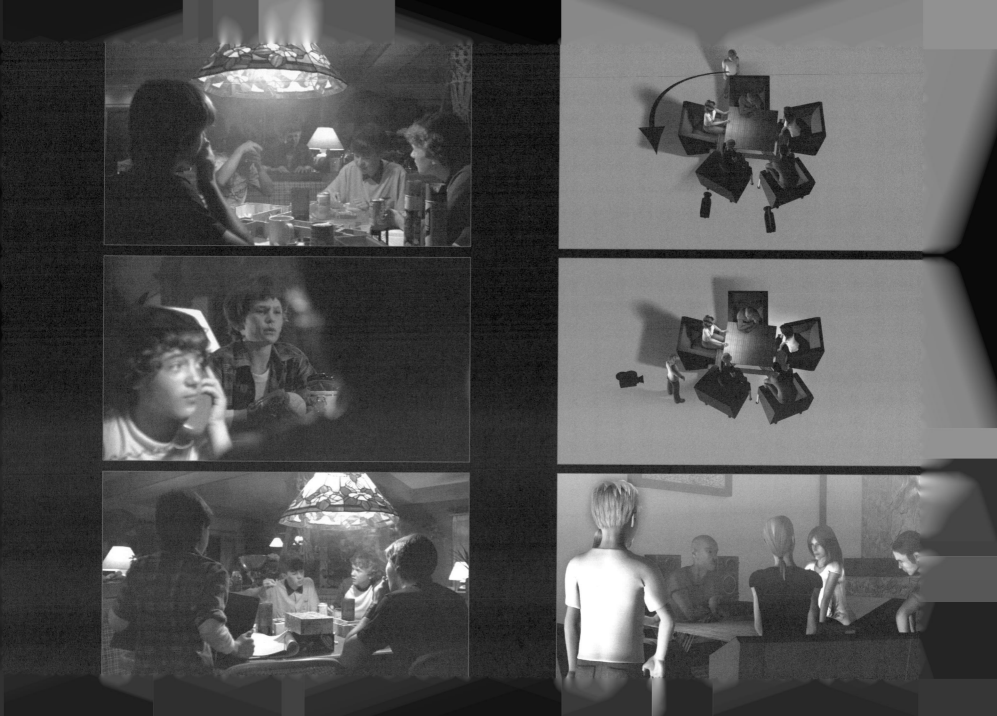

PLAYING WITH SPACE

If a meeting between two characters is particularly potent, or emotionally charged, you can reflect this with lens choice. By using a wide range of lenses, you can create the slightly dreamlike feeling that occurs when your emotions run wild.

The first shot is more interesting than most over-the-shoulder shots, because it's taken from further back than usual, placing the character's face almost central in the screen. This could be because the camera couldn't be moved any further to the left, since the actors are positioned next to the lockers. Whether intentional or not, the effect is to create a powerful shot of Reece Ritchie, showing his connection to Saoirse Ronan. If the audience only saw her shoulder or the edge of her head, as normally happens, this wouldn't be as strong, but because more of her head is shown, the audience feels how intently Ritchie is looking at her.

In the film itself there is more coverage of the two talking, before the camera cuts to the second frame that's shown here. This shot is taken from a near-identical camera position, but with a much wider lens. This makes them appear further back, farther apart from each other, and increases the scale of the surrounding corridor. The camera also floats around a little, and the overall effect is one of minor panic and disorientation. Having established a beautiful moment, it is a brave choice of the director to let it drift into a more surreal mood.

The next cut surprises the viewer by looking almost straight into Ronan's eyes. This cements the relationship that has just been established, because now the audience sees the scene from Ritchie's point of view.

A conventional director would probably have shot from the corridor side of the actors, rather than the locker side, and would have been satisfied with angle/reverse angle. You can see that pushing visuals to their extremes can add a lot of potency to a scene, even when the dialogue on the page is relatively simple.

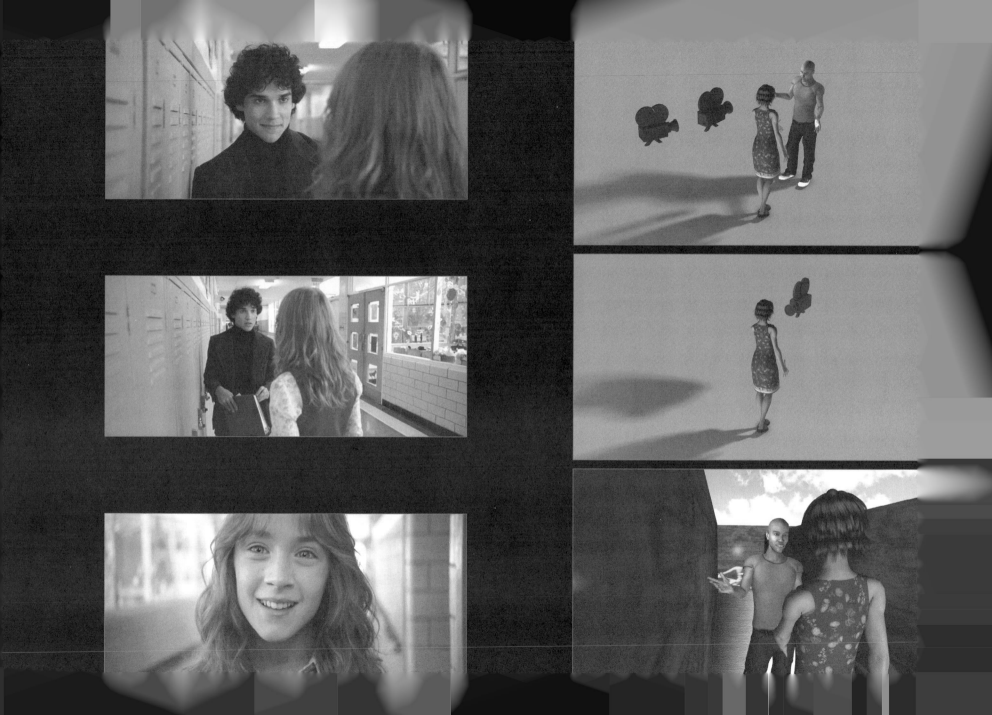

PACING

Characters who make speeches try to connect with the crowd they are talking to. Whether or not this is successful depends on the script, but a director needs to show the effect the speech is having on the crowd.

The opening shot of Brad Pitt establishes that he is giving a speech, largely because of his performance. It is an interesting choice, though, because many directors would open a speech scene with a wide establishing shot.

In the next shot, the view shifts behind the characters he's addressing, and the camera dollies with him, keeping him roughly central in the frame. The director keeps Pitt's performance in view, but also shows how many people are there without resorting to an establishing shot.

When he turns around to walk back up the line, the camera cuts to another dolly shot from the other side of Pitt. This time, the camera is focused on those who are listening to him. He remains largely in profile so the viewer can see the essence of his performance while watching the crowd's reaction to his words.

When shooting speeches, you can keep the speechmaker still, standing on a podium, but movement opens up many possibilities. The simple arrangement of actors and two dolly tracks used in this scene makes for a rich and visually powerful setup.

There is only one cut, when Pitt changes direction. If you tried to cut between the two setups throughout the scene, everything on screen would appear to be changing direction with each cut. When shooting a scene like this, be certain that you've got good footage of the moment that he changes direction, because that is where you will need to cut.

Inglourious Basterds. Directed by Quentin Tarantino. Universal Pictures, 2009. All rights reserved.

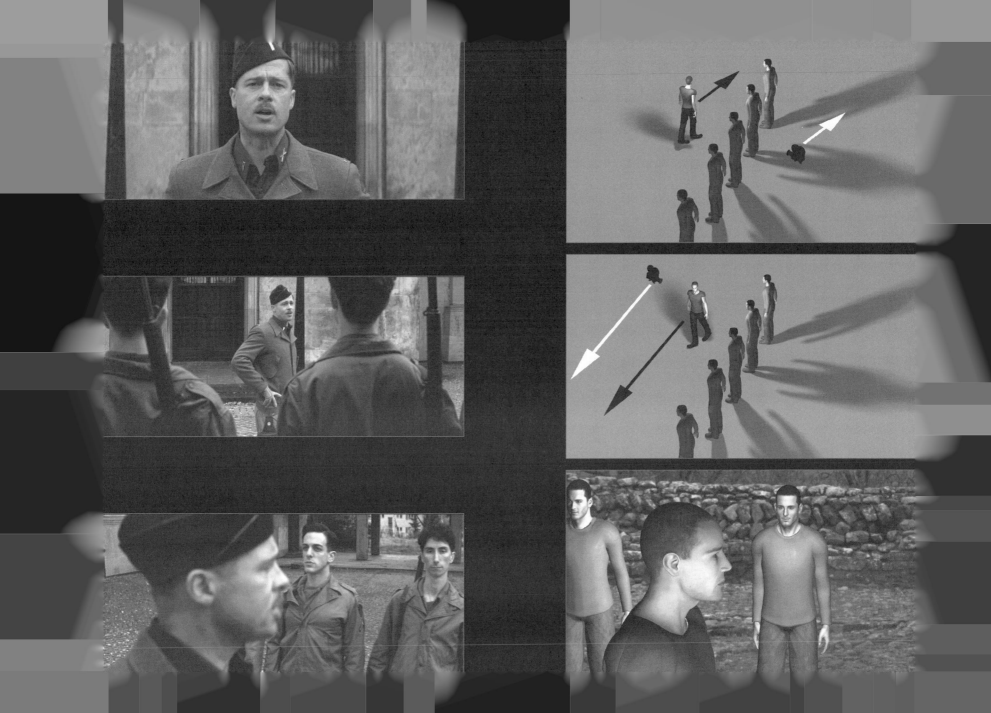

PARALLEL SPEECH

Long speeches can be difficult to pull off, especially when there is a lot of exposition taking place. Ideally, your script will keep this to a minimum. If, however, you have a scene that requires somebody to make a relatively long speech to a large crowd, you can maintain interest by making changes in height, angle, and proximity throughout the shot.

This is easier to achieve than it might sound. In these shots from *A. I. Artificial Intelligence*, William Hurt walks down the center of the room. By carefully spacing the extras, the director makes the room seem full. Some of the extras and some props are close to camera, so that as the camera dollies to the left, this movement is emphasized and the shot is kept interesting.

The camera then moves around to the left, so the audience meets Hurt as he comes to a halt at the top of the steps. The audience is looking down on him, but rather than seeming diminished, he now appears to have the crowd in the palm of his hands. He is more brightly lit, and he is above them. In capturing the crowd's attention and rising to such a strong visual position, Spielberg also captures the attention of his film audience. They know from this brief camera move that Hurt is a character worth listening to.

As with many of Spielberg's moves, it is his combination of techniques that makes it powerful. The camera move itself, the actor's apparent height change, and the ending with him close to camera all contribute to the overall effect.

The real challenge with a shot like this is timing the move to exactly match the actor's performance. If you plan to shoot a scene like this, try to work with an actor who's capable of accurate timing as well as strong performance.

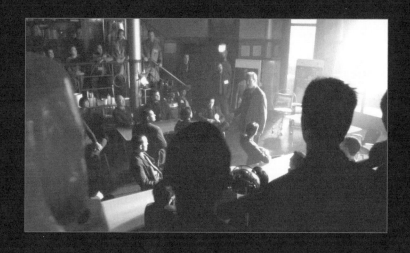

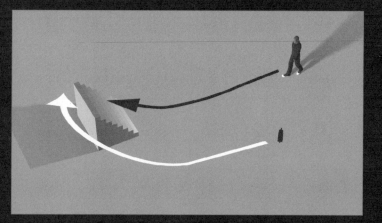

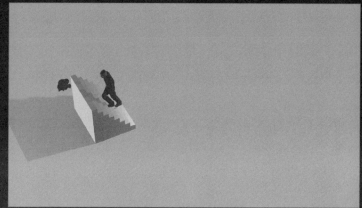

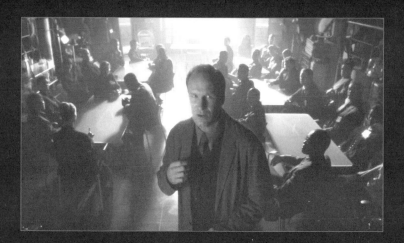

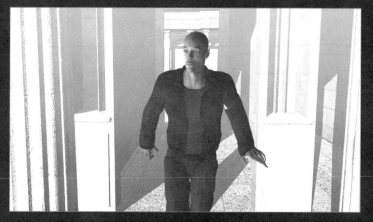

REVEALING PLOT

SHIFTING LEVELS

At a turning point in your movie, when things step up a gear, you might find it useful to direct your actors to move more energetically through the scene as they talk. This can help to show that change is occurring, and that decisions are being made.

These shots from *Melinda and Melinda* are achieved with a pan and tilt, but because the actors move to different positions on the steps, and because different numbers of people are in the frame at any one time, it makes for a fascinating scene.

The opening shot shows the two men leaving the apartment, and Radha Mitchell meets them. She turns to lean against the railing, which helps open this group up, so the audience can see their faces as they talk. The men leave, and she heads up the steps. The camera stays on her and moves in slightly (although the shot would have worked without any move at all).

She turns to talk to them at the top of the steps, again ensuring that her face is on screen. It doesn't matter that they are off screen at this point, because the interest in the scene is whether or not she will join them for a day out. That's all they are interested in, that's all the audience is interested in, so the viewer only needs to watch her. The director doesn't need to cut back to them.

She then moves back down the steps and joins them, and the final moments of the conversation show their reactions to her decision, so it doesn't matter that she has her back to camera. You can execute this type of setup so long as you are willing to let some actors go out of frame. Don't always try to get absolute coverage of every angle. If you can capture the scene in a more elegant way, do so.

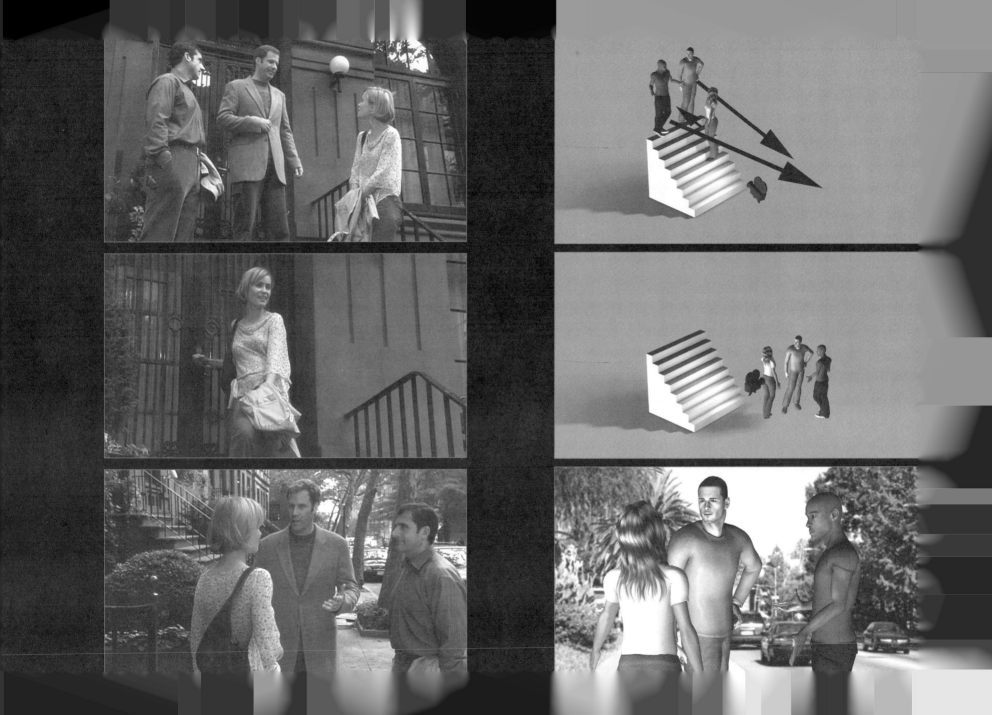

CLOSE CUT

Showing both actors in one shot is a good way to shoot a dialogue scene, especially when plot is being revealed. In many cases, you can shoot the whole scene in one take, moving to a second angle as the scene progresses. Or, as shown here, you can cut to the second angle.

In the first shot, the characters are focused on the envelope they've retrieved from the mailbox. Although the actors angle their heads slightly so that the camera can pick up their faces, they can't really be seen clearly. The audience is also focused on the envelope.

The cut then shifts to a view that is face-on to the actors, shot by a second camera at a similar distance and with a similar lens. The audience, however, is able to see their expressions more clearly because of the cut. To further facilitate this, the director places the actors physically very close to each other. This level of proximity between two people is rare, but it works on screen because when the actors look at each other, they have to really look. You can't glance at somebody when you're this close.

For the actors, this will feel unnaturally close, and they may need some coaxing. It will be easier to get them to put their faces this close together if you arrange them so their bodies are touching, with one character leaning on the other slightly.

Shots such as this help show the relationship between two characters, but when you want to make a plot point that the audience remembers, it helps to limit the number of cuts in the scene. By cutting to this one shot of the characters in close contact, you enable your audience to listen to everything they say.

Ghost World. Directed by Terry Zwigoff. United Artists, 2001. All rights reserved.

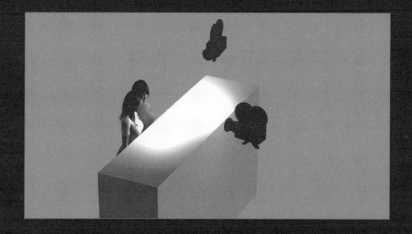

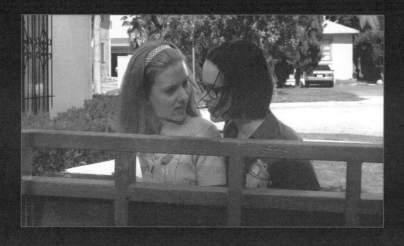

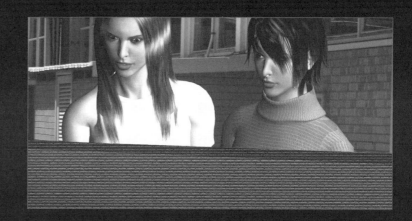

HARD REVERSE

These shots from *Nineteen Eighty-Four* show how much power you can achieve with one cut. Most of this scene takes place with the characters walking toward a moving camera, but as they come to rest, the camera jumps to the opposite side of them. This cut comes as a vital plot point is revealed.

Master Shots 2 stresses the benefits you can gain from having actors talk without looking at each other. You can mix this up by having one character try to make eye contact, while the other remains uninterested. Here, John Hurt looks across at Richard Burton throughout the whole scene. Burton barely glances at him, and the power imbalance between them is clearly established.

As an audience member, you want Burton to look at Hurt, but when he finally does, it is a surprise. The two of them stop walking and turn to face each other. This is a powerful moment, because they are facing each other for the first time in the film, and a major shift in the plot takes place. At this moment, the director cuts to a shot taken from the opposite side of the actors.

This cut is powerful because it cuts to the exact opposite angle. A cut to a different angle would not be as powerful as this opposite angle, because the viewer sees the actors reversed in the frame. This suggests that something has been exchanged between them.

The lighting here is also crucial, because in the opening shots, both characters are quite brightly lit against the surrounding darkness. But then, as a secret is exchanged, both are thrown into silhouette. It is as though they have entered a secret world together, with nothing more than a cut.

When you shoot a scene like this, the cut works most effectively when the audience doesn't suspect it is coming, so a long, slow walk should precede the moment of change.

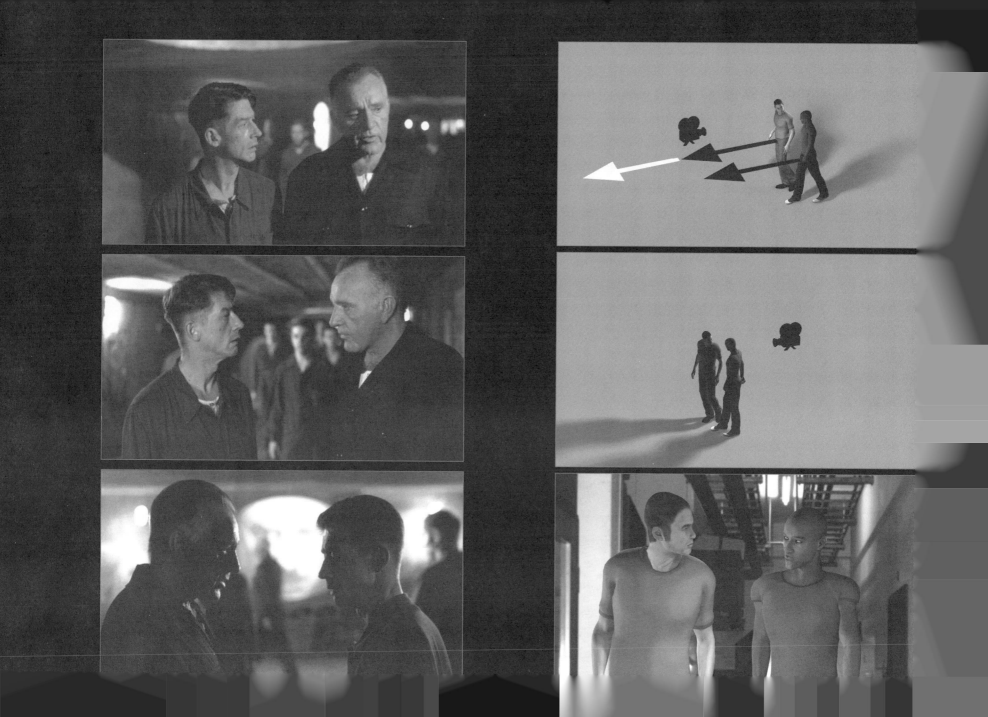

FACE TO FACE

There are times when you need to show a character revealing plot points, without him dominating the scene. In these shots from *A. I. Artificial Intelligence,* it's important for the audience to see Sam Robards revealing some plot details, but this scene has to be emotionally owned by Frances O'Connor.

To achieve the correct balance, the director starts with the two facing each other. Then, as the plot details are revealed, Robards moves around to the side, so that his face is favored. This movement of his could look unnatural or unmotivated, but because the camera is moving in, it appears realistic.

Once the plot details have been revealed, Robards needs to move out of the way, so that the focus is on O'Connor's reaction. To achieve this, Robards moves back to face her. By now the camera is close and looking up. He bends forward and looks up at her, as though trying to get a response from her, which means she can look down at him, thus facing the camera almost directly.

If this scene was shot with two characters standing next to each other, the camera cutting from one to the other, it would be dull. By adding a simple camera move, and shifting one actor, Spielberg causes the audience to notice the plot, and then to feel the scene's emotional charge.

As with so many of Spielberg's setups, the challenge is to make the actors comfortable with moves that are somewhat forced. If the actors are uncomfortable, a scene like this will just look like a flashy setup. You really see the skill of the director here, not in the moves he's chosen, but in the level of comfort the actors appear to feel when acting out the scene.

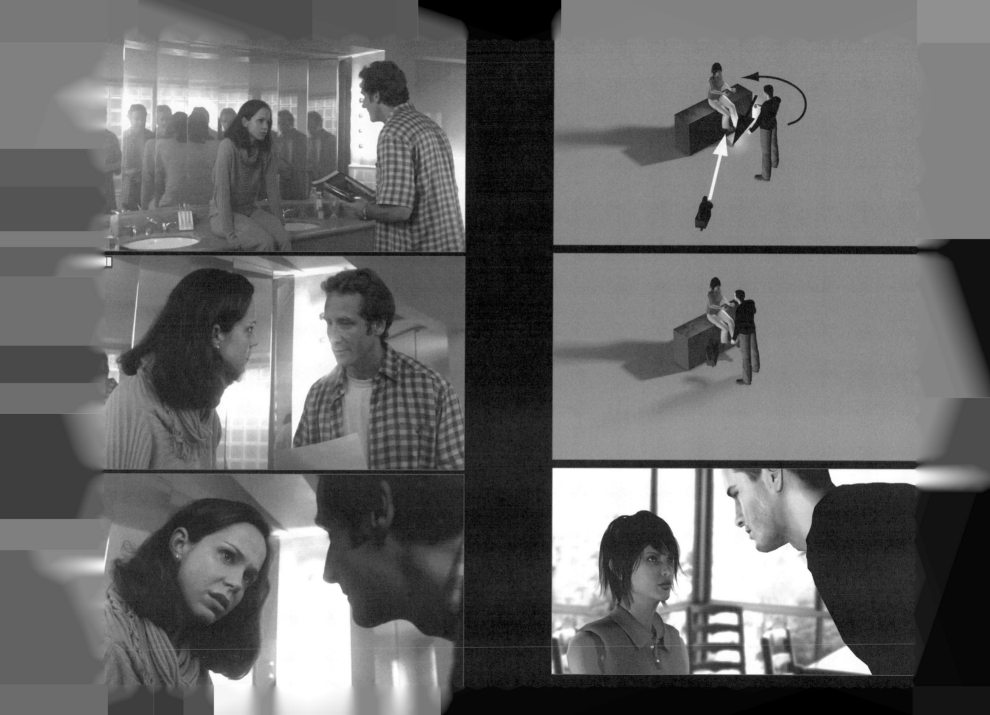

FACE UP

During scenes where plot details are revealed, or hinted at, it can help to show that one character knows more than another. This scene from *Twin Peaks: Fire Walk with Me* uses three cameras, two of which remain motionless. The camera that is close to Sheryl Lee slowly pushes in on her to show that she is the one in the know.

The establishing shot from above does more than just set the scene. Establishing shots can be tiresome, because they can be a lazy way of revealing nothing more than where the scene takes place, and where everybody is positioned. If you're going to use an establishing shot, it helps to push the image as far as it can go. Here, a high camera with a wide lens looks down on the two characters, who are arranged in unusual positions on chairs.

This kind of staging, with actors lying in strange positions, could be dismissed as Lynchian weirdness, but it adds richness to the scene. Real people do not sit or stand talking to each other the way they do in soap operas. Real people flop and lie and position themselves all over the furniture.

With the establishing shot out of the way, the director cuts to shots of their faces, but as the conversation takes place, only the camera above Lee pushes in. This shows an imbalance of power; she is the one who knows what's going on. Although she is the victim of much that goes on in this film, the camera move here makes it clear that she is the one on the inside of the mystery.

When moving your camera, even in small, slow moves such as this, remember that it can have a huge effect on how each character is perceived. Had the director pushed the camera in on both actors, it would have a completely different effect.

Twin Peaks: Fire Walk with Me. Directed by David Lynch. New Line Cinema, 1992. All rights reserved.

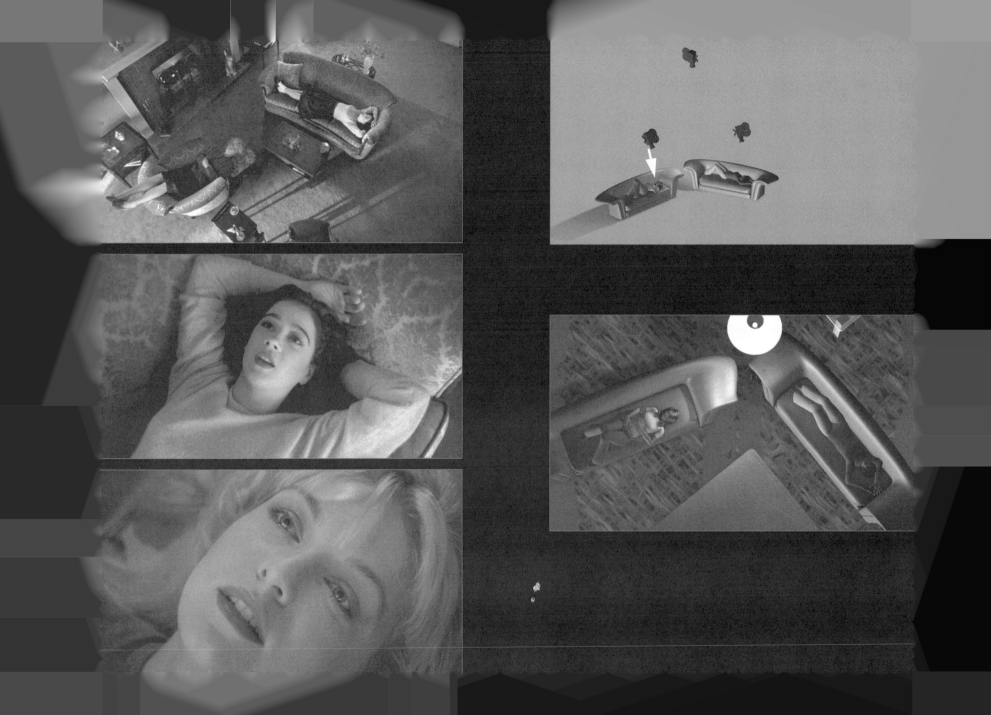

BACKGROUND SWITCH

When one character reveals key information to another, there is often a sense of discomfort. In this scene from *V for Vendetta*, the character that's seated at the beginning is reluctant to share his suspicions. By starting the scene with the character's back to the camera, the director suggests his reluctance.

The second character faces the camera, asks a question, and then moves to the left to sit down. As he does so, the first character crosses the frame, and the camera follows him. He moves across the room simply to get a drink of water. In other words, there is nothing in the plot that requires him to move. He could sit where he is and say what he thinks. The reason the director gets him to stand up is that by moving him across the frame and past the second character, we feel his unease.

By having him move from one side of the frame to the other, without a cut, the director shows a subtle change is going on. The fact that the first character's back remains turned to camera at the end of the shot also reflects his unease. He glances across at the second character, but only slightly.

The camera itself does not move position, but pans to follow him. It's an alarmingly simple setup, with the characters' movements and orientation to the camera dictating the level of discomfort.

Don't underestimate the effect that can be created by shifting the character from one side of the frame to the other. Although people move around scenes all the time, when you do it in a slow way, in one move, without a cut, it raises the tension. The plot revelation becomes far more interesting than if the characters merely looked at each other and spoke their lines.

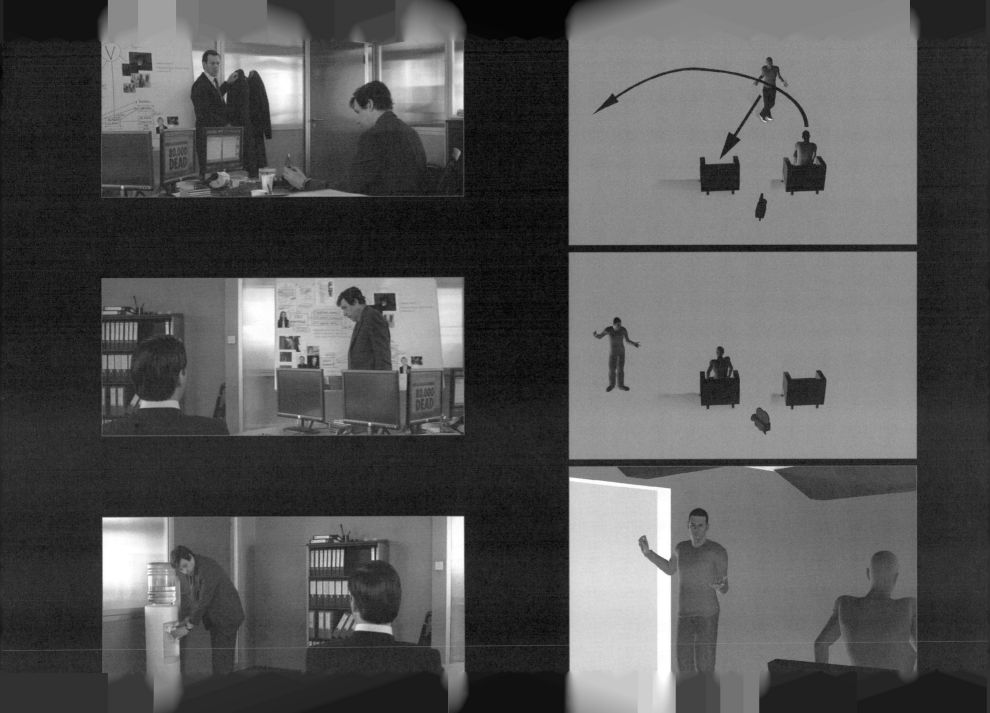

INVISIBLE BARRIER

While plot is being revealed, it is important that the audience remains interested in characters and relationships. These shots from *The Reader* show one character's resistance to the other's attention. The dialogue is minimal, so the layers of character are added by careful positioning of the actors and the camera to create the impression of a barrier between the characters.

The first shot shows David Kross with his back turned to the camera. Although he looks over his shoulder at Karoline Herfurth, he does not immediately turn to face her. She stands in the doorway, and although her face is turned toward him, she does not enter the room. This is the threshold she will not cross, and it serves to create some distance between them.

Rather than shooting over-the-shoulder shots, the director has chosen to place each character in their own frame, further separating them from each other. Although there is a hint of a possible relationship between the two, the barrier prevents them from getting close.

In the final shot of Kross, a longer, more flattering lens is used to create a little more intimacy, but although he now faces her directly, his body is turned away. He has not shifted around in his seat, and this maintains the dislocation between the two.

Scenes like this are effective because they pull the audience in two directions at once. In terms of the plot and facial expressions, we sense a growing intimacy between these people, but this is contradicted by everything else on screen. You can add great depth to a scene by manipulating this contradiction.

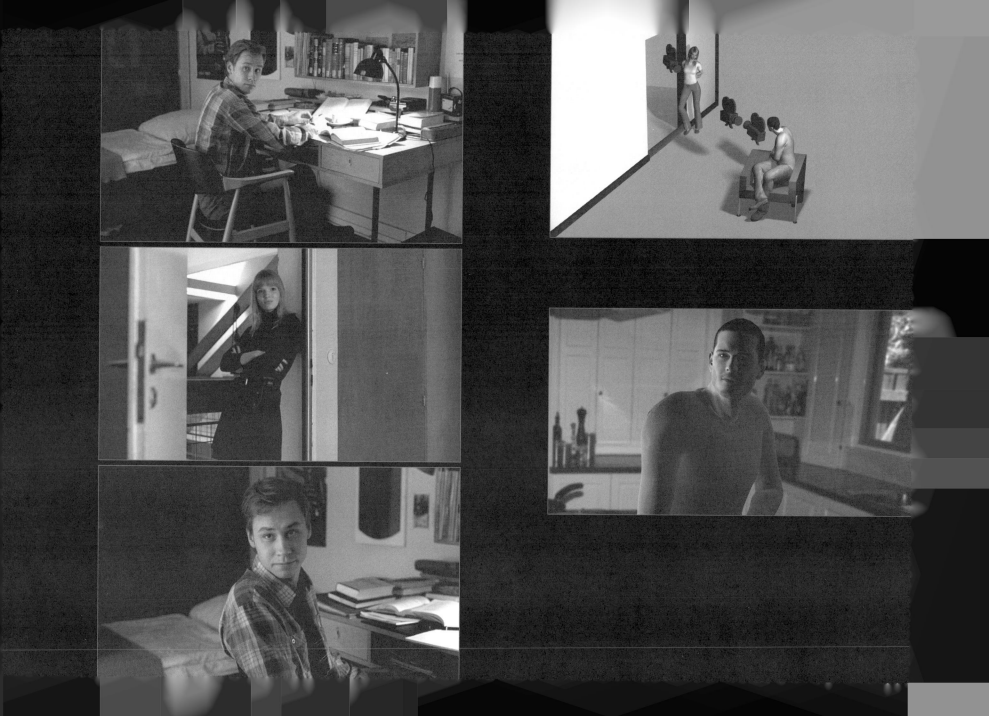

NO CONTACT

People don't look at each other much in the real world, and you can take advantage of this to keep a dialogue scene interesting to watch, when relatively mundane plot points are being revealed.

This scene from *Ghost World* is important to the plot, and sets up a few important ideas, but it is not a rip-roaring mystery, so the director has kept it interesting by using the camera to reveal the characters as much as the plot.

The first shot establishes their positioning, and by having Scarlett Johansson look away at something off-screen, the director shows both faces at once. The director then cuts to shots of each character, almost from directly in front, and they talk without really looking at each other.

Above all, these two are old friends, and this is shown by their complete comfort with each other. People who've been friends for a long time barely even glance at each other when they talk. When you meet somebody for the first time, there's lots of polite eye contact. When you're trying to make a point to somebody, or show your feeling, there's lots of eye contact; but when you're just chatting with an old friend, there's almost no eye contact. To emphasize this point, the director has placed the actors on different levels, so that looking at each other is almost impossible. When one does look at the other, the eye contact is never returned. Far from creating a sense of separation, this sustains a feeling of intimacy while the mechanics of the plot are laid out.

This also demonstrates that whenever you have a scene that needs brightening up, placing the actors on different levels always gives you something more interesting to work with.

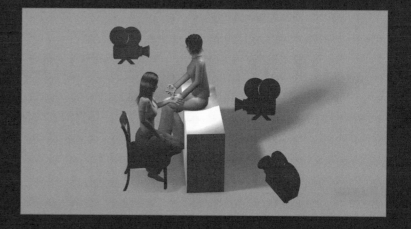

SHIFT TO BACKGROUND

In some scenes, the plot point you want to reveal is not made by the dialogue itself, but by an action the character makes, or just by her expression. For something so subtle, you need to stage the scene so that your audience focuses on the actor's face at the precise moment she makes a decision or feels an emotion.

This scene from *North Country* shows Charlize Theron move from the foreground (where she can't be seen clearly) to the background, where she faces the camera. The director changes from a slightly obscured view of her face to a direct full-face view, and this enables the viewer to see what she's feeling.

A scene like this requires that the actors have a lot of "business" to motivate their mundane actions. In this case, they are washing the dishes. Whether this was in the script or was added by the director, it is essential for the scene to work. If you ever work on a script where this kind of scene takes place at an empty table, move the actors to somewhere they can be busy with their hands. That way you can justify their movements throughout the scene. Also, a slightly mundane setting can make an important revelation seem all the more startling.

The activity also gives Theron motivation to move to the back of the room. She is clearing dishes away, moves toward the cupboard, and then stops there to take in what has been said.

Although this excessive movement of props and people will provide a challenge for your sound recordist, it's worth the effort to bring more life to a few moments that could otherwise be cinematically flat.

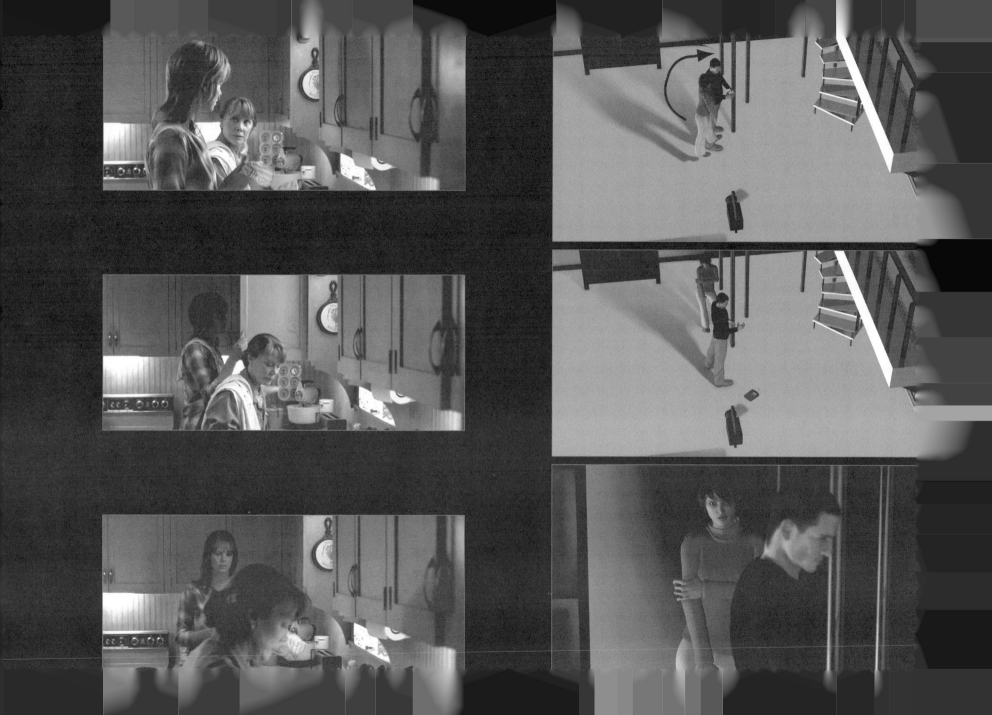

SWING PAN

Panning the camera from one character to the other rarely works, but if the background action is related to the plot, you can make this move powerful.

This scene from *Three Colors: Blue* pans from one character to the other and back again, as they speak. A viewer might think this seems forced, except that the conversation is, in part, about the stage show going on below the two characters.

If they were sitting against a wall, the pan would appear forced, but by including the background, the director shows the full scene (including the important background action) without a single cut. It doesn't matter that the background is out of focus, because the conversation explains what's going on.

This scene could end on one character delivering a line, but the director chose to have both characters lean in at the same time, so that they share the frame. The final pan occurs at the same time as this movement, then the camera rests on the two of them.

When shooting this setup, you should slightly offset the camera toward one character. This means that when the two come into the frame the camera remains at an angle to them, which keeps the focus on them. If you place the camera exactly between them, the camera will come to rest on empty space, directing attention to the background. If that's what you want, that's fine. But if you want to keep the attention on the actors, keep the camera slightly closer to your main character.

Although this is a simple setup, it's often the simple ones that need the most tweaking to come off exactly right. You'll notice that Juliette Binoche sits quite far back in her chair. This enables the audience to see more of her face, rather than just her profile. It's worthwhile to rehearse your actors in getting their timing right. This will ensure that you're getting the best possible look at each face before going for the first take.

Three Colors: Blue. Directed by Krzysztof Kieślowski. Miramax, 1993.

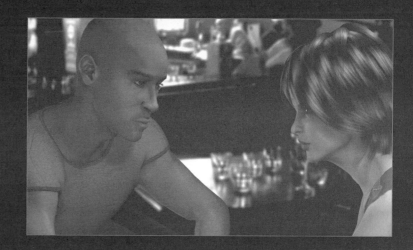

WALKING AND TALKING

SPIRAL DOWN

Staircases can be difficult locations to shoot in because they are confined, but they can add visual interest to characters who are talking as they move.

In this scene, she wants to keep talking, but he is trying to leave. This means there is a distance between them, so as they move down the staircase the director can cut back and forth between the shots. If they were walking down together, it wouldn't work, so the director needs some justification for the distance between them. It might be that one is rushing ahead, for example.

The camera setup consists of framing each actor almost centrally, and keeping the same camera distance as they move down the stairs. The actor's camera is slightly closer to him, giving him the point of view. If the camera was at an equal distance to both, the audience might identify with her more, as she is higher up. As such, positioning the camera slightly closer to the viewpoint character is essential.

You can keep the actors on the move or have them stop, but it's wise to keep the distance between them the same throughout, or the audience may be confused as to where they are. If you want to see one character catch up to the other, stay on that character while the movement takes place.

As they talk, you can have the lower character look back, as shown in the frame grab from *The Science of Sleep*. For most of the scene, he looks ahead, but the occasional glance backward helps to establish a connection between them as they move.

It helps to shoot this sort of shot with a Steadicam or similar stabilizing device. Extreme caution is always required when you ask your camera operator to move backward down a staircase. Ensure that a strong assistant carefully guides the camera operator.

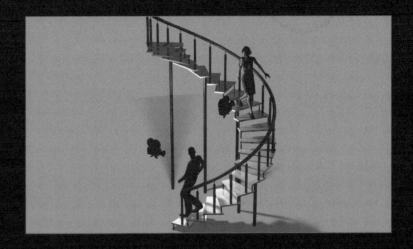

RUSH PAST

Dialogue can be spoken in a great rush, with two characters shouting brief lines at each other. In scenes like this, it helps if the movements of the actors and the camera reflect the drama. A good way to do this is to have the camera and actors moving in opposite directions.

In this shot from *The Abyss*, the camera follows one actor moving in opposition to another, creating the maximum amount of momentum. The audience follows the first actor down the corridor, and at the same time another character rushes toward him. As this is shot with a short lens, the corridor walls appear to speed by, and the approaching character rushes up.

She stops at the side of the corridor and he continues on his way. Partly, this is because he's going off to solve the problem, but it also means that as he continues the conversation he has to look back down the corridor to see her, which keeps his face in shot.

It's worth noting that when she stops, she is in a brightly lit part of the corridor, so that the viewer concentrates on her as she delivers her lines. Then, as the scene continues, the director switches the focus back to him as he turns around to shout back at her.

This approach works extremely well in a tight corridor, as there is ample justification for her stopping (to make room for him), but the same principle could be applied in many locations.

The Abyss. Directed by James Cameron. 20th Century-Fox, 1989. All rights reserved.

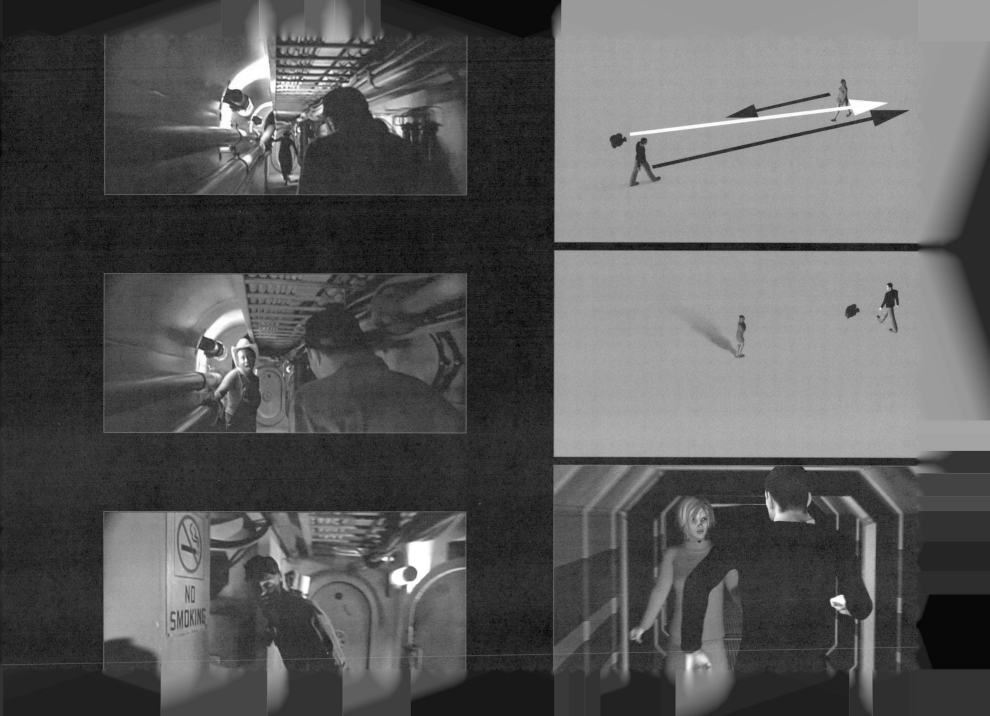

FINDING THE LENS

When actors walk alongside or in front of the camera, as shown in this shot from *The Reader*, the director must ensure that they keep their faces in view of the camera. Actors don't usually need much encouragement to do this, but you should find good motivations for them, or the scene will look forced.

You can see here that as they walk, each turns as though to look back at the crowd and the events going on around them, but really they are finding the camera lens, and keeping their faces in shot. When turning to face each other, they turn slightly more than necessary so that the audience can see their faces.

At the end of the shot, the older man stops at the door. Rather than looking over his shoulder, he turns his whole body around, so that his face can be seen. Good actors will make this look entirely natural. It helps if the scene has lots of action going on around them, so that their movement fits in. In this scene, they are surrounded by protesters, police vans, and people coming into the courts, so it works. If they were walking down a country lane it might not be so effective, so use this technique only when it can be justified by the entirety of the scene.

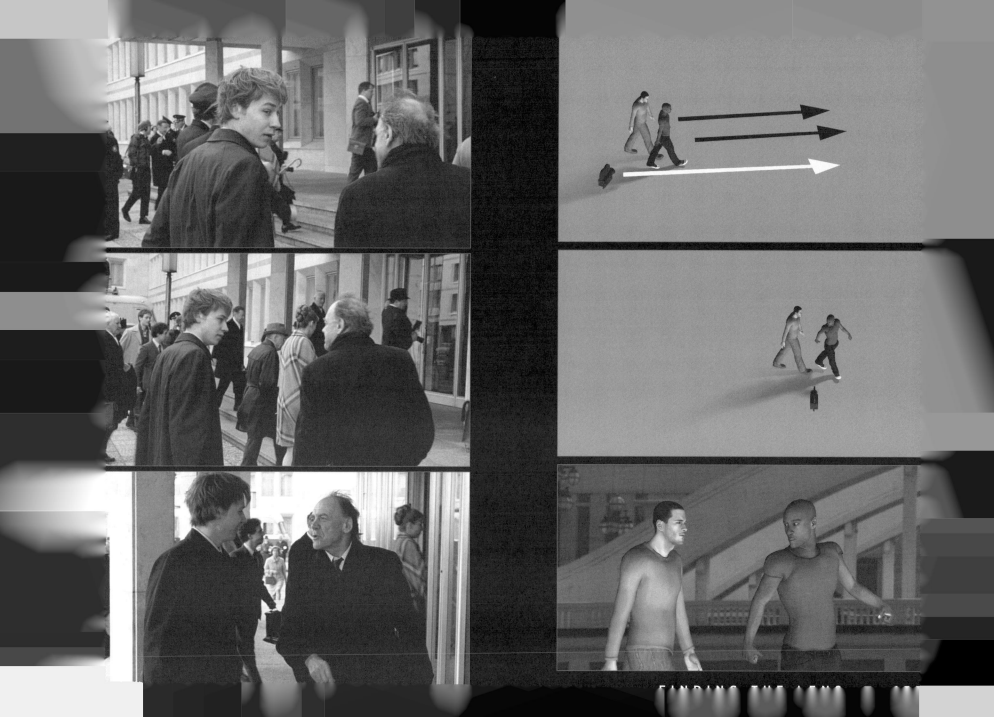

BACK TO CAMERA

When you have a group of three people on the move, add variety to your coverage by shooting from in front and from behind. This can be more interesting than the standard approach of shooting a medium close-up of each person from the side.

You can see here that when the camera is behind the actors, they angle their bodies and their faces to be seen better. They even pause, so that the couple can turn to face the tall man. Then, as they continue, a gap remains between them, leaving room for them to turn toward each other as they walk.

If the conversation is interesting enough (as it should be) you can afford to show their mood through their body language alone, so don't force the actors to keep their faces in view for the whole shot.

When the camera cuts to the front view, the actors are all closer together and facing forward, largely because this fits them all into the frame. They continue to glance at each other, but not as often, because showing their expression is more important than having them look at each other.

The problem is that the setup from behind is quite different from the setup in front. The actors are arranged quite differently, so you cannot repeatedly cut from one view to the other. If you use this technique, use one angle and then cut to the other, but do not attempt to cut back and forth between the two.

This setup can be a stylistic choice, but is also a good technique to have ready in case you are in a location where shooting from the side is difficult. If there are trees, walls, or other obstructions that prevent you from moving alongside the actors, shooting from behind and in front can capture the group dynamic with just a couple of shots.

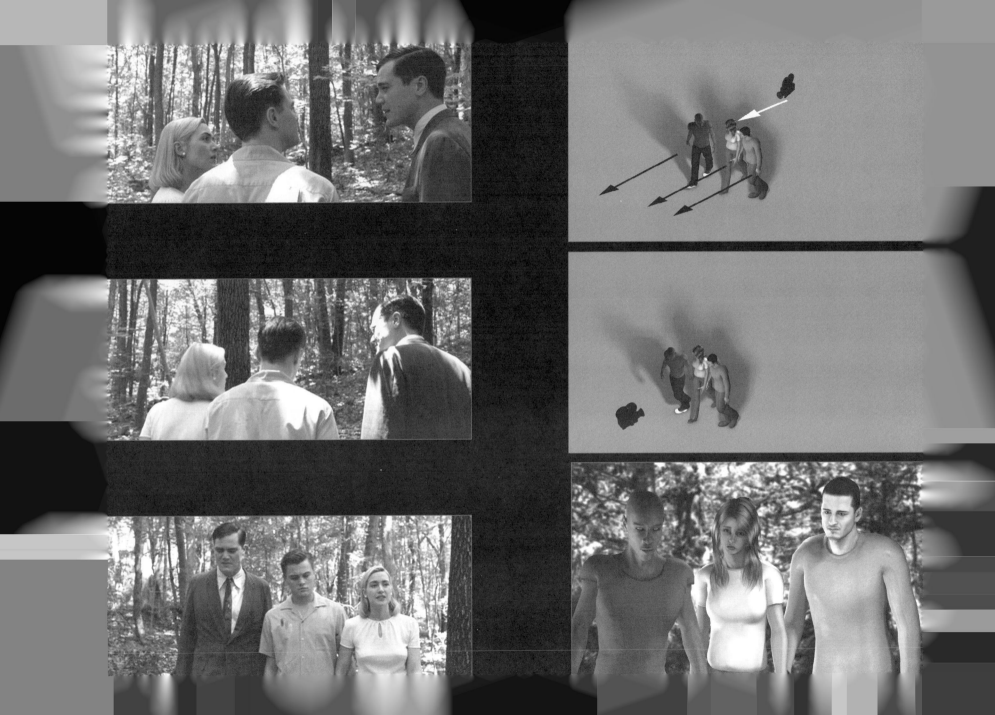

MUTUAL INTEREST

There are times when simple coverage is the best way to capture a scene where the actors are walking. This example from *Almost Famous* shows the first moment in the film where these two characters need each other and try to connect. The coverage reflects this by staying resolutely in front of the actors, moving where they move.

Although it isn't clear from the frames shown here, this scene covers quite a lot of ground, with the actors crossing the road and walking down a long street. Rather than moving the camera around them, the director simply keeps it in front of them and captures their relationship.

When the director cuts to closer shots, they are not at angles to the actors, but are pointed straight at their faces. This gives the scene a strong cohesion, and makes the audience feel the actors' connection, while everything else is moving past. As in many of the shots described in this book, the characters barely look at each other as they talk.

The problem with shooting everything in one direction is that continuity errors can creep in. It is difficult to time every take to match exactly, especially when there is considerable background action. In this example, there are several continuity errors, as background action slips out of synch from cut to cut. One solution is to shoot an additional angle, but this would break the carefully crafted emotion of the scene. Perhaps the best solution is to time background action as carefully as possible, and cut around the problems as well as you can.

Almost Famous. Directed by Cameron Crowe. DreamWorks, 2000. All rights reserved.

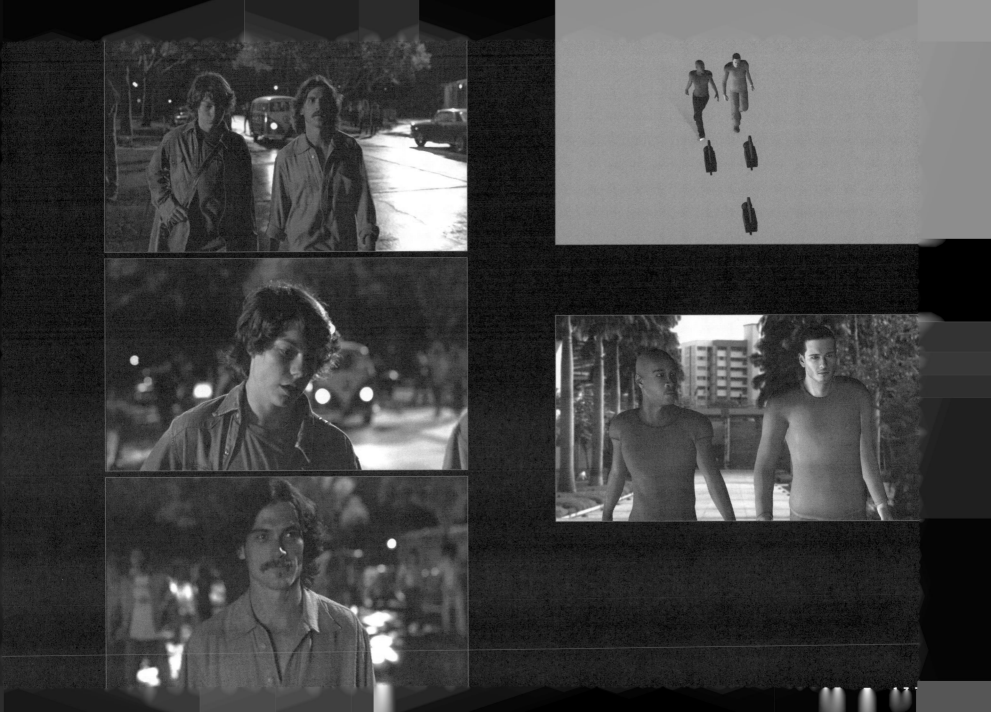

OPEN SPACE

Sometimes you can frame your main character alone in the scene, even though others are present. The movement that follows can bring them back together.

In this scene from *Only Clouds Move the Stars,* Thea Sofie Rusten is framed on the left, looking at the boy as they talk. (The audience knows he's there because of an earlier, overhead establishing shot.) As they talk, he moves into frame and past her, but she remains focused on the space where he was standing.

By keeping her looking at the same place, the director achieves two things. First, the character remains facing the camera as they talk, and second, her deep sense of self-involvement is shown. Although she is carrying on a conversation, she is wrapped up in her own thoughts.

By the time she turns to approach him, he has positioned himself on the left-hand side of the frame, facing her. This means that when she turns, the focus can shift to his face. At all times, somebody's face is in shot. You shouldn't force this setup onto a scene unless it truly reflects where the characters are in their journey. Staring into space works only if the character is genuinely in such a trance-like haze. Used inappropriately, this can look pretentious.

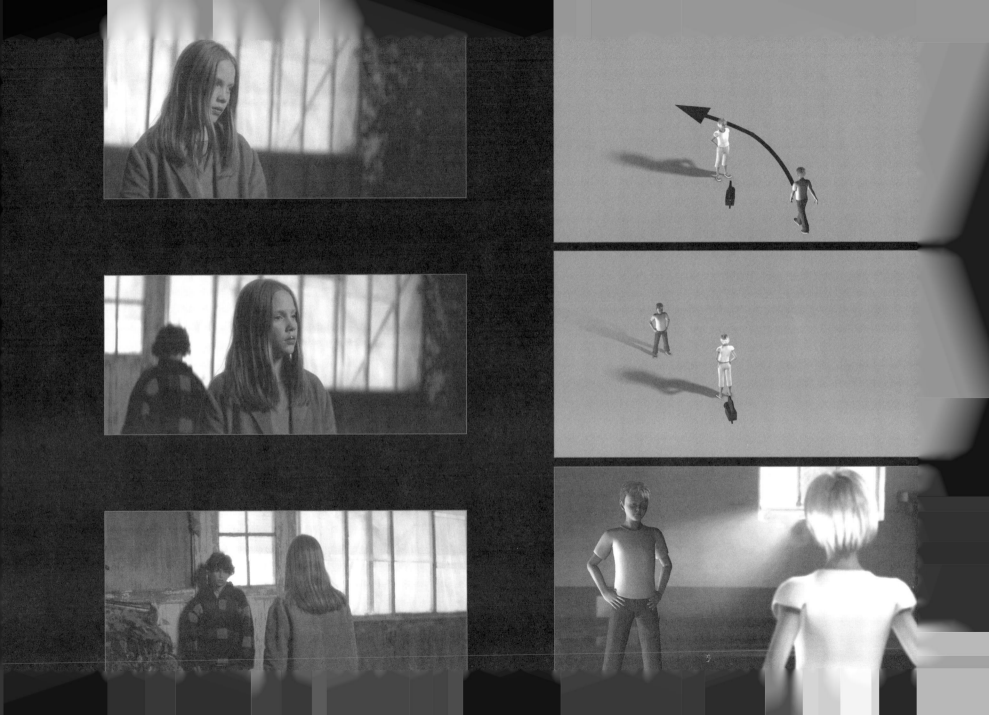

FOLLOWING

When one character pursues another, trying to be heard, you can keep the camera in front of them and capture the whole performance by tracking backwards. In this example from *The Abyss*, a Steadicam is used to give more maneuverability in a confined space. Although this looks like a simple shot, it is meticulously blocked so that both actors are visible throughout.

The Steadicam operator has framed the actors so that they are almost exactly in the center of the frame. This is ideal when moving through a tunnel, because it helps to keep the actors relatively settled in the frame, while simultaneously making the environment rush past.

At the beginning of the shot, the camera is just to the left of the actors, so the audience can see him over her right shoulder. The camera then moves over to the right, and he shifts so that viewers can see him over her left shoulder.

Although you usually want the actors to ignore the camera, this is one time when you should ask them to be aware of the lens. The actor who's closest to camera should keep a consistent pace, and the actor at the back should maneuver so that he is in shot as the camera operator shifts from side to side.

In some cases, a director will tell the actors to just act and let the Steadicam operator do all the framing to compensate, but you'll get better results if everybody contributes to making this a tight shot.

The Abyss. Directed by James Cameron. 20th Century-Fox, 1989. All rights reserved.

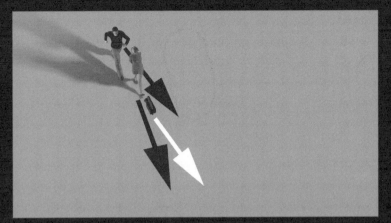

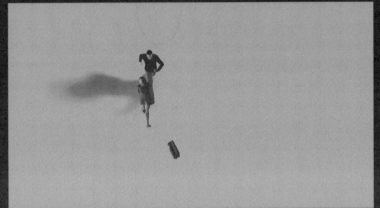

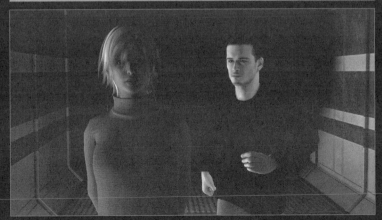

OFFSET WALK

When characters have long conversations on the move, you have the opportunity to be creative with your camera. You can start the shot with the actors fully visible in the frame and follow them through their dialogue, but it can also be interesting to reveal these characters slowly.

In this scene from *Paris, je t'aime*, the camera starts a long way from the actors and gradually moves around in front of them. The camera is never quite parallel with them, which is important because it gives the impression from the outset that the viewer is on a collision course with them. The subtle angle and slight sense of getting closer makes it clear to the audience how this camera move is going to end.

The advantage of a move such as this is that it really makes your audience listen to the dialogue, which is important in such a long scene with so many words being spoken. It also gives you time to flesh-out the characters through what they say and through their body language, with their facial expressions being added last of all.

You can even have the actors stop and face each other while the camera keeps moving, as shown here. When the camera is on the front of them, you can continue the shot, tracking backwards at an even distance from them or cutting to another angle.

Paris, je t'aime (segment titled *Parc Monceau*). Directed by Alfonso Cuarón. La Fabrique de Films/First Look Pictures, 2006. All rights reserved.

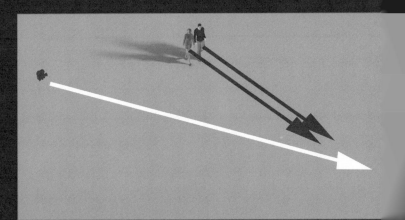

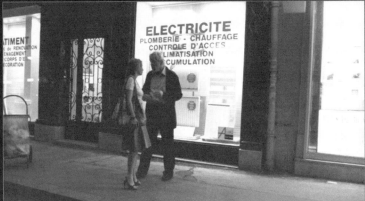

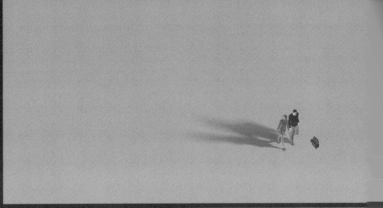

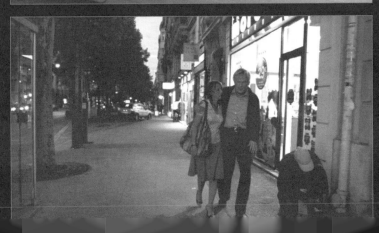

REPEATED SWING

When your actors walk through a busy scene and then come to a rest, you can move the camera in complex ways to take in their faces, the environment, and their body language. This scene from *Star Trek* shows the characters and their surroundings, capturing the energy of two people in a fast-paced, exciting space.

The actors start the scene higher than the camera, and as they move down the stairs the camera moves backward. The actors move past, and the camera pans 180 degrees to follow them. It continues on the same track, but now facing in the opposite direction.

This is a strong move in itself, but the actors are now facing away from the camera, and we need to see their faces for the final part of the scene. The director's first solution is to have Chris Pine turn right around to look at somebody who's walking past.

At this point the camera arcs around the actors, so that when they come to a rest it frames them both in profile for the final dialogue. Pine's turnaround acts as good motivation to send the camera off on this arc, and helps it feel like part of a flowing scene, rather than a forced move to bring the camera to its final position.

A move such as this is not ideal for essential dialogue, because there's too much going on, but for a light moment or an offbeat scene, it's a great way to get a lot across at once.

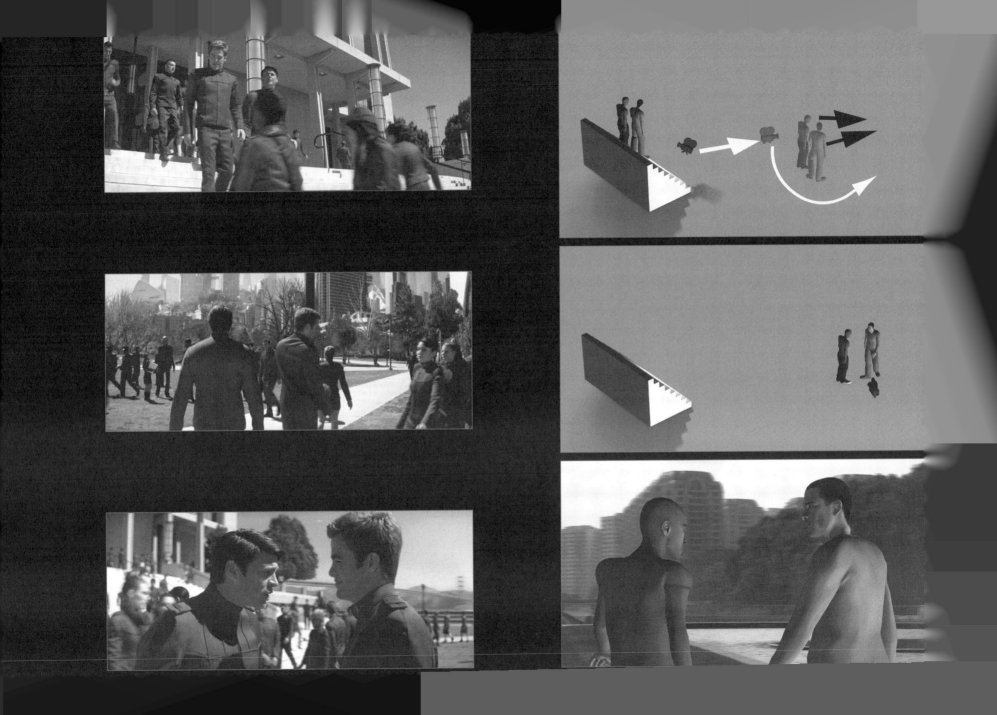

TETHERED CAMERA

When you tie the camera's movement and height to a character, you put the focus absolutely on that character, at the expense of all others. This works best for somebody who is giving a speech, or at least addressing a group of people.

In this scene from *Full Metal Jacket*, the camera is absolutely tied to R. Lee Ermey's movement, so the focus is on him, not the people he's talking to. He walks up one side of the room, turns around, and walks down the other side of the room, and the camera remains at the same distance. His face is in the same part of the frame throughout. At the end of the scene, the camera stops when he stops, and the focus changes just in time for a cut to some dialogue.

Kubrick shot full frame (as shown here) and cropped down for theatrical release, but this effect works just as well in widescreen as it does with the full frame.

When shooting this way, the smoother the movement the better, so use a Steadicam or a wheel-based dolly system rather than a handheld camera. If you do go handheld, it might be better to get closer to the actor so that the sense of presence is never lost.

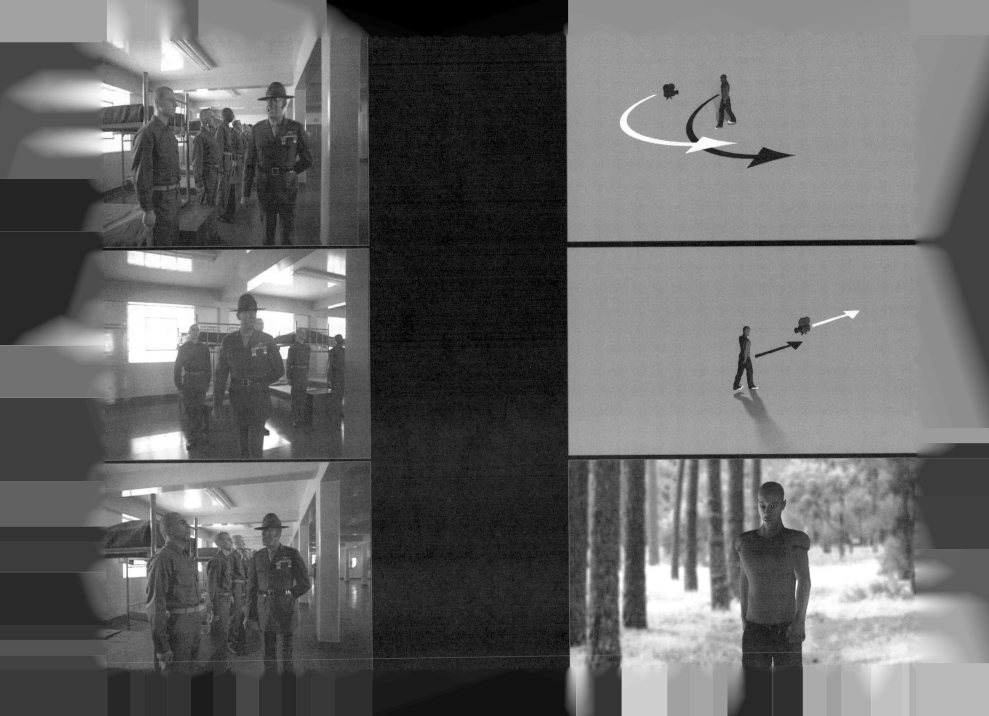

ARGUMENT IN MOTION

When emotions are running high, it's good to keep your characters on the move to reflect the shifting balance of power and the unstable emotions.

This scene from *Revolutionary Road* could be seen as angle/reverse angle with a twist. For most of the scene, the actors stand facing each other, delivering lines, and this is justifiable because they are directing their anger straight at each other. But there are also times when the characters move, so that the distance between them is always shifting. This makes the audience uncertain of where the argument is going and how the scene will end.

The opening shot shows Kate Winslet almost lunging at Leonardo DiCaprio. This is not an over-the-shoulder shot; she is alone in the frame to emphasize that she is taking a stand against him. She turns and walks away.

The director then cuts from the reverse angle and she walks toward the camera. The argument continues with her back turned to him, leaving him in place. This setup, with both characters facing the camera, is often used in soap opera, and is regarded as a cheap, fast way of shooting. So why does it work so well here? Partly it's because this is such a fast-moving scene. He does not linger in the background, but rushes straight up to her, and his taunts force her to turn toward him.

To get this right you need to find a balance between motion and stillness. Let the actors be almost still when they deliver their most important lines, but keep them on the move when they are working through the argument.

This scene moves through several rooms, with the actors repeatedly moving toward and away from each other, and it is much more effective than if they simply stood in place shouting at each other.

Revolutionary Road. Directed by Sam Mendes. Paramount Vantage, 2008. All rights reserved.

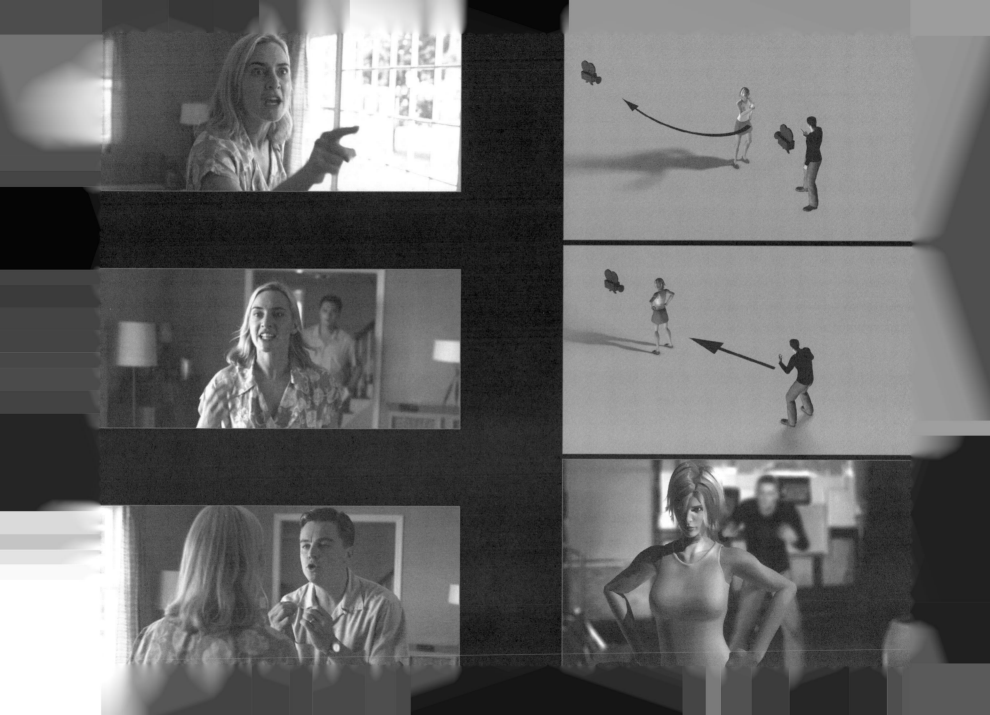

FREEZE REVEAL

When a character is shocked by something that's said, or when a piece of disturbing news is revealed, it's common for the camera to push straight in. A variation on that has the camera moving back in one direction, and then moving straight forward to push in. As you can see in this scene from *The Majestic*, this works by planning various movements specifically for the scene.

The shot opens with three characters walking toward the camera. The main character is in the middle of the frame. There is a mass of background action, but that is specific to this film and not required for the technique to work.

At the moment the shocking news is revealed, Jim Carrey stands still. The camera keeps moving backward, although the other two men gradually come to a stop. As they turn to face him, their turn almost drags the camera back, and it pushes all the way in to a medium close-up on Carrey.

This is a dramatic move because it captures that feeling of disorientation that comes with a shock. It also works well to suddenly isolate him in the frame. In a matter of seconds he changes from a man walking with a small group of friends to a man alone in the frame, devastated by what he's been told.

Making the camera go back in the direction it's just come from, or re-tracking, is sometimes frowned upon because it can appear clumsy. That is why the director has worked hard here to use the other actors' body movements to pull the camera back in. The move is also timed precisely to the plot revelation. Used in the wrong place, a move such as this would draw too much attention to the mechanics of the shot, so use it with caution.

The Majestic. Directed by Frank Darabont. Warner Bros., 2001. All rights reserved.

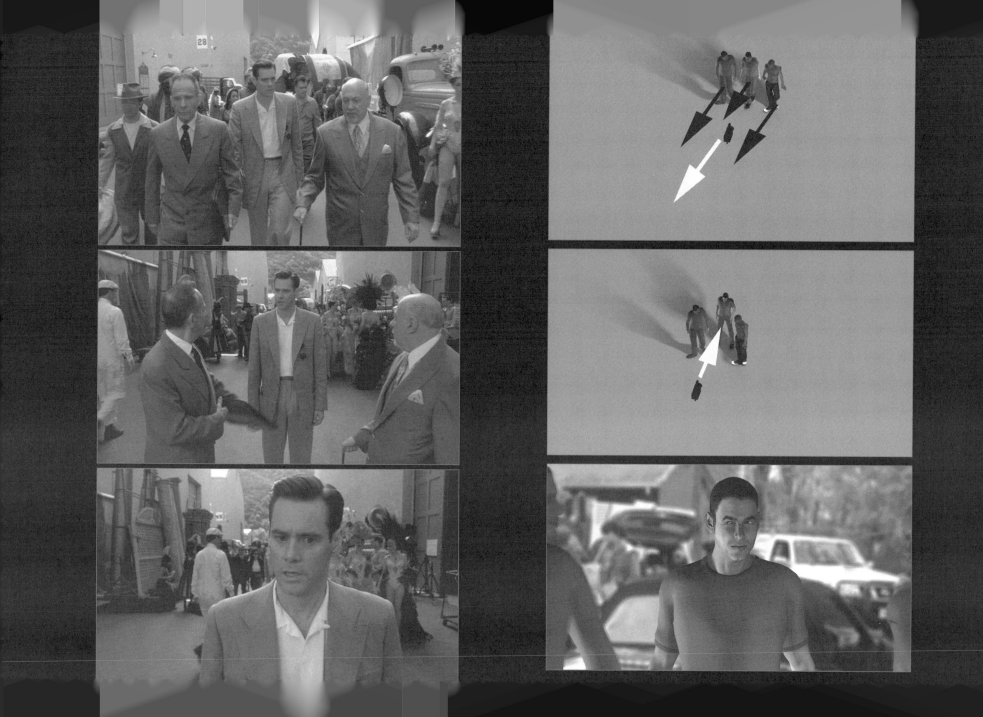

HOMING IN

Sometimes the most intense scenes occur when characters are whispering and acting covertly. In this scene from *E.T.*, the characters are ostensibly looking for things they need. What's actually going on is a conversation about how the main plot is affecting everybody on an emotional level. To capture this, Spielberg starts with a wide shot, then slowly moves in to show just the characters.

The move is quite simple, pushing in toward the actors and then titling up to keep them and the table in frame. A lesser director might have had them stand, but by having them kneel by a low table the sense of secrecy is increased. The scene is not all whispered, but by conveying this feeling of being huddled away (with just one light in a dark space), Spielberg sustains the covert nature of the scene even as the actors raise their voices.

The move also serves to isolate the characters from each other slightly as their emotions rise. At the beginning, the two of them are together in the center of the frame, but by the end of the shot they are on either side of the frame. There is even a physical barrier between them (the lamp and the cloth) to suggest separation.

These small but symbolic changes in the way characters relate to each other only work when you use one continuous shot. If you made a cut you would lose the effect of gradually moving the two of them apart.

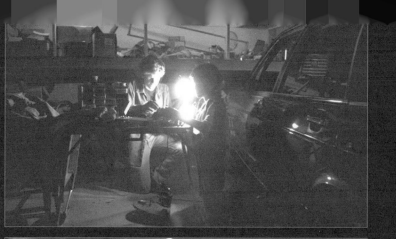

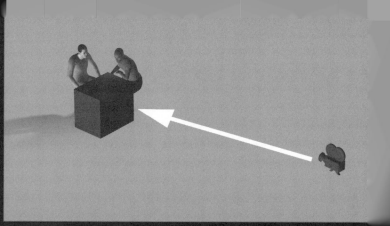

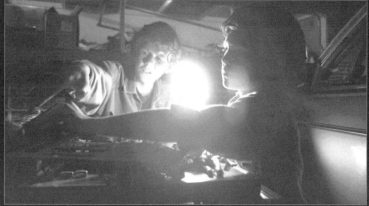

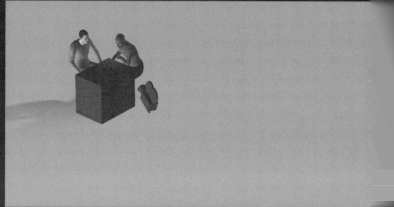

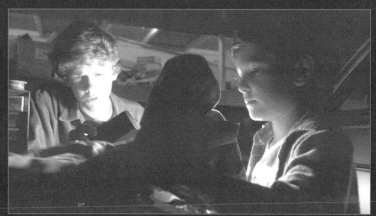

MIXED DISTANCE

Dialogue scenes often start quite wide, then move in closer to the actors, gradually ending with close-ups. This scene from *Onegin* takes this idea to its extreme by moving rapidly from a wide shot to a close-up. This suits the incredibly intense emotions that have built throughout the film.

If you're shooting a scene that the audience has been waiting for — a culmination of everything that's gone before, where characters finally reveal their feelings — this is an effective technique to use.

The first shot is not extremely wide, but wide enough to show a distance between them. There is also some distance between the camera and Ralph Fiennes, and the walls are some way away from Liv Tyler. It feels as though everyone is distant from everything. Although they are trying to connect, there is a huge distance for them to cross.

Then, to the viewers' surprise, this distance is crossed in a single look. As Tyler turns, the director cuts to a long-lens shot that shows nothing but her reaction. The next cut goes straight to a close-up of Fiennes. In moments the viewers have crossed the divide between them. The director makes his audience uncomfortable by keeping the shot so tight on Fiennes during his emotional collapse.

This is a stunning scene in terms of performance, but the director makes the most of it by repeatedly collapsing and expanding the space between the actors.

Onegin. Directed by Martha Fiennes. Siren Entertainment, 1999. All rights reserved.

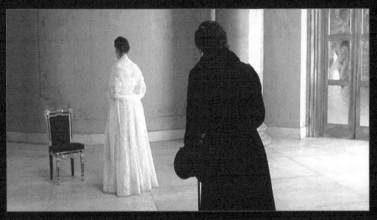

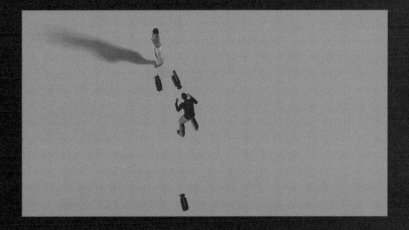

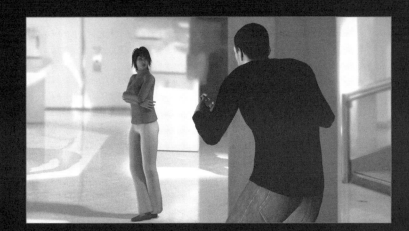

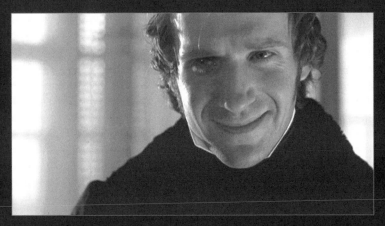

MOVING OUT

When emotions spill over into uncontrollable crying, you might direct one actor to resolutely resist eye contact. This heart-wrenching scene from *Only Clouds Move the Stars* makes astonishing use of this technique. It works so well because the scene begins with this close-up, rather than with an establishing shot.

The opening shot, filmed with a long lens, pushes the two characters together. He's sitting at 90 degrees to her, so the viewer sees his face and her profile. This gives enough of a look at the state she's in, without shooting directly into her eyes. It doesn't matter where they are located, so we don't need to see any more than this. The reverse shot is angled so that his face remains in view, and it doesn't matter that she covers her face with her hands.

As the scene progresses, and she calms herself, the director cuts to a wider shot of the two of them. This is effectively using an establishing shot at the end of the scene rather than the beginning. By moving out in this way, the camera takes the viewer back to reality in the same way it takes the characters. When people collapse with intense emotions the outside world vanishes, and this approach captures that feeling perfectly.

Only Clouds Move the Stars. Directed by Torun Lian. SF Norway, 1998. All rights reserved.

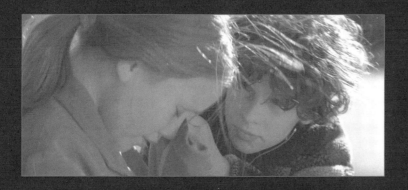

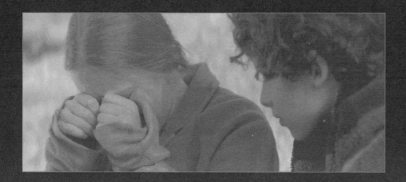

TURN WITH MOVE

At the beginning of this scene from *North Country*, it looks as though Charlize Theron is in the dark, overwhelmed and unable to cope. As the scene progresses, the camera moves alongside the two characters, and she turns to face the light. With one camera move and a simple turn of her body, the director shows the transformation she undergoes in this brief but powerful scene.

When the shot opens, she is absolutely central in the frame, which puts all focus on her. This is important because she is barely lit, and if she was off to one side of the frame, a viewer might not look at her. The director enhances this effect by placing the camera close to a wall, so that the right edge of the frame is black and uninteresting.

This move is just a dolly and pan, but by timing it to coincide with her move into the light and her turn toward her son, the director reveals the emotional journey of the scene.

When shooting a scene like this you don't have to put your actors on steps, but this is an easy way to get them on different levels, which helps with this move. If they were both sitting against a wall, for instance, it would be difficult to get the same effect at the end of the shot. Whatever location you use, have both actors face the same direction at the start of the shot; then only one has to turn during the move.

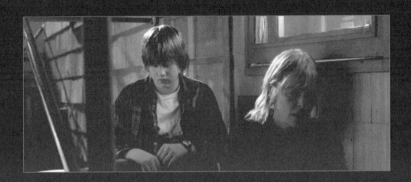

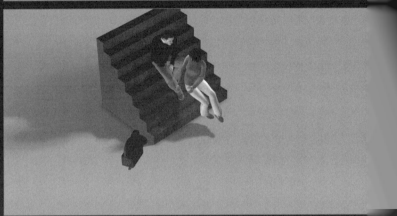

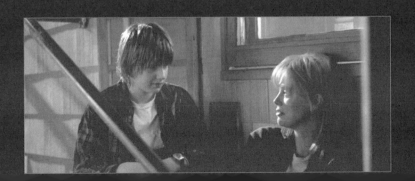

INTIMACY

PUSH TO TALK

Intimacy isn't always relaxed, and this scene from *Garden State* shows how two uneasy characters can still share an intimate moment. They do not gaze at each other, but sit awkwardly alongside each other and glance across. It works well because the audience sees them take up their positions on the end of the bed.

When the scene starts, his back is to the camera and she is facing him. As she comes around to sit on the bed, he sits next to her and they talk. At times her body is turned toward him, but she doesn't look directly at him. At other times, she looks at him, but her body is turned away. These subtle changes need to be brought out by directing your actors well, but the camera move is also essential.

Throughout the scene the camera pushes in. It begins at their head height and moves forward, lowering down as they sit, and pushing in tighter as they talk. This gives the effect of everything closing in intimately, despite the awkwardness of the characters.

To shoot in this way, you'll do best with a camera on a crane and dolly, but you can achieve the same effect handheld or on a basic Steadicam. The movement should begin as she heads toward the bed (or whatever they are sitting on), and should progress at a constant pace. If it's a long scene, the camera may need to slow to a gradual rest once they are framed tightly.

Garden State. Directed by Zach Braff. Fox Searchlight, 2004. All rights reserved.

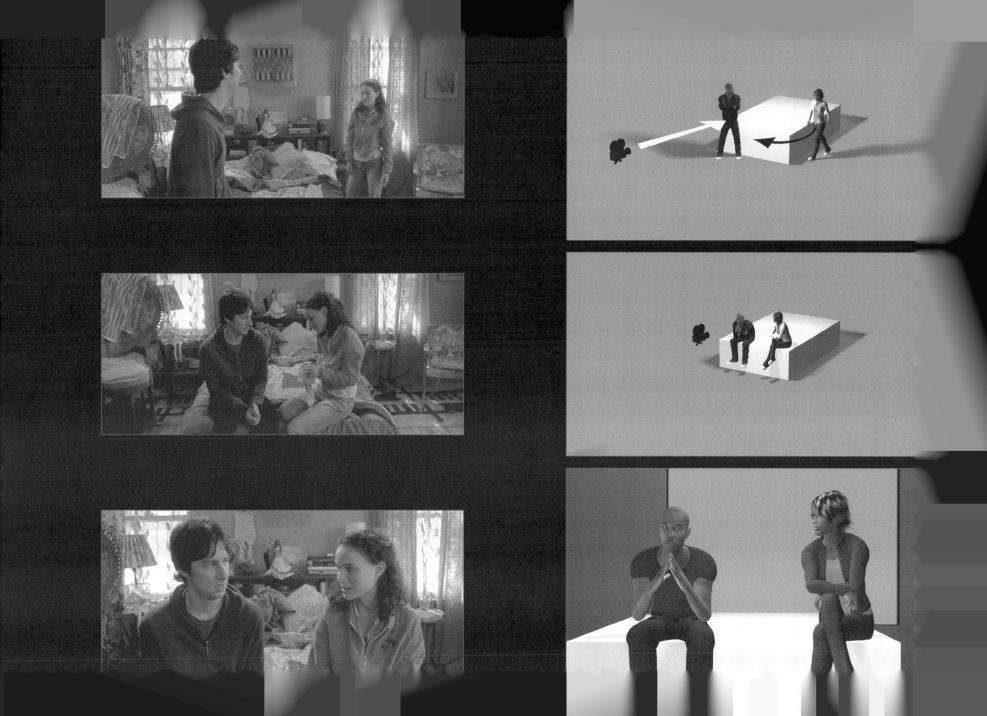

CLOSE FACES

When you put two faces close together, you can capture all the performance with one camera, but you can get a stronger scene with several angles.

This scene from *Defiance* opens with a wide shot directly facing the actors. This acts as an establishing shot, showing where they are in the room and what each actor's body position is in relation to the other. Without this, the viewer would have no sense of where they are or how they are sitting. It only needs to be used once, briefly, and then close-ups can carry the rest of the scene.

There is a close-up with his face toward the camera while hers is turned slightly away. By using an identical angle to that of the establishing shot, the director maintains the strong sense of connection between the two. It would be tempting to cut to a slightly different angle, but this would weaken the sense of connection. The fact that she is turning away from camera emphasizes her interest in him and her need to hear what he has to say.

A third angle, from the side, means the audience can keep looking into her eyes when she relaxes and turns away from him. This scene is largely about her speech and her body angle to him. Although the audience needs to see his reaction, the cuts are used to keep their focus on her dialogue, while still letting them see his response.

To shoot a scene like this, position your actors in a way that feels comfortable for them but keeps their faces extremely close. To maintain a sense of stillness, suggest to your actors they avoid overt shifts of body position. Be careful not to force the actors to be too still or they may tighten up.

If you have two cameras, it's wise to shoot both close-ups at the same time, as there is no change in lighting setup for each character.

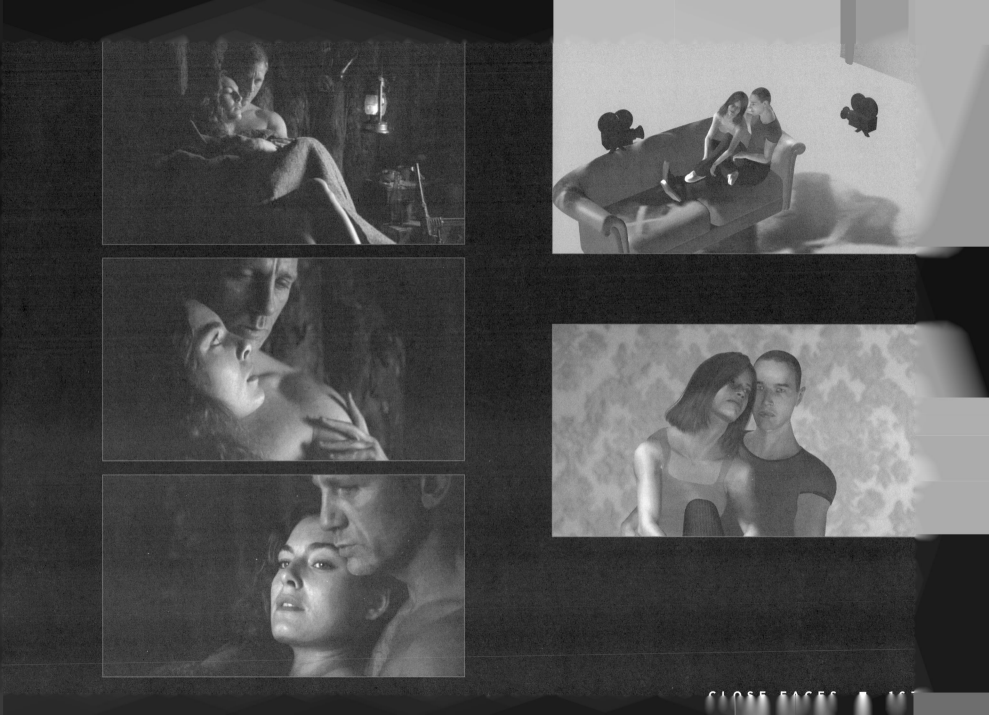

HEAD TO HEAD

When people shoot their first film, or when they shoot fast, the main mistake they make is to have their actors look at each other all the time. Throughout *Master Shots, Volume 2,* you'll see examples of scenes where the actors barely look at each other. In the real world, people talk without making eye contact most of the time. This means that direct eye contact is more powerful when used sparingly. Ironically, you can create a strong sense of intimacy between two characters when they are physically close but not looking at each other, as shown in this shot from *Love Actually*.

The shot is achieved with one moving camera, and there are no cuts. This is a camera move that should go unnoticed by the audience as they concentrate on the dialogue. To achieve this, the actors time their body movements to coincide with the camera movement.

The camera begins on eye level with the actors as they lie on the couch. Both are facing the camera, but staring into space. As the camera approaches, it rises up, and the actors roll onto their backs. This keeps their faces in view throughout the move, so the audience continues to listen to them, rather than notice the camera move.

If the camera move is hidden, why have it at all? Although brief, this scene denotes a change in mood. When they begin talking, they feel stuck in a problem, but by the time they're on their backs, they have an idea of how to solve it. This sensation of hope is echoed by having them look up and out. If the camera remained still, but they moved to look up and out, the director would not capture the mood change. By tying the camera to the actors' movements, the director reveals the heart of the scene.

To create this shot, use a crane or a handheld camera. Whatever equipment you use, maintain the same distance from the actors as you move up by creating a smooth arc. If you get too close before moving up, the effect will be more dreamlike than hopeful. The key is to keep the same distance from the actors until you are above them. You then have the option to bring the camera to rest or to keep it moving upward.

Love Actually. Directed by Richard Curtis. Universal Pictures, 2003. All rights reserved.

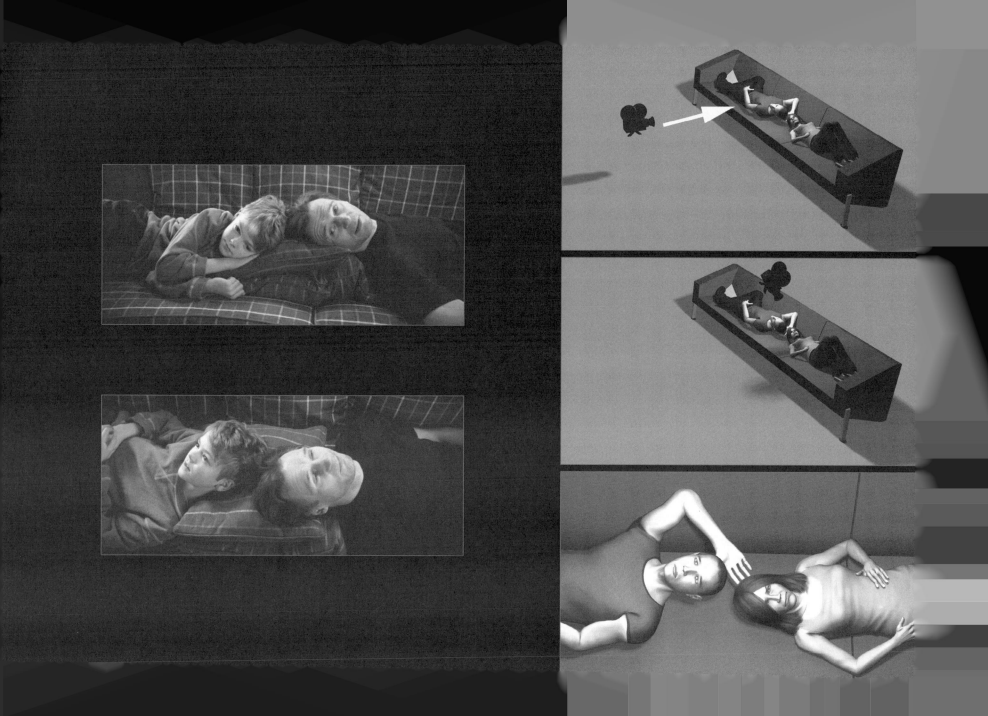

RAISED CAMERA

This scene plays out between a mother and child, but could just as easily work with adults. The intimacy shown here is uncomfortable, because the child is so vulnerable and almost submissive in his desire to be loved, while the mother resists that intimacy.

The scene opens with her much closer to camera, but she is in profile, and therefore he becomes the focus of the scene, even though he is less brightly lit. He moves from this standing position to put his head on her knees, as the camera rises up to look down at him.

The camera only needs to rise up a short distance, but it tilts down at quite a strong angle and the move itself is quite rapid, to match his urgent movement into position. The shot works because he is so focused on connecting with her, making direct eye contact. By having the camera rise up, the director has the audience look down on him and feel his need and vulnerability.

In so many scenes, it's what changes that counts. If the scene had opened with him right next to her or kneeling next to her, the audience wouldn't feel the change that occurs when he moves to connect with her. It is by having him stand back, and then move in to a lower level, that the director achieves the effect.

A. I. Artificial Intelligence. Directed by Steven Spielberg. DreamWorks/Warner Bros., 2001. All rights reserved.

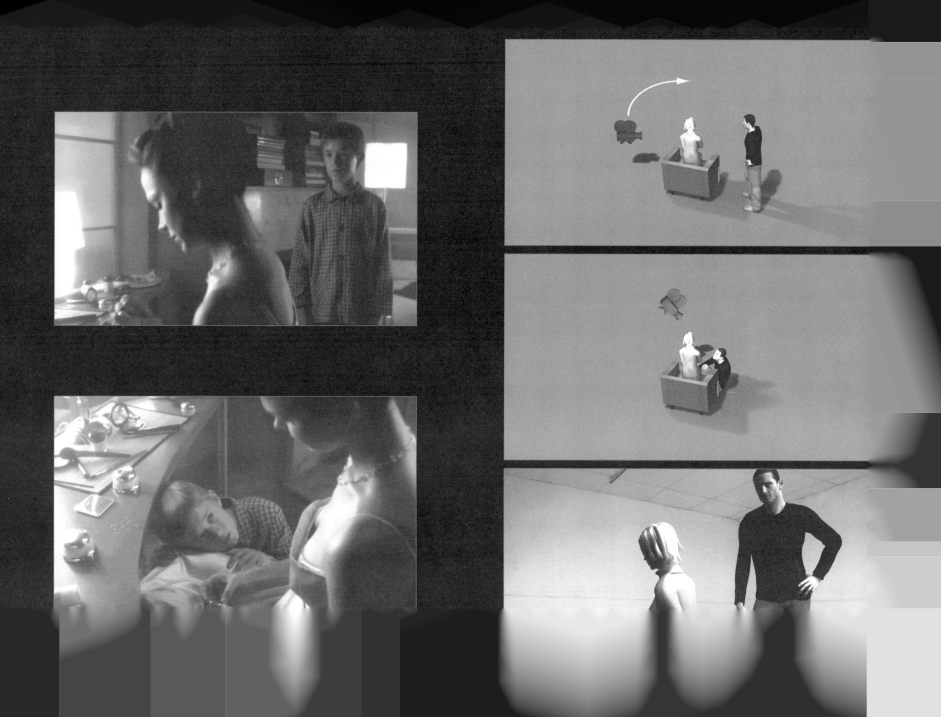

ARC AND PUSH

A scene that ends with a kiss should start by conveying some anticipation — but not certainty — that the kiss is coming. Not least, the viewer needs to hear the dialogue that's going on in the build-up. If the shots give away that a kiss is coming, the audience stops listening.

This shot ends with a push in on the two actors as they move closer together. If the shot was nothing more than this push in, it probably wouldn't work. (It works in 9.1, Push to Talk, because they only talk — they don't kiss.) So in this shot, the camera's starting position is almost alongside the actors. It then arcs around until it's in front of them, then pushes in.

When you open with this shot, you may need to get the most distant actor to lean forward so your audience can see him. The closest actor should also face forward. As the camera moves around, they can both face the front, then look at each other as the camera gets closer.

A shot like this might not actually end with a kiss, of course, but it is set up for one. If a kiss occurs, that will fulfill an expectation, and if one doesn't occur, you'll leave the audience eager for one to come later.

To achieve this move, you need to find a way to arc smoothly and then change direction. You can do this handheld, or with a Steadicam, or using a wheel-based dolly. Whatever you use, make sure the transition is continuous, without a pause between the end of the arc and the beginning of the push forward.

Donnie Darko. Directed by Richard Kelly. Newmarket Films, 2001. All rights reserved.

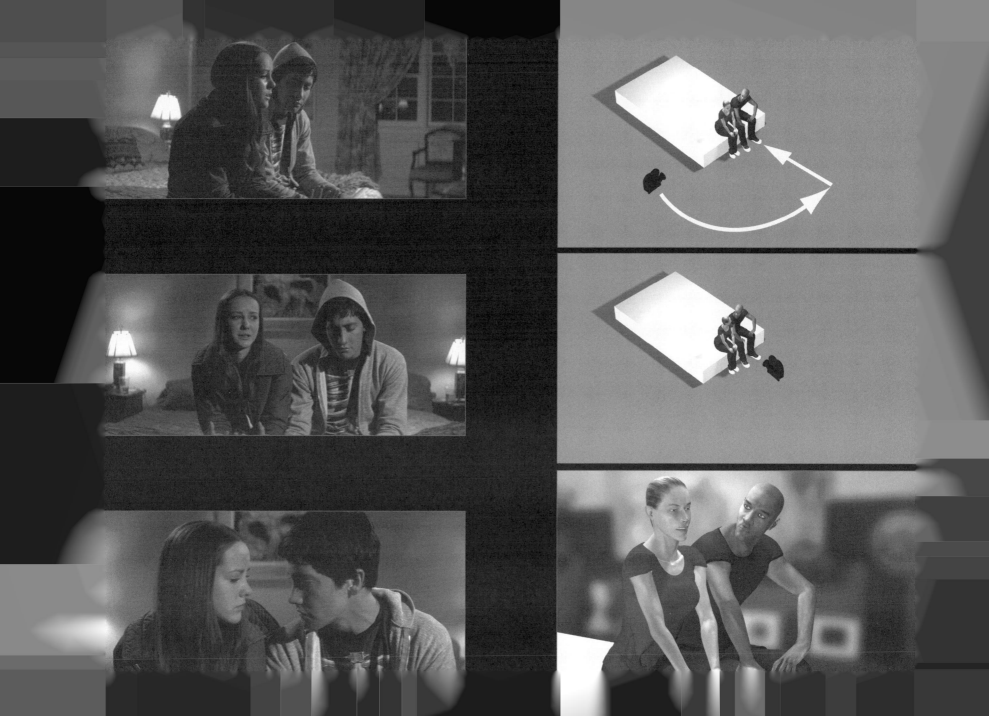

WHISPERING

When one character whispers to another, you can show both faces on screen at the same time. It's a realistic way to show reaction and interaction. In this scene, the actors soon turn to face each other in classic angle/reverse angle, but by opening in this way, the director makes the scene richer.

No major camera move is required, and the camera is in roughly the same place for both shots. In one, a wider lens is used, and the actors are pushed to the side of the screen. In the next, a long lens is used so that nothing other than their faces is shown. This draws the viewer into the conversation, and because the actors are whispering, the viewer listens closely.

To shoot this way, you have many options, such as dollying past the actors, or pushing in, but the simple approach of a jump cut to a medium close-up is effective. The less motion there is in the camera, the more your audience focuses on the actors' quiet words.

In the wider shot, you can push the actors to the edge of the frame to emphasize that this is covert, and that they are hiding away.

The Other Boleyn Girl. Directed by Justin Chadwick. Columbia Pictures/Focus Features, 2008. All rights reserved.

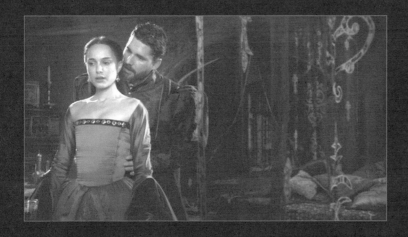

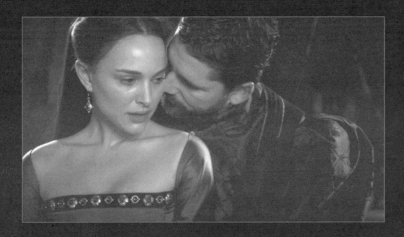

PARTIAL ANGLE

When two people are physically close together, you can jump cut between two close angles to create a gentle intimacy between them.

Rather than giving each actor a close-up, the director of *The Science of Sleep* chose to shoot the scene from two angles that are not far apart. One angle favors him, and the other favors her, but in both shots the two characters can be seen clearly. Although an unusual approach, this works well and is more intimate than a jarring cut between two close-ups. It allows the viewer to see their body movements as well as their faces. By shooting two angles, the director also has more editing choices than if he'd shot this with one roving camera.

When you shoot in this way, you will find the main challenge comes in editing, because every cut is essentially a jump cut. You should remain aware of this when shooting, and instruct your actors to repeat their physical actions as closely as possible from take to take.

As with many of the shots in this book, you can see that the characters are using their hands as a physical connection. This is a great device for generating intimacy between two characters who aren't yet fully intimate. It's also an excellent way to give the actors something to look at other than each other, which can go a long way toward making their performances appear more realistic.

The Science of Sleep. Directed by Michel Gondry. Warner Independent Pictures, 2003. All rights reserved.

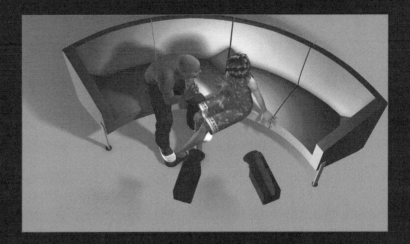

OUTER FOCUS

A good way to establish a connection between two people is to show them close together each time they are in the scene. One way to do this is to have them focus outward on something other than each other. In this example, the couple is watching television.

The director cuts to their point of view, showing what they are watching on television, but at no point does he cut to a shot of just one character. Whether using the wide shot or the medium close-up, the director keeps both faces in view.

If the couple were to look at each other the whole time, we might not see enough of their faces to sense what they are feeling. By having them look out, the director makes his audience look almost straight into their eyes. If they glance at each other, that's okay, but their apparent focus should be outward, even if they are talking about something important.

Set up one camera off to the side, with a wider lens, to establish where they are in the room. Place the second camera directly in front of the actors, with a long lens, framing nothing other than their faces.

The Company. Directed by Robert Altman. Sony Pictures Classics, 2003. All rights reserved.

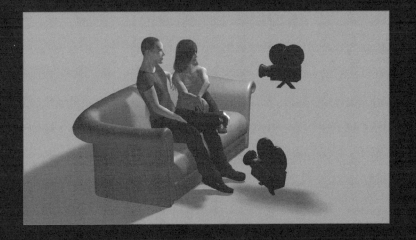

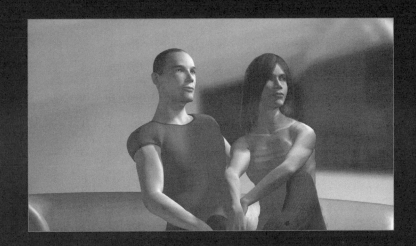

LOW AND CLOSE

Although my aim in this book is to show you alternatives to the standard angle/reverse angle, there still are times when it can be used to great effect. The main problem with the standard approach is that people rarely stand facing each other while delivering dialogue. People move about, and they don't look at each other. Sometimes, however, you can push two characters so closely together that shooting them with the standard angles works well.

In *Juno,* Jason Reitman comes up with hundreds of different ways of arranging his actors, changing angles and camera height while choreographing great movement. When he really wants to focus on the dialogue though, he finds a way to get his actors right next to each other, and then shoots close-ups in the traditional pattern. If the whole film was shot this way, it would be dull, but by saving these setups for the really potent dialogue, Reitman allows his actors to act in a simple environment, and the audience gets to watch without distraction.

The trick is to find a way to get the actors facing each other, without making it seem contrived. Here, they are literally crammed into a space that's too small for two people. They aren't sitting opposite each other, but alongside each other, each backed up against a wall or bed. The brief establishing shot shows this position, then the director cuts to close-ups. This creates intimacy between the actors without artificially pushing them together.

Setting up this shot is all about finding a location that enables you to push the actors together in a physical space. Be wary of shooting in tight spaces, such as closets, as you might not have room to get behind the actors to shoot the reverse angles. If you're shooting on a set you're fine, as you can move a wild wall out and shoot from wherever you want. But if you're on location, don't cram your actors into a closet that forces you to shoot with ultra-wide lenses, or you will lose the warm close-up feeling you want.

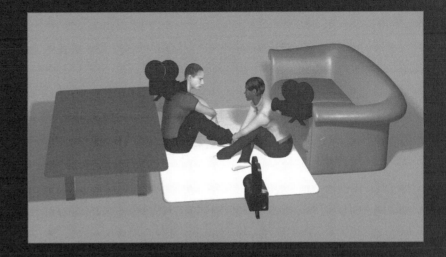

COUPLED ANGLES

Sometimes you want to switch from one character to the other, but you want to make it a bit more interesting than the standard angle/reverse angle. This scene from *Pirates of The Caribbean: Dead Man's Chest* shows how a mix of two-shots and a close-up can achieve this effect.

The first shot shows both actors. Johnny Depp is facing the camera, glancing up and across at Keira Knightley. She stares straight ahead. It's also worth noting that the camera is shooting through the staircase, which creates a stronger sense of the space they are in. Shooting through something (also known as dirtying the frame) is one of the simplest ways to add interest to a shot.

Rather than using this first shot purely as an establishing shot, then moving to close-ups, the director cuts to a new angle that is the same distance from the actor. This time, Knightley is facing the camera. It would be possible to run the whole scene this way, cutting between the two angles as each character speaks. The director opted to add one close-up. This is shot from the same angle as the establishing shot, but with a longer lens. It's a close-up, looking straight at Depp. The close-up is shot from his head height, which puts the focus strongly on his dialogue.

If you were to shoot the whole scene with the two medium-distance cameras, it might work, but by adding the close-up you give yourself a better chance to edit the scene seamlessly. Also, actors tend to work harder when in a close-up; if you need to lift the energy of the scene, the close-up will give you the footage you need.

Shooting a scene like this requires three simple setups. The first two shots should be taken using the same lens and at the same distance from the actors. Each camera should remain quite still as the actors move within the frame. The close-up should be shot with a long lens, and the camera can follow the actor's movements.

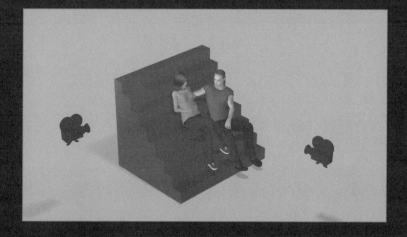

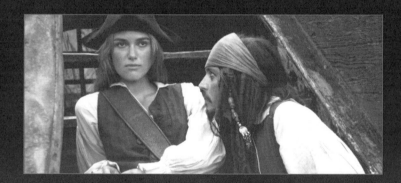

OBJECT HINGE

Give your actors an object to look at, and you can cut between them at a shallow angle. This is less jarring than the traditional angle/reverse angle, but lets you show each actor clearly while connecting them by having the object in both frames.

This scene from *The Science of Sleep* illustrates this well. In both angles, the toy horse is placed between the camera and the actors. In the first frame, the toy horse is on the left and the actor is placed centrally. There is room on the right for the other actor to drift into the foreground, so the audience knows he's there.

In the second frame, the setup is almost identical, although there is a slight difference in camera height, largely because he is leaning in to look at the toy horse.

By having them both look at one object as they talk, the director connects them more powerfully than if they were simply looking at each other. She does glance back at him, but having the toy horse as the focus of their attention gets them through an awkward moment in their conversation.

Having the actors physically touch the object, as he does here, reinforces the connection. It's as though by touching something that is in both frames, they are almost touching each other. This is an effective device when you want to show two characters developing intimacy, slowly and nervously.

The Science of Sleep. Directed by Michel Gondry. Warner Independent Pictures, 2003. All rights reserved.

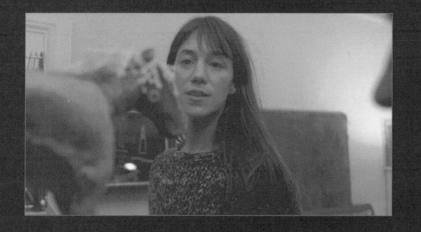

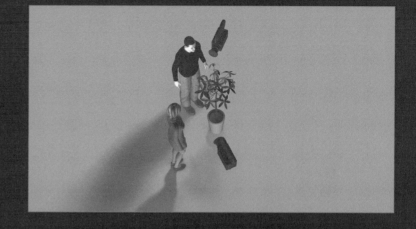

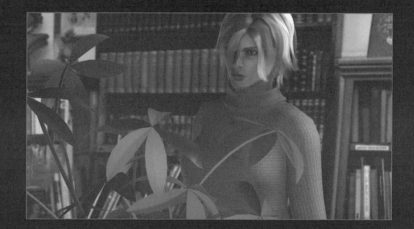

LONG DISTANCE

SOLO MOVE

Most directors dislike scenes that involve phone calls. It can be a sign of lazy writing. Also, films are usually about dramatic conflict, so where's the interest in watching somebody talk to a phone?

This scene from *Juno* shows that you can use phone conversations to good effect, revealing plot details as well as giving some insight into the character's state of mind. When shooting a phone scene, though, be aware that they are usually the first scenes to end up on the cutting room floor. Make them good, or don't shoot them at all.

The shot opens with the newspaper ad and the phone in the same frame, while Ellen Page dials the number, so this simple setup shows three things at once.

The camera shifts from what she's looking at to her. This move begins quite smoothly, with the camera moving down. As she moves the phone up to her ear, the camera whip pans with the phone. From there, the move continues slowly, with the camera moving around, going lower, and gradually tilting up to look at her. Although there is a very fast pan in this shot, the whole move feels slow and steady because the pan coincides exactly with her arm movement.

The beauty of this move is that it gives the director time to show her in close-up, as she waits for the phone to be answered. Then it opens up the space around her, so the audience can see her body language.

If you can avoid it, don't shoot close-ups during phone conversations. Watch real people when they're on the phone: They tend to act out what they're thinking or saying. Use this in your phone-call scenes and you add realism and open many opportunities to show humor. In some cases body language can openly contradict what's being said, which is something you couldn't do so overtly if two people were in the room.

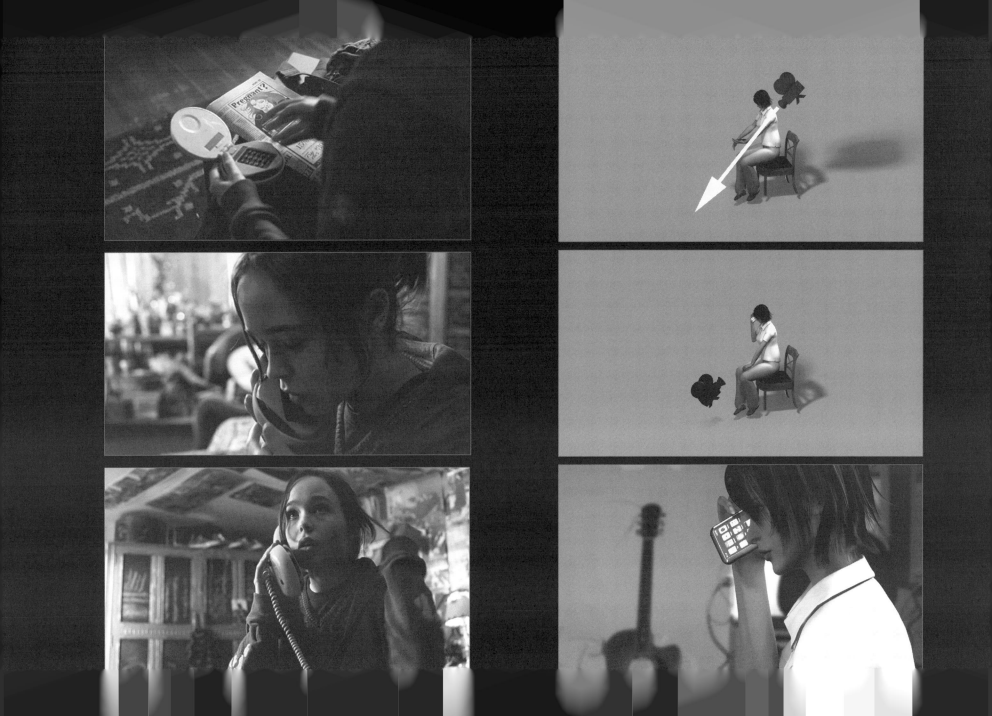

REMOTE OBSERVER

Shooting an actor from slightly behind can induce in your audience a slightly voyeuristic feeling. Although that feeling could be creepy, it can be used to create something as subtle as a feeling of isolation, as shown in this scene from *Lost in Translation*.

As Scarlett Johansson talks on the phone, she is shown from two different angles, both from slightly behind her. The cameras are stationary, which is why the audience doesn't experience a creepy feeling. If the cameras crept up on her, or wobbled a lot, the audience would feel as if they were watching a horror movie.

The director set up these shots to isolate her in two different ways. In the first shot, she is shot with a long lens, and because the viewpoint is from behind her, watching her, the audience gets the sense of her being alone in this room, struggling to make contact with the unheard person on the other end of the phone. If the audience were looking straight at her, they would just be watching somebody make a phone call. By having her almost concealed by the angle, and by having other objects intrude on the frame, the director isolates the audience from her. The long lens, however, shows enough of her face that the viewer connects with her. This simple shot, which is a combination of angle and lens choices, makes the character appear to be alone while also making the viewer empathize with her.

In the second shot, her face can't be seen at all, only the room around her and the city beyond. This places her firmly in the location, and stresses that she is a long way from home. If this scene only showed the hotel room, the director would have missed a great opportunity to show that the character is actually looking out at the city that seems to be engulfing her life.

Lost in Translation. Directed by Sofia Coppola. Focus Features, 2003. All rights reserved.

CONTRASTING MOTION

For scenes that show both ends of a conversation, it's useful to show a strong contrast between the characters' movements in the scene. These shots from *Pretty Woman* are already in contrast, because Julia Roberts is in a lush room while her friend is in a dingy apartment. Rather than relying on the production design to carry this contrast, the director moved the actors and camera to reflect the situation.

In the first shot of Roberts, she is lying down on the bed. This looks natural, but note how her head is angled back and to the right so only her face is in view. Her positioning looks luxurious, but is also far more interesting than if she were just sitting up against the pillows.

Her friend in the apartment is far from still. She moves from place to place, picking things up, struggling with objects, and generally finding it difficult to even cross a room.

This is an extreme example of contrast, because everything is being contrasted at once. One character is freshly bathed, relaxed, and in luxury, barely moving except to gently sit up, while the other struggles and strains through a dirty space. You can use contrast in a more subtle way, shooting one character at rest while another paces.

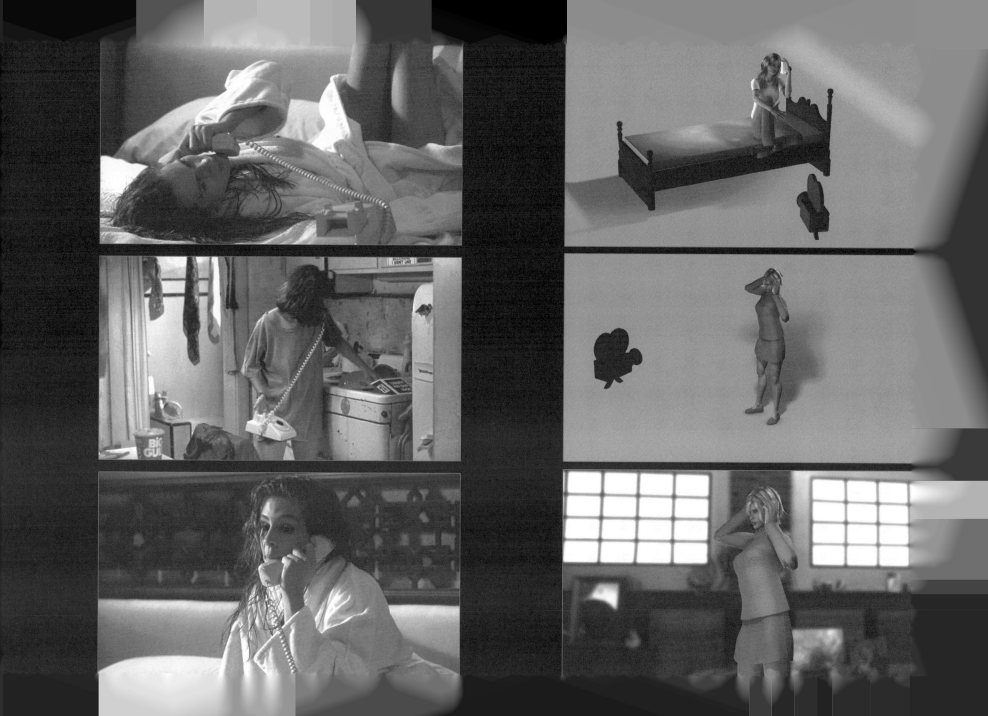

SENSE OF LOCATION

A character's phone conversation can be used to reveal plot and illustrate more about the location. This scene from *Pretty Woman* appears to be nothing more than a shot of Richard Gere talking business, but it develops into something more interesting.

He moves forward to the window, and turns his back on the camera. The director has carefully positioned him so that the audience can see his reflection in the window. It isn't a clear reflection, but it's enough for the shot to still feel like it is a shot of the character, rather than the back of his head.

From here, the camera rises to reveal that a party is going on below, which is a clever way of showing where he is and what's ahead of him. When the camera rises, he turns away from the window to show a little of his face as the conversation ends.

This technique could be used without a phone by having the character cross a room and look out of the window. It works well during a phone conversation because in rushing this move you would make it too obvious. It is the slow revelation of the partygoers below that works effectively, taking him from the isolation of his phone call to a waiting crowd.

If you can find ways to connect everything visually in one shot, you should do so. You could always show a shot of him looking out of the window and then a shot of the party, but it would never be as elegant as this approach.

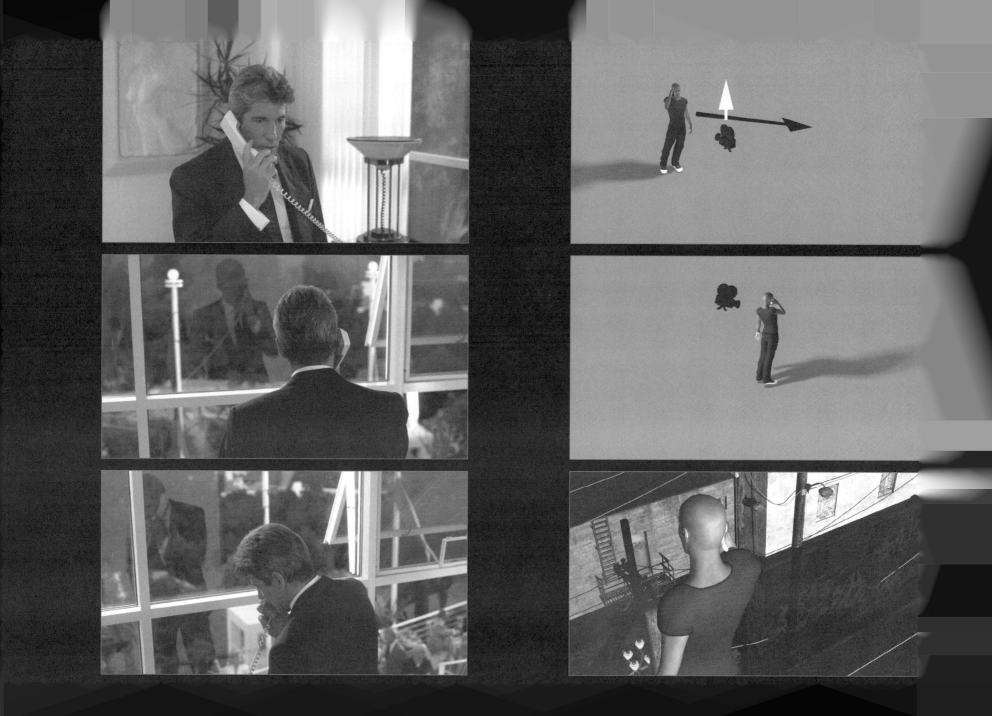

WALL TURN

This scene from *Almost Famous* makes clever use of space to change the perspective on a phone conversation at a moment of change for the character.

In the first shot, he is seen talking on the phone, while two other characters watch. Placing them across the corridor is justification for him turning his back partly to the wall, which brings his face toward the camera. It's possible to shoot quite a lot of the scene from here.

The director then cuts to the person on the other end of the phone, who is, by contrast, all alone. This is emphasized by the use of a long lens to throw the background out of focus. She is also quite central in the frame.

She then says something which shocks the man on the other end of the phone, and the director cuts to a shot of him turning to face the wall. His turn toward the wall would be impossible to capture, except that the phone was placed next to another corridor. The camera shoots from down this corridor, and he steps slightly to the left as he turns, so that he can be seen face on, with the other characters visible in the background.

If you were to position a phone at a corridor junction like this, you would give yourself many different angles from which to shoot the conversation. Normally, if a phone is up against a wall, you have a maximum of 180 degrees to work with, but this gives you far more scope for movement.

The phone-call shots in this book all use non-mobile phones, largely because many directors like to use old-style phones. Despite this, you can just as easily apply all the techniques to mobile phone conversations.

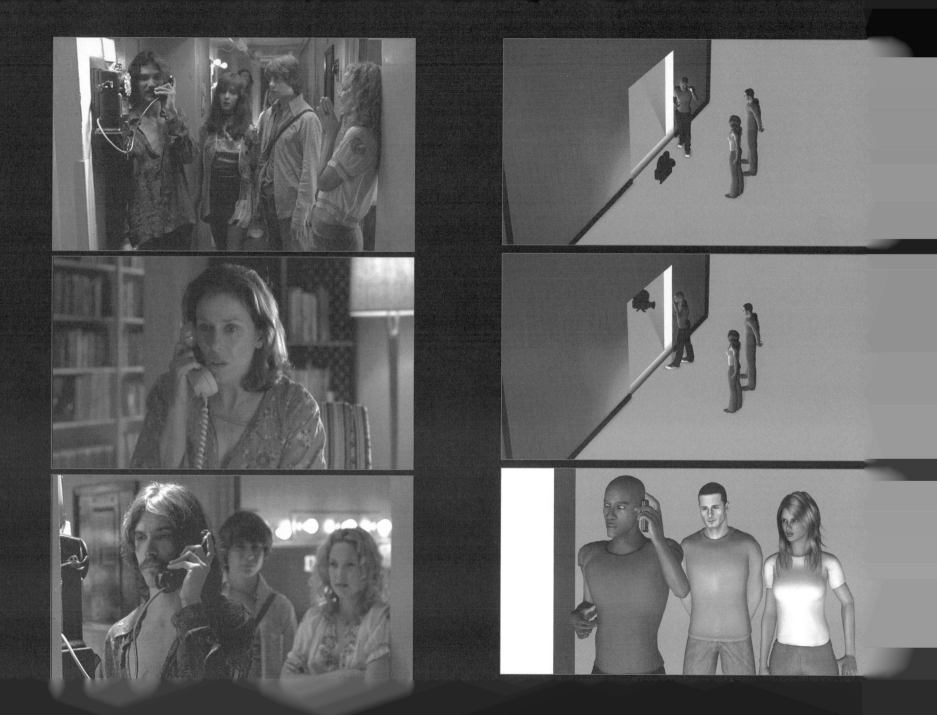

CREATIVE STAGING

REVERSE BODY

As you become more accomplished at setting up your shots, you will find innovative ways to stage all your scenes. These examples show that there is a huge range of shots, from the flashy to the more sedate, which can add creative flair to your dialogue scenes.

In this scene from *Pirates of the Caribbean: Dead Man's Chest,* the actors could quite easily stand facing each other in the traditional angle/reverse angle positioning. Instead, by making a slight adjustment, the director makes this a much more interesting setup.

In the opening shot, both look out at the location and background action. This is more than an establishing shot, because it shows the ship being loaded, which is a plot point. At this point, Tom Hollander turns around, facing away from the background action.

This simple change in his body angle makes for a much more interesting setup. Rather than shooting tight, over-the-shoulder shots, the director uses these medium shots to capture both actors at once. By angling their heads, they show the audience their faces, even though their bodies are facing opposite directions.

Having their bodies face in opposite directions shows the sense of conflict between them, and having them refuse to look at each other builds the feeling that they are unwilling to communicate clearly.

This is only a tiny variation on the traditional setup, but is far more interesting, showing that it's worth taking the time to improve your shots.

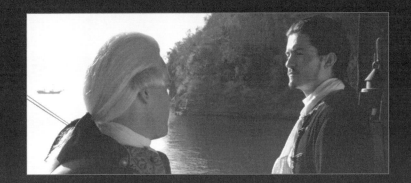

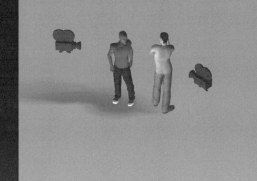

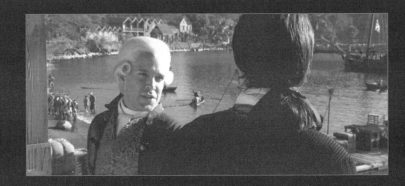

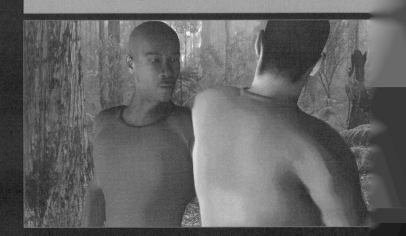

MOTION EXCHANGE

This scene from *Onegin* shows how a simple pan, combined with actor movement, can show the impact that dialogue has on one character. This particular effect works well when the news or information is extremely important to the character, but the messenger isn't aware of the impact. The main character is able to move away, turning her back on the messenger, to hide her feelings.

The scene opens with the camera at Liv Tyler's level as she plays the piano, with the second character walking in behind. Tyler talks to the second character as she approaches, and as the information is exchanged, so is their movement. As the second character comes to a stop, Tyler stands and moves forward. This all happens with a sense of flow and no hesitation.

This move enables us to focus in on Tyler's reaction; the secondary character drops out of focus, then drops out of the frame altogether. The camera stays low and does nothing more than pan, tilt, and move slightly to the side to keep Tyler in frame. The low angle adds majesty to her move forward.

By moving the camera slightly to the side, the director gives his audience the subtle feeling that they are moving out of her way. Again, this adds a certain grace and presence to her movement.

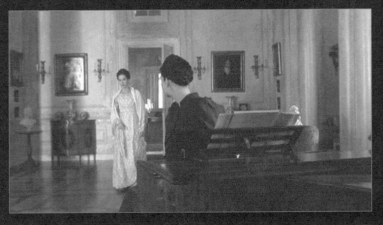

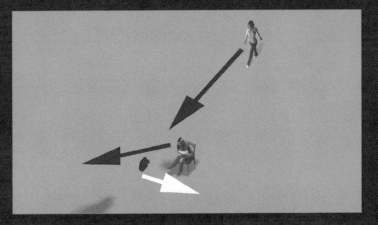

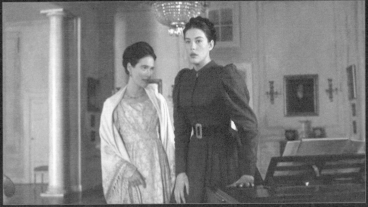

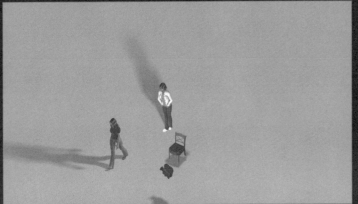

TRACKBACK

The unexpected is always useful, and never more so than during a dialogue scene. Audiences are so accustomed to mundane dialogue scenes that when you go to the trouble of staging something more impressive, the scene feels more intense and exciting, even if the dialogue is quite plain.

This shot from *A Very Long Engagement* appears to be a simple pullback from the main character, who is talking to people off-screen. As the camera pulls back, the other characters come into the shot as they deliver their lines.

This is a highly stylized effect that would not suit all films, but its elements have the potential to be adapted. Although this shot happens quite rapidly, you could use the same principle to shoot (at a slower pace) a meeting over a long table, where the other characters gradually come in as the discussion progresses.

All the actors in this scene are busy with their hands, and nobody looks at anybody else. These two valuable lessons have been repeated many times in this book, to the point where you will realize that, whatever else you do, you should give your actors something physical to do, and stop them from staring at each other.

A Very Long Engagement. Directed by Jean-Pierre Jeunet. Warner Independent Pictures, 2004. All rights reserved.

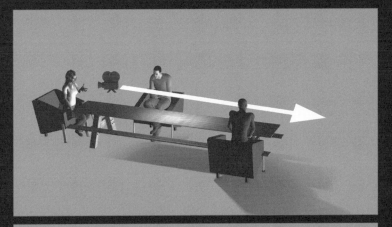

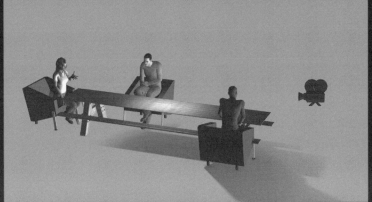

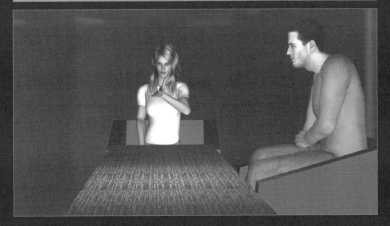

OFFSET ANGLES

The basic premise of *Master Shots 2* is that you should avoid having your characters face each other and deliver lines. You can modify the basic setup slightly and create interesting staging. This works when you want a simple conversation where the focus is on the dialogue, but you want to avoid the usual angle/reverse angle setup.

Getting this right requires innovative use of your set or location, so that you can arrange your actors in unusual places, positions, and at an angle to each other.

This scene from *Juno* has the two characters sitting in a cabinet, which is quirky in itself, but also puts them at right angles to each other. The master shot is wide enough to show where they are in relation to each other.

When the director moves to the closer shots, the right angle between the characters means that Ellen Page has to turn her head to make eye contact. Conversely, the other character is always facing her. This puts Page's character slightly on the defensive, with a feeling of being vulnerable or watched.

You can shoot a scene like this with a basic three-camera setup and no camera movement, and it will be more interesting than if the characters are simply facing each other. Note how the director has also given one character food to play with; this means she has something to do other than talk. Small touches like this make a character far more interesting to watch.

If you're ever stuck for innovative ways to arrange your actors, ask them for ideas, and they will often come up with something usable. They generally enjoy the challenge, but always have a backup plan in case they are short on ideas.

Juno. Directed by Jason Reitman. Fox Searchlight, 2007. All rights reserved.

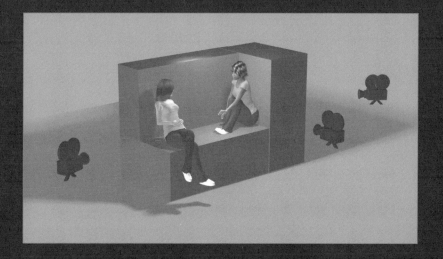

DIFFERENT ROOMS

Having your characters talk to each other while in different rooms keeps a scene interesting, but requires a careful approach. Unless you want to isolate them from each other, the scene should begin with your characters in the same room, and then have them continue the conversation while apart.

Truffaut made great use of this technique in *La nuit américaine* (released in the United States as *Day for Night*), with the two characters talking in one room, criss-crossing the room — and the frame — before one character leaves the room. When he does, the audience thinks he's left or that the scene has ended, but the characters continue to talk.

First, the audience sees his reflection in the mirror. It's important to note that he directs his gaze at her in the mirror, as he talks to her and she turns away from the camera. Although he is in the background, and much smaller in frame, the focus remains on him.

Rather than continuing with this mirror trick, Truffaut maintains the energy by having the character peer around the corner. This movement wouldn't suit every character, but it is certainly more dynamic than having him stand in the doorway and chat.

This technique doesn't necessarily create a particular effect, but enables you to show your characters having an energetic conversation in a near-naturalistic manner. Better still, the camera barely moves, so the setup is simple, and you are left to work with the actors.

DISTANT SLIDE

Even when an important conversation takes place, you don't have to be right up with the actors to sense the drama. The opposite can be true, as shown in this single shot from *V for Vendetta*.

In this shot, the camera dollies from one corridor into the next, slowly revealing the actors. The audience can hear them talk clearly, as though right next to them, but the actors remain in the distance. This has a strange effect, because it makes them appear somewhat lost in the world they inhabit.

The camera comes to a stop, and the dialogue continues for some time until a third man joins them. If the scene was shot from this distance without the dolly move, it would lose some of its elegance, but it would also lose some of its meaning. When we, the audience, slide out from that corridor to observe these characters, it feels like we're creeping up on them and spying on them from a distance. At this point in the film, they are floundering a little, so seeing them look small, distant, and spied upon helps to echo this sensation.

A shot such as this could be carried out in any space, but a confined space, such as a corridor, helps to create a strong visual. The lines of the corridor walls are all effectively pointing to the middle of the frame, where the actors are located.

V for Vendetta. Directed by James McTeigue. Warner Bros., 2005. All rights reserved.

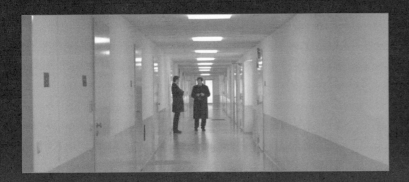

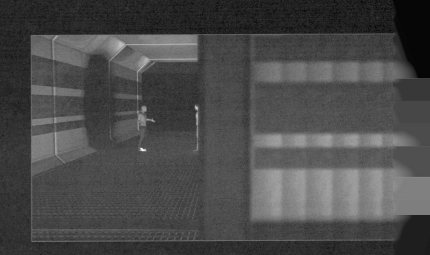

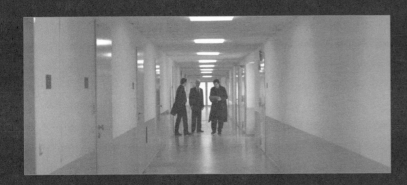

FLAT REVERSE

A reverse angle can work well when it comes unexpectedly. In this famous shot from *E.T.*, the viewers' expectations are built around seeing what the characters are seeing. Instead, the director cuts to an angle that shows Drew Barrymore delivering a line. It's a light moment, but keeps the suspense going a little longer.

The opening shot has the two boys leaning in. This makes them easier to frame, and is justified by the fact that they would lean in to see what was in the closet. Barrymore walks forward. The audience absolutely expects that something is going to happen, or that it is going to see what she sees.

Instead, she turns around, and the viewpoint of her is almost from above. The viewers catch a glimpse of things that are in the closet, but not the thing they want to see. In this way, the tension of the scene is drawn out, even as she holds the audience with a charming delivery of her line.

This setup is so famous that you'd struggle to use the same idea exactly, but the principle is invaluable. You build an expectation, and then have one character turn, so that you can shoot her without revealing what's in the other direction.

Note that when the actors are looking toward the camera, they aren't actually looking into the lens. If they did, this shot would be from E.T.'s point of view, which would have an entirely different effect. Rather than just telling your actors to avoid looking into the lens, give them all the same mark to stare at. If you don't, inevitably you'll get three different eye lines.

E.T.: The Extra-Terrestrial. Directed by Steven Spielberg. Universal Pictures, 1982. All rights reserved.

MOVE THROUGH SCENE

Although *Breakfast at Tiffany's* has many flaws, it also has some examples of camera movement and staging that were ahead of their time. Most of these are so elegant as to go unnoticed by the audience, which is as it should be. This shot of Audrey Hepburn appears to be nothing more than an actor walking across a room, but it has many different effects on the audience's perception of the scene.

The shot begins with Hepburn framed almost centrally, busying herself with the refrigerator and the cat. There is no cut to the other actor, even though we can hear his voice. This tells the audience they are watching her scene, in her movie, and at this particular moment the focus is entirely on her. (This reflects the plot at this point, of course.)

As she moves forward, she passes the other actor slowly enough for the viewer to see him and his position in the room, but without him being truly featured in the shot. This glimpse of him, as she walks through the scene, is more dismissive of him than if he wasn't shown at all.

Finally, she kneels with her back to him, her head turned just enough for the audience to see her, but not him, completing the feeling that even though there are two people in the room, she is alone.

The camera height at the end is important, because although she crouches, the camera stays at the same level as the secondary character. This breaks the viewers' identification with her, ever so slightly.

This sort of carefully crafted move only works if every shot in your film is crafted with the same attention to meaning. Position your actors in places that reflect who they are and where they are in relation to each other, and, whatever they may be saying, you can tell the whole story visually.

Breakfast at Tiffany's. Directed by Blake Edwards. Paramount Pictures, 1961. All rights reserved.

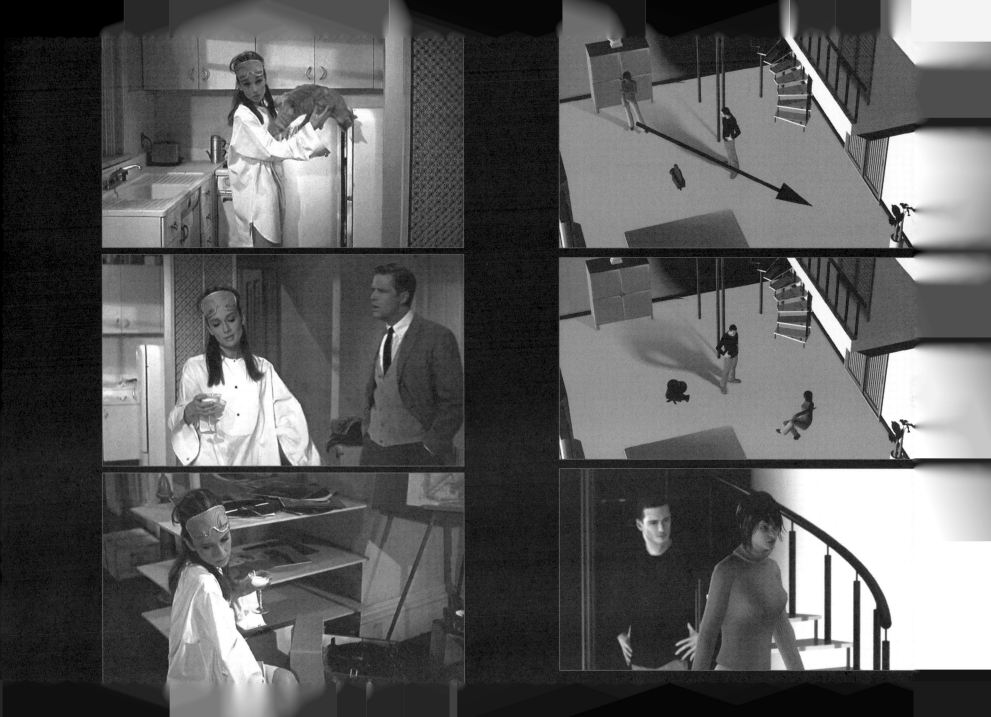

CHARACTER REVEAL

You can add great depth to your scene, without moving the camera at all, by revealing more background as characters leave the frame. This works best when you want to focus strongly on one main character.

In *A Very Long Engagement,* the director sets up the camera close to Audrey Tautou and slightly below her eye line. The camera looks up slightly, so the audience isn't distracted by her moving hands. The tilt also lets the viewer look up at the face of the first background character.

As they talk, the background character often turns to the foreground, but Tautou does not turn her head. This places the focus on her expression, and the scene plays from her point of view.

The camera moves forward slightly, as the background character moves away, revealing a second background character who continues the conversation. He too looks directly at Tautou, but she doesn't turn, maintaining the focus on her. The slight push in helps to reframe the shot on the second background character, but could also be achieved with a slight tilt down. Whichever movement you choose, it should coincide with the first background character moving out of the frame.

You could easily extend this idea to have characters moving in and out of frame, but all the while keeping the main character as the brightest, largest part of the image.

A Very Long Engagement. Directed by Jean-Pierre Jeunet. Warner Independent Pictures, 2004. All rights reserved.

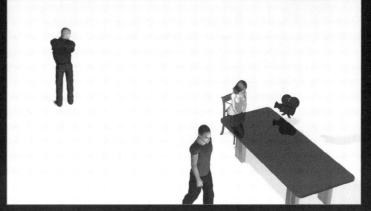

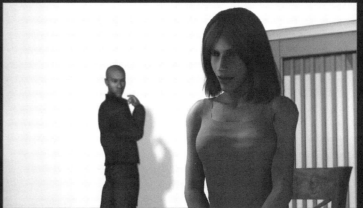

PUSH BETWEEN

There are times when the location is as important as the characters, because it tells part of the story. During this kind of scene you can afford to shoot your actors from behind. We still get to hear their dialogue. As the scene progresses, you can push the camera between them to capture the main character's reaction.

This shot from *The Majestic* shows how a scene should always be a story in itself, rather than just a series of shots where things happen. This shot contains a dramatic buildup, some conflict, and a final reaction. The camera work reflects this.

The shot opens with the characters down in the bottom left of the frame, because the room they are staring at is as important to the scene as they are. The camera then moves forward, and as the actors turn toward each other, it begins to pan to the right to favor Jim Carrey. The camera then pushes between the two actors, making this a single shot of Carrey delivering his lines.

You could shoot this scene by getting a wide shot and lots of coverage, but by using this move, you enhance the on-screen story. This is a moment in the film when something comes between these two men and — at precisely that moment — the camera also moves between them. It helps the viewer to share some of that feeling of conflict, and is more effective than simply cutting back and forth between two actors.

The Majestic. Directed by Frank Darabont. Warner Bros., 2001. All rights reserved.

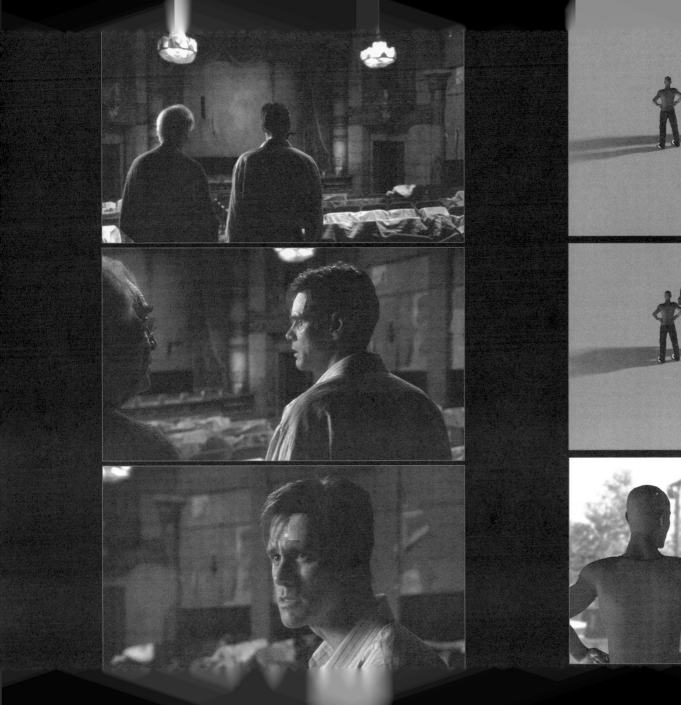

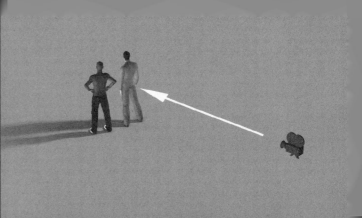

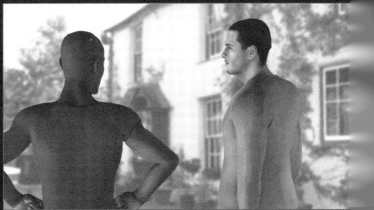

CLOSING THE GAP

Most people who watch this scene notice that there's a toy Garfield stuck to the porthole. What they shouldn't notice is that the director has carefully positioned actors and props to create subliminal ideas of separation. As the scene progresses, the characters attempt to overcome this.

The first shot of the characters is taken with a long lens. As they are a good distance apart, only one can be in focus at a time. The audience is aware of her movement in the foreground as he speaks, but it watches him.

When she speaks, the camera racks focus to her. At the same time, the strips of film hanging from above come into sharp focus. It's almost as though he's imprisoned — the film strips look like bars coming down in front of him. If you think this is stretching the interpretation, these film strips certainly act as a barrier between the two of them.

He moves forward in an attempt to connect with her and sweeps those film strips aside. He's pushing the physical barrier away. This is shot with a wider lens, putting the two of them center-frame, to show that they are closer to each other than to the world around them. Also, he obscures the window behind him. The viewer can no longer see the toy Garfield.

The joke's over, and the director turns serious here. This is the sort of attention to detail that separates great directors from the ordinary. You only have to start paying attention to the possibility of using symbolism, and you will find ways to add it to your movies.

The Abyss. Directed by James Cameron. 20th Century-Fox, 1989. All rights reserved.

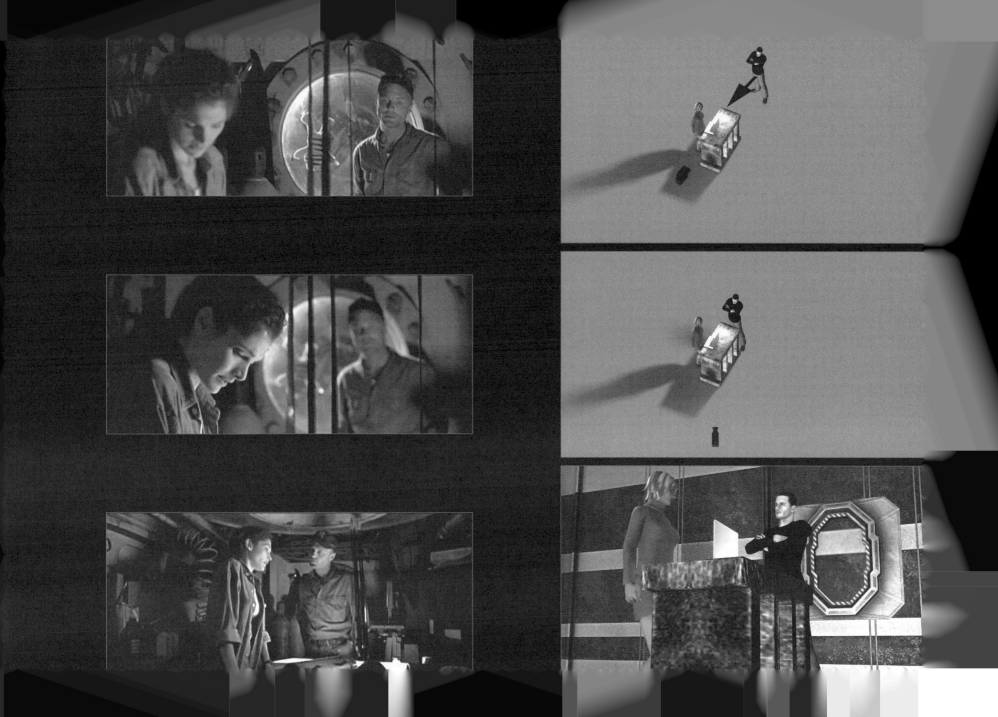

CONCLUSION

When you put the shots demonstrated in *Master Shots 2* into your films, you will meet some challenges. These may come from the actors who don't want to get bogged down in technical moves, or from the financiers and producers who want you to work faster. The truth is that working creatively does not take longer and does not impede actor performance if you are prepared.

Plan your shots in advance, plan them again once you've seen the set or location, and be ready to adapt them on your morning walkthrough. Once your crew knows that you're working in this way, they will raise their game. Creative departments, such as production design, will cooperate more if they understand you are filming in a way that enhances what they are putting into the work.

This is a book about shooting dialogue, and you may find the greatest resistance comes from the people who deliver the lines: actors. There is a widely held belief that there are "actors' directors" and "camera directors." Thankfully, this myth is being discredited as the best directors know how to work with both aspects of the production. There are still some people, however, who think that if you plan a complex camera move you're not interested in actor performance.

Reassure your actors that you are using these moves to show them at their best, and you should get their cooperation. If possible, show them rushes after the first day or two and they will be converted to your cause.

It's best not to tell your actors this, but you will probably get a better performance out of them if you give them lots to do. All actors are self-conscious. Even the greats, even the most jaded and world-weary actors, suffer from some degree of apprehension on set. They want feedback from the director that they are doing a good job, and you must give it to them. When you can't tell them they're doing well, you must help them improve. The best way you can help them is to reduce their self-consciousness.

Actors have several jobs to do: They have to remember their lines, the performance they've planned, the direction and adjustments you've suggested, and the marks you've given them to hit. They still find room in their heads to worry about their performance, and that can spoil a good take. If you give them one more performance-related thing to think about, you can make them so busy that they have to act on automatic. The result is anything but automatic. It is usually far more real and raw than when your actors are carefully honing their performance.

So when you ask them to hit another mark, or do something else with their hands, or turn their heads to a particular angle, expect some protest. They may tell you that you are wrong, or that the character "wouldn't do that." They are probably panicking because they worry it's too much to do at once. This is a good sign. It means you're going to push them into a space where they act almost unconsciously. Be gentle, but push them over the edge.

Without good dialogue it's difficult to tell a good story. As a visual storyteller, your job is to capture each scene in a way that reveals character and advances story. Take the shots from this book, adapt them, mix them, invent your own, and use them in your films. When you make them your own and invent new ways of using them, you become a real director.

ABOUT THE AUTHOR

Christopher Kenworthy has worked as a writer, director, and producer for the past ten years. He directed the feature film *The Sculptor,* which played to sold-out screenings in Australia and received strong reviews.

He's the author of the best-selling *Master Shots*; two novels, *The Winter Inside* and *The Quality of Light*; and many short stories.

Recent works include sketch comedy for the BBC's *Scallywagga*, a title sequence for *National Geographic Channel*, visual effects for *3D World*, music videos for Pieces of Eight Records and Elefant Records, and an animated wall projection for The Blue Room Theatre, Perth, Australia.

Current projects include screenwriting, several directing assignments, and the development of additional *Master Shots* applications.

Born in England, Kenworthy currently lives in Australia, working on projects based there, in Europe, and the United States. He's married to co-writer and co-producer Chantal Bourgault. They have two daughters.

www.christopherkenworthy.com
chris@christopherkenworthy.com

MASTER SHOTS
100 ADVANCED CAMERA TECHNIQUES TO GET AN EXPENSIVE LOOK ON YOUR LOW-BUDGET MOVIE

CHRISTOPHER KENWORTHY

BEST SELLER

Master Shots gives filmmakers the techniques they need to execute complex, original shots on any budget. By using powerful master shots and well-executed moves, directors can develop a strong style and stand out from the crowd. Most low-budget movies look low-budget, because the director is forced to compromise at the last minute. *Master Shots* gives you so many powerful techniques that you'll be able to respond, even under pressure, and create knock-out shots. Even when the clock is ticking and the light is fading, the techniques in this book can rescue your film, and make every shot look like it cost a fortune.

Each technique is illustrated with samples from great feature films and computer-generated diagrams for absolute clarity.

Use the secrets of the master directors to give your film the look and feel of a multi-million-dollar movie. The set-ups, moves and methods of the greats are there for the taking, whatever your budget.

"Master Shots gives every filmmaker out there the blow-by-blow setup required to pull off even the most difficult of setups found from indies to the big Hollywood blockbusters. It's like getting all of the magician's tricks in one book."
— Devin Watson, producer, *The Cursed*

"Though one needs to choose any addition to a film book library carefully, what with the current plethora of volumes on cinema, Master Shots is an essential addition to any worthwhile collection."
— Scott Essman, publisher,
Directed By Magazine

"Christopher Kenworthy's book gives you a basic, no holds barred, no shot forgotten look at how films are made from the camera point of view. For anyone with a desire to understand how film is constructed — this book is for you."
— Matthew Terry, screenwriter/director,
columnist *www.hollywoodlitsales.com*

Since 2000, CHRISTOPHER KENWORTHY has written, produced, and directed drama and comedy programs, along with many hours of commercial video, tv pilots, music videos, experimental projects, and short films. He's also produced and directed over 300 visual FX shots. In 2006 he directed the web-based Australian UFO Wave, which attracted many millions of viewers. Upcoming films for Kenworthy include *The Sickness* (2009) and *Glimpse* (2011).

$24.95 | 240 PAGES | ORDER NUMBER 91RLS | ISBN: 9781932907513

CINEMATIC STORYTELLING
THE 100 MOST POWERFUL FILM CONVENTIONS EVERY FILMMAKER MUST KNOW

JENNIFER VAN SIJL

BEST SELLER

How do directors use screen direction to suggest conflict? How do screenwriters exploit film space to show change? How does editing style determine emotional response?

Many first-time writers and directors do not ask these questions. They forego the huge creative resource of the film medium, defaulting to dialog to tell their screen story. Yet most movies are carried by sound and picture. The industry's most successful writers and directors have mastered the cinematic conventions specific to the medium. They have harnessed non-dialog techniques to create some of the most cinematic moments in movie history.

This book is intended to help writers and directors more fully exploit the medium's inherent storytelling devices. It contains 100 non-dialog techniques that have been used by the industry's top writers and directors. From *Metropolis* and *Citizen Kane* to *Dead Man* and *Kill Bill*, the book illustrates — through 500 frame grabs and 75 script excerpts — how the inherent storytelling devices specific to film were exploited.

You will learn:
· How non-dialog film techniques can advance story.
· How master screenwriters exploit cinematic conventions to create powerful scenarios.

"Cinematic Storytelling *scores a direct hit in terms of concise information and perfectly chosen visuals, and it also searches out... and finds... an emotional core that many books of this nature either miss or are afraid of.*"

— Kirsten Sheridan, Director,
Disco Pigs; Co-writer, *In America*

"*Here is a uniquely fresh, accessible, and truly original contribution to the field. Jennifer van Sijll takes her readers in a wholly new direction, integrating aspects of screenwriting with all the film crafts in a way I've never before seen. It is essential reading not only for screenwriters but also for filmmakers of every stripe.*"

— Prof. Richard Walter,
UCLA Screenwriting Chairman

CINEMATIC STORYTELLING
THE 100 MOST POWERFUL FILM CONVENTIONS EVERY FILMMAKER MUST KNOW JENNIFER VAN SIJLL

JENNIFER VAN SIJLL has taught film production, film history, and screenwriting. She is currently on the faculty at San Francisco State's Department of Cinema.

$24.95 | 230 PAGES | ORDER NUMBER 35RLS | ISBN: 9781932907056

CINEMATOGRAPHY FOR DIRECTORS
A GUIDE FOR CREATIVE COLLABORATION

JACQUELINE B. FROST

The essential handbook for directors and aspiring filmmakers who want to get the best visuals for their films while establishing a collaborative relationship with their cinematographer.

Through balancing interviews with working ASC cinematographers and the technical, aesthetic, and historical side of cinematography, this book guides directors toward a more powerful collaboration with their closest ally, the cinematographer. Topics include selecting a cinematographer, discussing the script with the cinematographer, choosing the appropriate visual style for the film, color palette, various film and HD formats, and postproduction processes including the digital intermediate.

"I urge all aspiring filmmakers to read Cinematography for Directors. *Frost has the ability to put the director at ease by bringing clarity to the notoriously elusive relationship between the filmmaker and the cinematographer... The numerous thrilling interviews she conducts create an empowering message: that the dynamic between the director* and their cinematographer can be a relationship of understanding, ease, humor, passion and, above all, true collaboration."

— Bryce Dallas Howard, Actress (*Terminator Salvation, Spider-Man 3, As You Like It, Lady in the Water, The Village*), Writer, Producer, Director

"Far too few books about the filmmaking process address the complex, challenging, and intensely collaborative relationship that exists between the director and the cinematographer. Drawing on her vast experience as a working cinematographer and as a film school professor, Frost deftly combines her clear appreciation of the profession of cinematography with a pragmatic guide for how to accomplish these often startling and culturally-significant moments of visual artistry."

— Denise Mann, Head, UCLA Producers Program; Associate Professor, Department of Film, TV, Digital Media, University of California, Los Angeles

JACQUELINE B. FROST has been teaching film and video production and film history for twenty years at various universities including Miami, Penn State University, and the University of Oklahoma. She currently teaches cinematography and advanced film production at California State University, Fullerton where she is an Associate Professor. She regularly teaches a course through

the UCLA extension entitled, Cinematography for Directors, on which the book is based. In addition to teaching, Jacqueline has been the cinematographer on numerous sort films, independent feature films, and documentaries that have been screened in film festivals.

$29.95 | 292 PAGES | ORDER NUMBER 127RLS | ISBN: 9781932907551

THE MYTH OF MWP

In a dark time, a light bringer came along, leading the curious and the frustrated to clarity and empowerment. It took the well-guarded secrets out of the hands of the few and made them available to all. It spread a spirit of openness and creative freedom, and built a storehouse of knowledge dedicated to the betterment of the arts.

The essence of the Michael Wiese Productions (MWP) is empowering people who have the burning desire to express themselves creatively. We help them realize their dreams by putting the tools in their hands. We demystify the sometimes secretive worlds of screenwriting, directing, acting, producing, film financing, and other media crafts.

By doing so, we hope to bring forth a realization of 'conscious media' which we define as being positively charged, emphasizing hope and affirming positive values like trust, cooperation, self-empowerment, freedom, and love. Grounded in the deep roots of myth, it aims to be healing both for those who make the art and those who encounter it. It hopes to be transformative for people, opening doors to new possibilities and pulling back veils to reveal hidden worlds.

MWP has built a storehouse of knowledge unequaled in the world, for no other publisher has so many titles on the media arts. Please visit www.mwp.com where you will find many free resources and a 25% discount on our books. Sign up and become part of the wider creative community!

Onward and upward,

Michael Wiese
Publisher/Filmmaker